Tar Wars

Oil, Environment and Alberta's Image

GEO TAKACH

TAR WARS

THE UNIVERSITY OF ALBERTA PRESS

Published by

The University of Alberta Press
Ring House 2
Edmonton, Alberta, Canada T6G 2E1
www.uap.ualberta.ca

LIBRARY AND ARCHIVES CANADA
CATALOGUING IN PUBLICATION

Takach, Geo, author.
 Tar wars : oil, environment and Alberta's
image / Geo Takach.

Includes bibliographical references
and index.
Issued in print and electronic formats.
ISBN 978-1-77212-140-7 (paperback).—
ISBN 978-1-77212-275-6 (EPUB).—
ISBN 978-1-77212-276-3 (mobipocket).—
ISBN 978-1-77212-277-0 (PDF)

 1. Oil sands industry—Alberta. 2. Oil
sands industry—Environmental aspects—
Alberta. 3. Oil sands industry—Social
aspects—Alberta. 4. Oil sands industry—
Alberta—Public opinion. I. Title.

HD9574.C23A54 2016 338.2'7282097123
C2016-902887-9
C2016-902888-7

First edition, first printing, 2017.
First printed and bound in Canada by
Houghton Boston Printers, Saskatoon,
Saskatchewan.
Copyediting and proofreading by
Meaghan Craven.

 The University of Alberta Press is
committed to protecting our natural environ-
ment. As part of our efforts, this book is
printed on Enviro Paper: it contains 100%
post-consumer recycled fibres and is acid-
and chlorine-free.

 The University of Alberta Press grate-
fully acknowledges the support received for
its publishing program from the Government
of Canada, the Canada Council for the Arts,
and the Government of Alberta through the
Alberta Media Fund.

 This book has been published with the
help of a grant from the Canadian Federation
for the Humanities and Social Sciences,
through the Awards to Scholarly Publications
Program, using funds provided by the Social
Sciences and Humanities Research Council
of Canada.

Canada Canada Council Conseil des Arts
for the Arts du Canada

 Alberta
Government

To the inextinguishable inspiration of Martha Kostuch (1949–2008),
environmentalist extraordinaire and exemplary embodiment of Maya
Angelou's belief that courage is the foundation of all other virtues.

Communication can be the very model of democracy, or the very method of its subversion.

—GREGORY J. SHEPHERD & ERIC W. ROTHENBUHLER,
Communication and Community

Contents

Acknowledgements

APPRECIATING THAT IT TAKES a village to raise a book—and certainly the dissertation from which this one springs—I thank an immense throng of instructors, scholars, librarians, university administrators, learning colleagues and personal supporters for helping to realize this adventure.

Special huzzahs extend to a gallant gaggle of scholars at the University of Calgary, led by Brian Rusted, George Melnyk, Aritha van Herk and Clem Martini (all personal heroes of mine), with contributions from Barbara Schneider, Ann Davis, Maria Bakardjieva, Wisdom Tetty, David Mitchell, David Taras, Doug Francis, Wayne McCready, Lorry Felske and, externally, Gerald White. The able administrative aid of Denise West-Spencer, Megan Freeman, Mimi Daniel, Jeannette Burman, Tess Murphy, Erin Coburn, Kristine Ennis and Samira Jaffer remains appreciated, along with the kinship and sage advice of Rebecca Carruthers Den Hoed, James Butler, Naor Cohen, Peter Zuurbier, Kris Shellska, Chaseten Remillard, Gillian Steward, Kwame Akufflo-Anoff and Todd Andre.

Singular gratitude gushes to my dear, southern harbour-keepers, Jawn Sojak and Debbie Macdonald. A special shout-out to Drake Dresen, my grand old chum, for his sage summitry.

I am intensely indebted to the remarkable filmmakers and profes- sional communicators who generously shared their experiences, wisdom and insights for this study.

I thank my munificent funders—the University of Calgary, the Social Sciences and Humanities Research Council of Canada, and MacEwan University—and the unsung taxpayers whose labours fortify these fine institutions.

I am delighted to work with the team at the University of Alberta Press again, and continue to salute its ethos, professional excellence, anonymous peer-reviewers, press-committee members, funders and assigned editor, Meaghan Craven.

Finally, as ever, I resoundingly recognize and laud the unwavering sustenance, guidance and methodological majesty of Bonnie Sadler Takach.

The formidable support, teaching, intellect and/or creative work of these fabulous folks are as instructive and inspiring to me as I hope that this humble effort might begin to be to you.

1
The
Problem
of the
Sands

Ecology Meets Industry, Albertan Style

BEYOND ITS TITANIC TECHNOLOGICAL CHARMS, life in our society today seems to focus increasingly on a different kind of conflict than the military escapades that marked our species' slog through prior millennia. Since the Industrial Revolution mechanized and multiplied our plundering of Earth's bounty to meet the needs of capitalism, our ecological consciousness has asserted itself in dribs and drabs, in landmarks like John Stuart Mill's linking societal demise to the overexploitation of natural resources in the eighteenth century, the idealization of nature by Romantics such as Henry David Thoreau a century later, and the environmental movement said to be triggered by Rachel Carson's *Silent Spring*[1] in the 1960s.[2]

More recently, the rising profile of ecological concerns in the face of our ever-accelerating demands on Earth's resources, aided by a torrent of innovations in science and communication, has placed the snowballing social movement in the heated crosshairs of powerful interests

deeply vested in business as usual. Those interests, led by Big Oil and sycophantic governments, have invested substantial resources in combatting environmental issues by manufacturing doubt about the scientific veracity of those concerns[3] and by demonizing those who raise them, exhuming Cold War–style witch hunts with catchphrases like "Green is the new red" and terms like "eco-terrorist."[4] That this clash of economy versus environment is built on a foundation as remote from reality as the Ancient Greek myth of the winged horse, Pegasus, compounds the tragedy—and begs ironic extensions of that simile involving rhetorical droppings on the public below.

Our society has elevated and even celebrated economic growth as its prime directive. Nations measure their value according to their annual production of material goods (conveniently measurable in US dollars), rather than, say, the well-being of their natural and constructed environments and all living residents, whether human or not. (A notable exception, the tiny Buddhist state of Bhutan, has adopted Gross National Happiness (GNH) as its benchmark, audaciously bypassing the Western, sacred cow-pie of people as consumers rather than citizens. GNH is founded on a "holistic approach towards notions of progress," sustainable development that equally privileges non-economic aspects of well-being.[5]) In a typical Western example, Canadian election campaigns, abetted by mainstream, conglomerate-owned media, fixate on The Economy with a tenacity known only to mineral erosion, spawning salmon and indignant two-year-olds. And although the federal Green Party most apparently reflects environmental concerns, it is marginalized in a first-past-the-post system that pooh-poohs the preference of approximately 600,000 Canadians (representing 3 to 4 per cent of the popular vote) who voted Green in each of 2011 and 2015, save for those who re-elected the party's leader and sole member of Parliament, Elizabeth May, in a British Columbia riding.[6] Talk of a coming recession permeated the headlines in many news outlets in 2015, as if economic growth was our perpetual birthright. Beyond illustrating the devastating folly of this business-as-usual model, climate change has also precipitated paradigms and discourses of ecological modernization (for example, "green" growth)

and economic sufficiency, the latter being largely eclipsed in the public sphere by the notion of sustainable development.[7]

Alas, the undeniable (and flightless) elephant in the room is that endless growth, charmingly called "biggering" by Dr. Seuss a generation ago,[8] is unsustainable, not only physically and scientifically,[9] but also socially and morally.[10] Despite her ample generosity, Mother Earth only has so much fresh air, water, land and non-human life for us to commandeer. Yet we continue to treat the natural world as our limitless plunder pit, while serving the deceptive idol of growth and exacerbating its dramatically rising social, economic and particularly environmental injustices. Inertia is a formidable force in any system, and the privileged, relative few who are well-served by global capitalism have invested tanker loads in riding the one-trick pony of fossil-fuel extraction into the ground, consequences be damned. Still, the undeniable tension, popularly framed as an all-or-nothing conflict between economic development and environmental protection, gathers steam, to all degrees of noxiousness.

An exemplary epicentre of such a conflict (complete with steam) is Alberta, site of the bituminous sands, called the world's largest industrial project[11] and roundly condemned as producing the dirtiest oil on the planet.[12] Buried beneath the northeastern, boreal-forested expanse of the province, the resource comprises the world's third-largest recoverable source of oil,[13] at about 170 billion barrels "under currently available technology and under the current economic conditions," with up to 315 billion barrels ultimately recoverable.[14] According to some, the bituminous sands is also the world's largest capital project[15] and perhaps even the largest such project in history.[16] It is said to have reinvigorated the American environmental movement and inspired civil disobedience with an intensity unseen since the 1970s.[17]

The project has become so contentious that even its name is disputed. Long-standing residents often use "tar sands," as do prominent critics of the project, while the Government of Alberta and the oil industry adopted the cleaner-sounding "oil sands" after extraction began commercially in the 1960s.[18] Proponents of development and/or the status quo duly

followed suit. That view is exemplified by the *Edmonton Journal*'s refusal to print one writer's op-ed pieces using "tar sands"[19] and by the *Calgary Herald*'s branding that term "loaded and inaccurate" and "part of the propaganda lexicon for radical environmentalists."[20] (Coincidentally or not, both newspapers, owned by Postmedia Network Inc., have run banner advertising from the Canadian Association of Petroleum Producers, the voice of the oil industry in Canada, and at least one study has shown *very* friendly coverage of the oil industry in the *Herald* in the face of environmental critics.[21]) Others, including "industry old-timers"[22] use both terms interchangeably, in lieu of the more scientifically accurate but colloquially bulky "bituminous sands."[23] This dichotomy grants a glimmer of just how polarized and paralyzed any semblance of debate around the project has become in Alberta and beyond. In the interests of novelty if not neutrality, this book will use my self-coined term, "bit-sands," to describe the resource and/or the related industrial project.

Brought to the attention of Euro-Canadian fur traders by a Cree man named Swan in the early eighteenth century, the bit-sands, visibly seeping from the banks of the Athabasca River, was used by Natives to seal canoes[24] when mixed with gum from spruce firs. Later, explorer Alexander Mackenzie described bituminous fountains into which one could stick a twenty-foot pole.[25] After decades of investment by, and jurisdictional tensions between, the Canadian and Alberta governments, the resource grew from the subject of Dr. Karl Clark's initial experiments in separating bitumen from the sands with steam, hot water and caustic soda in the 1920s to the start of commercial production in 1967. Development was accelerated by OPEC's oil embargo in 1973, the rising global demand for oil, escalating oil prices, technical improvements and other economic efficiencies, and enabled by substantial investment from the American oil industry. American interests, which were also involved extensively in developing Alberta's oil industry after the major, wildcat strike at Leduc in 1947, eyed the bit-sands as a future source of "unconventional" oil for domestic markets.[26] Consisting of a mix of 83–85 per cent minerals (sand and clay), 10–12 per cent bitumen and 4–6 per cent water,[27] the resource is called "unconventional" because it requires a mammoth logistical, technological and capital apparatus

to extract and refine. This contrasts starkly with conventional drilling and its iconic oil rigs and derricks, deployed in places such as the Middle East, Russia, Venezuela, Texas and Alberta.

The bit-sands has become a Brobdingnagian enterprise. Following years of slower, steady growth after commercial production began in earnest, the daily output of bitumen accelerated more rapidly in the early 2000s[28] and then doubled from about 1 million barrels in 2004[29] to 2.3 million barrels in 2014.[30] In 2011 the Calgary-based Canadian Energy Research Institute forecasted that the project would add $2,077 billion (in Canadian funds) in new investment, GDP of $2,106 billion for Canada (76 per cent of it in Alberta) and $521 billion for the United States, tax revenue of $311 billion for Canada ($105 billion for Alberta) and more than $623 billion in cumulative royalties for the province by 2035.[31] Within three years, those 25-year forecasts jumped, for example, to "total GDP impacts" of $3,865 billion and federal taxes of $574 billion in Canada alone, with production forecasted to soar from almost 2 million barrels per day in 2013 to 3.7 million by 2020 and 5.2 million by 2030, although the forecasted employment in Canada fell from 905,000 jobs (direct, indirect and induced) to 802,000.[32]

Income from non-renewable energy royalties averaged 29 per cent of Alberta's total revenue from 2002–2003 to 2013–2014[33]—56 per cent of energy revenues came from the bit-sands in 2014–2015[34]—and bitumen royalties were forecasted to rise to 70 per cent of total resource revenue by 2016–2017.[35] At one point, activity from the bit-sands was expected to make up 20 per cent of Alberta's GDP by 2020.[36] Alberta's dependency on a single resource, oil, fuelled nation-leading average, annual economic growth for 20 years,[37] and in further homage to that paramount impera-tive, the highest per-capita GDP among the provinces for 30 years.[38]

Beyond Alberta, the bit-sands has become an escalating magnet for international interest and controversy, attracting enormous investment from not only Canadian concerns but also major American oil com-panies like Chevron, Conoco Phillips and Exxon Mobil, and offshore enterprises such as BP (Britain), China National Petroleum Corp., Korea National Oil Corp., Total (France) and Statoil (Norway). One study found that 71 per cent of all bit-sands production is foreign-owned.[39]

Foreign interests invested $50 billion in the bit-sands between 2007 and 2013 alone, and that interest is said to be likely to continue as concerns over peak oil have receded and "Canada is one of a very few oil and gas producing nations that provide full access to reserves to all, without offering preferential treatment to domestic companies or a National Oil Company."[40]

However, all of this gushing discourse on Alberta's bituminous bonanza comes with at least three crucial caveats.

First, continued development of the bit-sands depends significantly on the vagaries of international politics and economics, particularly the price of crude oil. For example, the global benchmark, Brent, plunged from a high of about US$112 per barrel in mid-2014 down to about US$50 in just six months.[41] Alberta's heavy dependency on revenues from the extraction of non-renewable resources makes its fiscal position significantly more volatile than other Canadian provinces,[42] about 50 per cent more volatile than the provincial average.[43]

Second, not all of the economic impacts of further, accelerated development are positive. For instance, Alberta's and Canada's heavy reliance on the bit-sands has left their citizens vulnerable to mercurial commodity markets to fund essential public services. It has also driven up the value of the Canadian dollar to the detriment of the nation's manufacturing sector, its competitiveness in export markets, and likely also its ability to compete and innovate over the long term as the world shifts toward renewable and more sustainable sources of energy.[44]

Third, all of this development comes with enormous ecological costs. The aggressive—critics say unbridled—exploitation of the resource under the stewardship of the Alberta and federal governments has fuelled escalating protests at home and especially abroad over the resulting huge-scale devastation of air, water, land and wildlife.[45] The project's ecological boot print can be summarized in ten points:

1. The total area covering the bit-sands is 142,200 square kilometres,[46] or 21 per cent of Alberta's land area, roughly equal to the land area of Florida or more than double that of Ireland.

2. Of that total area, 4,750 square kilometres is considered surface-mineable, 99 per cent of which is leased and of which 767 square kilometres was disturbed as of 2013;[47] that disturbed area is larger than the land area of Beijing.

3. The remaining 135,250 square kilometres, or about 80 per cent of the total area of the bit-sands, is too deep for surface mining, but it is mineable in situ. While this method is less visibly destructive than open-pit mining, it still disturbs land, requires even more energy, generates more sulfur dioxide and greenhouse gases, and poses a serious risk to underground aquifers.[48]

4. By 2022 surface and in-situ mining operations are expected to deforest an area equivalent to 34.5 American football fields every day.[49]

5. Extraction burns coal, natural gas and diesel, and generates two to four times more greenhouse gases than extracting conventional oil,[50] and it produces more than twice the volume of toxic sulfur dioxide and mono-nitrogen oxides than the production of conventional oil.[51] This has helped Alberta's carbon pollution exceed the combined totals of Ontario and Québec, where more than 60 per cent of Canada's human population live.[52] The bit-sands contribute Canada's fastest-growing source of greenhouse gases,[53] and by 2022 bit-sands emissions are expected to be analogous to adding 22.6 million cars to the road in the United States.[54]

6. The bit-sands industry requires one barrel of (non-renewable) natural gas to produce each barrel of bitumen, and it burns enough gas to heat 6 million homes each day.[55]

7. Extraction uses three barrels of fresh water from the Athabasca River, the world's third-largest watershed, to produce each barrel of bitumen,[56] or thrice the volume used in conventional-oil production. In 2011 the process consumed 1.1 billion barrels of water, equivalent to the yearly amount used by 1.1 billion Canadians. By 2022 the bit-sands are expected to use up enough fresh water to fill 4.8 million bathtubs or 309 Olympic swimming pools every day.[57]

8. Each barrel of bitumen produces 1.5 barrels of tailings, which sit in toxic lakes that already cover an area 1.5 times the size of Vancouver,

British Columbia.[58] (Although the common term for these bodies of waste adopted by the industry and compliant media is "ponds," their size impels calling them "lakes.") By 2022 the bit-sands are expected to produce enough toxic tailings to cover New York's Central Park to a depth exceeding three metres every month.[59] Tailings lakes leak into the groundwater and the Athabasca River in an amount estimated by studies of one case at 6.5 million litres per day.[60]

9. The scale of mining operations severely threatens species such as the woodland caribou, while killing countless fish and birds and destroying some ecosystems that cannot be restored.[61]

10. A prominent study concluded that to limit global warming to 2°C over this century, described as "the de facto target for global climate policy,"[62] between 85 and 99 per cent of the estimated remaining 640 billion barrels of oil from the bit-sands must remain unburned.[63]

Apart from the monstrous environmental costs, the sheer scope of the bit-sands has stressed the labour market (including raising various issues around temporary foreign workers) and local infrastructure, while adding concerns over its effect on the province's social fabric, crime statistics and more. Of special concern are the devastation of traditional Aboriginal lifestyles in the region and the incidence of an unusually high number of cancers downstream of the industry's work.[64] These prompted iconic singer-songwriter and expatriate Canadian Neil Young to launch his controversial "Honour the Treaties" tour in 2014, to raise funds in support of legal challenges by the Athabasca Chipewyan First Nation to expansions of the bit-sands.

Young's tour joined expressions of concern by high-profile citizens such as South Africa's Archbishop Desmond Tutu, the decorated American musician Paul Simon, Hollywood celebrities like James Cameron, Daryl Hannah, Robert Redford and Leonardo DiCaprio, and a sole-purpose, dissenting organization, the UK Tar Sands Network, among many other groups at home and abroad. Aboriginal groups have launched a volley of legal challenges against the Albertan and Canadian governments for failing to enforce environmental rules and for violating their constitutionally guaranteed Aboriginal rights.[65] The enforcement of environmental

regulations of the bit-sands by the Albertan and Canadian governments is notoriously lax.[66]

As the bit-sands has become a resource of national economic consequence, its accelerated development is tarring more than just Alberta's reputation. Increasingly, Canadians in general are portrayed internationally as environmental pariahs.[67] Examples of resistance in Europe include a protest rally in the Spanish port slated to receive the first shipment of bit-sands oil;[68] giant art in London's Trafalgar Square depicting the resource's devastating effect on ecosystems, species and Aboriginal communities[69] and a theatrical "oil orgy" action disrupting a high-profile meeting of the Canada–EU Energy Summit.[70] In the US, growing concerns about Alberta's "dirty" oil are reflected in the media[71] and in political measures such as a petition by nearly fifty members of the House of Representatives to the Secretary of State to stop TransCanada's Keystone XL Pipeline from bringing bit-sands oil from Alberta across ecologically sensitive terrain to US refineries and tankers on the Gulf Coast.[72] American criticism of the project is particularly problematic for Alberta, as 87 per cent of the province's exports go stateside—the province is the largest supplier of oil to the US—while two-thirds of foreign investment in Alberta and 60 per cent of its foreign tourists are American in origin.[73]

Beyond all of the environmental, social, municipal and other costs of the sands, Andrew Nikiforuk argues that the royalties generated by the project detach Albertans from their elected officials by diminishing the state's need to tax citizens to pay for public services, thereby eroding the quality of democracy following Thomas Friedman's "First Law of Petropolitics."[74] Certainly, the province's history of aggressive promotion of the oil industry raises the issue of how beholden it continues to be to that industry. This is why democratic, public dialogue is central here.

Certainly, the bit-sands has become a focal point in the ongoing and polarizing debate over the costs and benefits of resource extraction.[75] But it has also become a site for contesting Alberta's identity[76] and even Canada's identity.[77] In an economy shaped increasingly by global forces, Alberta's place-identity and representations of its citizens' core values have become fiercely contested. This struggle is exacerbated by an anti-democratic tradition manifested first in the province changing

governments only four times since 1905 (most recently and startlingly in 2015 with the election of the social-democratic Alberta New Democratic Party[78]), and second in consistently recording the lowest voter turnouts in Canada.[79] Small wonder, then, that Alberta has become an international battleground in the foment over economy and environment, even if that conflict is false. After all, a healthy economy depends completely on a healthy environment in its broadest possible sense, including first and foremost its natural ecosystems and resources.

A high-stakes, international public-relations battle has emerged around the bit-sands. On one side are advocates of the dominant agenda that critics have come to call neoliberalism, an ideology which gained international prominence under Ronald Reagan in the US and Margaret Thatcher in the UK. Neoliberalism privileges market imperatives as the primary basis for organizing public affairs and particularly the economy. This agenda is epitomized by the Alberta government's no-holds-barred approach to exploiting the bit-sands under its former Conservative dynasty (1971–2015). On the other side of the battle are growing numbers of citizens at home and abroad expressing concerns about the devastating ecological impacts of the bit-sands.

In a society that communicates increasingly in images[80] and in visually constructed realities called simulacra,[81] a favoured weapon in the battle over the bit-sands is visuals. At the vanguard of this conflict are independent filmmakers producing documentary films challenging Albertans' environmental stewardship of the resource,[82] followed by government and industry producing advocacy videos defending it.[83] In the broadest possible terms, this deceptively simple binary has depicted the province as either an almost mythical, pastoral paradise or a scene of spectacular, ecological apocalypse. But beneath the simplicity of these reductionist tropes lies a complex, nuanced network of interests and cultural, political and economic forces. While certainly testing the limits of extractive capitalism late in the age of fossil fuels, this unfolding story further shows that how we communicate about our environment ultimately reveals who we are, be it as a political unit like a province, or as a society.

Thus, this book addresses links among land, natural resources and people in a world shaped increasingly by global economic forces and pervaded by the power of pictures. I present a case study in environmental communication, focusing on how place is constructed and contested in a resource-based economy in light of environmental concerns related to the extraction of oil. I use critical theory, narrative research, visual framing analysis and discourse analysis to study conflicting images of Alberta, trumpeted by its government as "Canada's Energy Province."[84] These images are produced in an increasingly prominent form of popular culture, documentary films and online advocacy videos, in the context of the bit-sands, perhaps the most visible flashpoint in the rising international tensions accompanying issues of environment and economy.

Aims and Approach of this Book

This study shows how identity is produced through communication,[85] and hopefully to engage and inspire readers like you to critical thought, engagement and action on social, economic and particularly ecological concerns in your community and beyond. To that end, this effort intends to transcend the bifurcated, polarizing and (for critics of Alberta's course of extraction) paralyzing status quo of the current discourse on the bit-sands. So my primary motivation for this work—beyond a desire to include underrepresented interests in the dialogue about Alberta's values and identity—is an overarching commitment to engaging in, and inspiring, discussion and debate that is framed neither by a neoliberal agenda nor a social movement.

To these ends, I take a critical approach, which emphasizes unfair practices of dominant interests in society and seeks to change them. I accept that neoliberalism—particularly as practised by the economic and political rulers of Alberta, at least over several decades before 2015— is anti-democratic in its sacrifice of critical thought on the altar of market supremacy in all social, economic and cultural matters.[86] I believe that allowing different, public voices to emerge is fundamental not only in a democracy but especially when the well-being of all life on the planet seems to be at stake.

To understand and promote the emergence of these voices, this book examines and explains how place-identity is contested and produced in Alberta in the context of extracting bitumen, from diverse viewpoints and interests. The journey unfolds in two parts. First, it probes the outlooks, motivations, communications strategies and environmental values of key participants in documentary films and advocacy videos about the province, all through personal interviews. Second, it analyzes a purposive sample of those productions and the frames through which their creators position Alberta, within their wider social, political, economic and cultural contexts.

For your host, this work culminates a long-standing curiosity about the province I called home for four decades. That affliction was first expressed in a literary journal[87] and then in my professional work over the years as a writer of speeches and publications for the public, private and volunteer sectors, and as a performing comedian. Curiosity vaulted to inspiration on reading Aritha van Herk's *Mavericks*,[88] leading to further explorations of Alberta's identity and its representations, expressed in popular print media,[89] two short "festival" films,[90] a one-hour documentary film broadcast on City TV stations across Canada,[91] an award-winning book published by the University of Alberta Press and titled *Will the Real Alberta Please Stand Up?*,[92] a live performance[93] and a publicly workshopped stage play in progress.[94] In fact, it was comments on the manuscript for the *Real Alberta* book from an anonymous scholarly reviewer that sowed the seeds for this one, triggering the inquiry and doctoral dissertation from which this work is adapted.[95]

Other aspects of this research have also found their way into a journal article,[96] a short documentary film for an art-gallery exhibition,[97] a book chapter[98] and other research in press at this writing. Clearly, Alberta is a gift that keeps on giving. In essence, I see Wild Rose Country as a fascinating, frustrating, hyperbolic Janus: "aggravating, awful, awkward, awesome,"[99] a place of dazzling initiative and innovation on the one hand, and of disturbing, systemic neglect of underprivileged citizens, democracy and the planet on the other.

Hosting what may well be history's largest single-site industrial project, centred as it is on feeding our society's spiralling addiction to

fossil fuels—and the escalating and potentially disastrous ecological consequences—makes Alberta a proverbial canary in the bitumen mine for the future of Earth. It provides a potent, international symbol of how human activities, and particularly the untrammelled extraction and consumption of the planet's resources, affect the precious natural systems that enable all life. But most important, hosting such a gargantuan exercise in fossil-fuel extraction gives us the opportunity to say something about it, to express our deepest convictions about who we are as a community (place-identity) and what kind of legacy we want to leave to the planet and to all life that follows us. This is why bit-sands advocates who stress the project's perceived minimal impact on global emissions, who try to compare Canada's "ethics" with those of tyrannical petrostates, or who dismiss conscientious objections against the Keystone Pipeline as empty symbolism miss the point so spectacularly.

This view of the tensions at work around the world in general and in Alberta in particular has underscored my efforts in recent years. However, scholarly work must challenge a simple, binary mindset. I must account for biases inherent in, first, the documentary films and advocacy videos under study and, second, in the contexts in which they were produced and screened—contexts of place, time, contemporary events and so on. Thus, I approach this work with the understanding that place-identity is expressed by diverse interests and forces in a continuing, complex and polyphonic communicative struggle for voice and social power.

In striving for a scholarly approach to a highly polarized, emotionally charged public issue, this book aims to explore and explain how producers of documentary films and advocacy videos use visual media to propagate and contest representations of place-identity in a resource-based economy. It offers a critical case study in place branding, centred on a global flashpoint among the growing tensions seeking to accommodate economic, ecological and other goals. That study followed four methodological steps: identifying relevant documentary films and advocacy videos; interviewing their directors and/or producers; conducting a critical, visual framing analysis of the work; and finally, locating and critically analyzing each film or video as part of a continuing discourse on Alberta in the context of environmental concerns about the bit-sands.

Chapter 2 sets out the four primary foundations of this inquiry: the practical role and significance of environmental communication, popular media, visual media and place branding in contemporary Western society.

Chapter 3 investigates the context of fossil-fuel extraction and related environmental concerns in Alberta through historical visualizations and contemporary framings in the popular media. I catalogue several frames used to position the province in the context of extracting the bit-sands, and I position those frames on a continuum of environmental ideologies.

Chapter 4 presents observations from my interviews and the films and videos in a visual framing analysis, situated as an extended discourse on representations of Alberta in the context of environmental concerns about extracting bitumen. I check for the presence or absence of my fifteen frames in each film or video, in light of current events and flows of political and economic power.

Chapter 5 seeks to unsettle the binaries related to onscreen representations of Alberta and the bit-sands that seem to paralyze dialogue about whom Albertans are and what they want to do with the formidable opportunity and responsibility presented by the bit-sands. I offer suggestions for onscreen representations of the province that both accept and transcend oil extraction, with a view to providing a rich visual portrait that may be more realistic, balanced and forward-looking, and perhaps also less divisive, than what we have tended to see in the polarized discourse to date.

Finally, Chapter 6 reflects on this research and shares observations on its implications, potential contributions and limitations. It concludes with suggestions for further aspects of the problem to explore, to understand how the identity of a place is constructed and contested in the face of environmental concerns in a resource-based economy.

As for tangible outcomes, this work seeks to provide insight, critique and analysis that might invite reflection (and perhaps even action) on responsive and responsible environmental policy in Alberta and beyond. Ultimately, I aspire to advance knowledge, dialogue and action on

lessons that sites of resource-based economies such as Alberta's offer to the rest of Canada and the world.

In sum, this book seeks to show how the identity of people in a place is constructed and contested through moving visual images amidst tensions between a resource-based society's need for economic development and the unsustainable environmental costs. This involves answering several questions:

- How do producers of conflicting representations of a place frame that place through visual strategies to advance their claims?
- What perspectives can be identified in the use of visual representations of place by dominant and dissenting interests in a resource-based economy?
- Who do such representations serve and with what aims?
- Who has resisted them and why?
- What social, political, economic or other forces shape the visual discourse of identity in a resource-based economy?
- Finally, what do representations of a jurisdiction's place-identity reveal about its citizens' relationship to the natural landscape, and ultimately to each other as a society, and to the wider world?

Answering these questions requires establishing a contextual foundation, so let's turn next to the four key principles on which this study is built.

2

Four
Foundational
Principles

OUR EVER-BURGEONING Information Age is distinguished, dominated and ultimately defined by an endless flow of news, data and knowledge, all accessible immediately and capable of being controlled and commodified. This raises questions not only about how all of that content is communicated but also why, by whom and with what effect. Although the implications of these questions reverberate across all manner of human endeavour, they seem particularly substantial and persistent in communications related to environmental issues.

In the early twenty-first century, the master-narrative of industrial progress that has fuelled Western society for centuries, and particularly extractive capitalism—economic development based on removing and exploiting Earth's non-renewable, natural resources—is running off the rails. More profound than even its social injustices, profiled in the international Occupy movement and the Aboriginal-led Idle No More protests in Canada, the rising ecological costs of extracting fossil fuels are now

widely seen as unsustainable and in need of urgent, remedial action if life on Earth is to continue to survive and thrive.[1] Short of the Cold-War spectre of nuclear annihilation, it's tough to fathom a more serious challenge visited on Earth by its dominant denizens than the massive, systemic degradation of its air, water, flora, fauna and natural ecosystems.

Small wonder that a growing ecological consciousness is contesting the dominant narrative privileging "Progress" in our society. Recent hallmarks of this include the awarding of the Nobel Peace Prize to the Intergovernmental Panel on Climate Change and Al Gore—the author of various books[2] and, most famously, the subject of a documentary film, *An Inconvenient Truth*[3]—for raising public awareness of the impact of climate change and the need to counteract it;[4] and the emergence of Bill McKibben's "creative activist" group, 350.org, as a global phenomenon.[5]

These events coincide with the rise of environmental communication, a subfield of communication studies that crystallized in the early 1980s. Communication about the environment involves much more than merely sharing information. On the premise that our experiences of and emotional connections with the environment are largely a product of discourse,[6] "the way we communicate with one another about the environment powerfully affects how we perceive both it and ourselves and, therefore, how we define our relationship with the natural world."[7]

So we can view environmental communication as an expression of some of our most fundamental values.[8] How we represent nature "usually reveals as much, if not more, about our inner fears and desires than about the environment," and nature and our inner psyche "can be regarded as coterminous, since our inner fears and desires often reflect or at least constitute in large part the 'external' environment."[9] Thus, "Our response to our environment shapes our culture, determines our lifestyle, defines our identity, and sets the tone for our relationships and economies."[10] This seems especially pertinent in resource-based economies, where "understandings of 'land' also underlie the complicated dance of resource development, even the concept of 'resource,' as they are negotiated between local populations and larger socio-political and

economic forces."[11] So there are strong, affective links among place, identity and how we communicate about our environments.[12]

While being careful to avoid environmental determinism due to the complex array of factors involved in construing the environment, I embrace the view that how we communicate about it stems from our individual experience, geography, history and culture.[13] However, the latter are rooted in our social relationships, reflecting human inter-subjectivity rather than so-called objective reality.[14] For example, in western Canada, viewed by early European visitors as vast, empty, wilderness and the world's last "Great Lone Land,"[15] the idea of nature as pristine and sublime became part of the region's literature and its popular consciousness. This idea was manifested in the wilderness-protection movement emerging in the nineteenth century. Formatively expressed in the creation of Canada's first national park in Banff in 1885,[16] the movement endures to this day.

More than merely communicating information, our messages about the environment also involve power in society, namely the ability to define our relationship with nature and what we do to it.[17] Thus, diverse constructions and representations of nature and the environment inform and advance our views and ideologies on a wide array of issues, in endeavours such as science, health, advertising, tourism, politics and business.[18] A key implication of nature as a human construct for environmental historian William Cronon is that nature is not "a pristine sanctuary" devoid of "the contaminating taint of civilization," but rather "a product of that civilization."[19]

Nor is nature a singular concept. It is subject to many constitutions and contestations, reflecting different values inextricably intertwined with dominant ideas of specific societies.[20] This requires us to ask "what ideas of society and of its ordering become reproduced, legitimated, excluded, validated and so on, through appeals to nature or the natural."[21] The environmental-communication scholar, Julia Corbett, posits a broad spectrum on which we can situate, isolate and analyze values related to the environment.[22] That spectrum ranges from more anthropocentric, *utilitarian* views of nature as a resource for human conquest and exploitation, through a progressively more ecocentric continuum of notions of

nature as meriting *conservation* (to maximize its benefits to humans over the longest possible term—a feature of neoliberal environmental rhetoric today[23]), *preservation* (transcending utilitarian concerns to include scientific, ecological, aesthetic and religious uses of nature) and, ultimately, a radical *transformation* of our relationships with the natural world and each other. The latter view ascribes intrinsic worth to nature and its non-human inhabitants, irrespective of their benefits or costs to people.[24]

A significant consequence of the tension among advocates of economic development and/or environmental protection is its polarizing effect. Advocates at the extreme end of either position frame the conflict as a winner-take-all game with no chance for compromise, thereby alienating (if not bewildering) many people situated between those poles.[25] Thus, this study will consider the panoply of perspectives along the spectrum, and Michel Foucault's advice not to focus on notions of accepted and excluded discourses but to consider multiple discursive elements that can be taken up in different strategies.[26] In this way, we may seek ways to begin to depolarize the discourses by finding common ground among them. This depolarization is central to allowing different public voices to emerge.

We can work to dislodge extremes by reframing that apparent conflict to get at what the United Nations' Intergovernmental Panel on Climate Change[27] and others[28] sagely identify as the *real* issue: not taking sides in a battle of black vs. white, but developing Earth's resources in a way, and at a rate, that its ecosystems can physically sustain. Crucial to the ongoing debate is the concept of salvation, namely preserving the environment from destruction or preserving economic growth and people's quality of life, in other words, saving the economy from shutting down due to ecological concerns. Polarity and its extremism create this "saviour" mentality by crediting the opposing side of the debate with the demonic power to destroy, when in fact neither side may be all-powerful or all-destructive.

As environmental concerns profoundly challenge the legitimacy of industrial society, this study of Alberta and its bit-sands calls for a critical approach. Critical research understands its political function and

seeks to produce social critique aimed at improving the world rather than supposedly "objective" knowledge aimed at knowing it better.[29] As Ulrich Beck notes in his oft-cited text on risk communication, where our health and security are increasingly threatened and "this 'security pact' [between citizens and their government leaders] is violated wholesale and systematically, the consensus on progress itself is consequently up for grabs."[30]

On a critical approach, then, viewing the anthropocentric end of Corbett's spectrum, the forces of globalized capitalism have excelled at commandeering environmentalist discourse to serve the dominant culture,[31] and at asserting claims of innocent intent, especially prevalent in resource-dependent economies.[32] Meanwhile, on the ecocentric end of the spectrum, the failure of environmental appeals to bring about the paradigm shift and the kind of transformative change scientifically shown to be necessary for our planetary survival have led even Canada's most eminent environmentalist, Dr. David Suzuki, to declare the movement a failure.[33] This may be because appeals to fear, a hallmark of "green" communications, actually alienate audiences by suggesting that an ecological problem is simply too large to bother addressing through individual action,[34] although this is debated.[35]

Bottom Line: How we communicate about nature and our other environments not only reveals our core values but also affects how we treat those environments and, consequently, the health and welfare of the planet and life on it.

PRINCIPLE 2: The Media Make a Difference

Echoing McLuhan's famously equating the medium of a message and its content,[36] communications philosopher John Durham Peters reminds us that media "are crafters of existence [...] our infrastructures of being, the habitats and materials through which we act and are."[37] Thus, more than merely providing a public forum for competing environmental claims, the media also actively influence if and how those claims are publicly presented.[38] Although ecological messages communicated in any single medium or format are unlikely to affect public beliefs or

behaviours in a linear, direct way—witness the discredited "magic bullet" theory of communications—the media as a whole establish a significant cultural context for the public to make sense of the environment and claims related to it.[39] As communications scholar Anders Hansen reminds us, this "dynamic interaction of media, publics, politics, claims, claimants and social institutions is where we must turn to understand the processes by which...and why some environmental claims succeed in the public sphere while others wither or fall by the wayside."[40]

Many factors and strategies can influence the impact of media constructions of environmental issues. The list starts with cultural resonances, public opinion and media norms,[41] and includes the weight of scientific authority; a scientific figure to package the issue in media-friendly terms; framing the issue as novel and important; visible economic inducements to act on the issue; a transnational champion to keep the issue in the public eye; and dramatization in highly visual and symbolic terms.[42] These and other complexities of environmental issues and media practices suggest a need for "more textured and expansive narratives" that break complex issues down to their interacting parts, and a wider range of voices to ensure more geographically and culturally diverse views and opinions, aimed at potentially "recasting the relationships between and within the realms of science, policy and civil society."[43] So "the main product of environmental and risk communication is not informed understanding as such, but the quality of the social relationship it supports, becoming a tool for communicating values and identities as much as being about the awareness, attitudes and behaviors related to the risk itself."[44]

Certainly, media representations of the environment offer insights into the process of forming the identity of a place and its residents. For example, "wilderness" has been essential to the Canadian imagination, "relentlessly repackaged and remarketed for domestic and foreign consumption."[45] Epitomized in the visual art of the Group of Seven, the wilderness and the North became "crucial tropes for understanding Canadian national identity when that identity was in a particularly fragile state vis-à-vis US domination."[46] Canadian cinema has positioned pristine nature and unpopulated spaces as "'Canadian' in opposition to

Europe's urban historicity or America's tumultuous cityscapes" in what film scholar George Melnyk calls "a synthesis of two movements—the earlier rejection/glorification of land in an oppositional binary created by the settler society in search of national identity and the resolution of that binary with a postmodern embracing of rurality and wilderness as a mythic construct rather than a pure naturalist reality."[47]

Such media associations with the environment, shown in studies of ads in North America, Europe and Asia,[48] trade on well-established, positive pictures of nature as innocent, good and unsullied by humanity.[49] These representations embody the Romantic ideal of nature as sublime and venerable, in contrast to the earlier, Enlightenment view of nature as hostile and in need of taming and exploitation by people.[50] This "semiotic linking of a [romanticized] view of nature with a rural past with national identity has undoubtedly been one of the most potent ideological uses in the modern age."[51]

Bottom Line: How we communicate about environments through media both reflects and shapes our view of ourselves as communities and as a society.

PRINCIPLE 3: Visual Media Are Particularly Powerful

The role of images and visual media can be seen in different ways, for example, in treating photos as either reflections and shapers of history[52] or as constructed manipulations of reality.[53] Debates over the perceived competing needs of artistic expression and capturing reality in photography, for example, are as old as the medium itself. Images are hardly objective,[54] as they are mediated by their creators in their selection and composition, and by viewers in their subjective perceptions. From an image maker's perspective, Gerry Potter observes, "As a filmmaker, I'm always a doubter; I'm always looking for the truth behind the image. I'm quite aware of how people can be manipulated by image and how we frame our stories like magicians. I'm aware that the image is a construction."[55] And from the viewer's perspective, some scholars suggest that we never see the entire picture and that in looking at images, our perceptions stem from desire, namely what we seek to consume as image.[56]

Beyond individual reactions, images also create social effects.[57] Images play a key role in the social, political and cultural construction of the environment,[58] although the effect of the media's use of images and symbols on essential public debates and decision making about environmental issues remains understudied.[59] We equate how we see the environment to how we understand it, make meaning from it and value it—a cultural assumption since the Enlightenment.[60] The modernist connection between seeing and knowing is fractured in postmodern thought, which views our society as ocularcentric "not simply because visual images are more and more common, nor because knowledges about the world are increasingly articulated visually, but because we interact increasingly with completely constructed visual experiences."[61] This constitutes a sort of hyper-reality or simulacra,[62] suggesting that we may not understand what we are really seeing.

Noting that "the environment is visualized through the use of increasingly symbolic and iconic images rather than those which are recognizable because of their geographic/historical/political or socially specific identity," communication scholars Anders Hansen and David Machin suggest that the repeated use of those images replaces and masks representations, "particularly those that locate and connect such issues in actual concrete processes such as global capitalism and consumerism."[63] With globalization, power flows from sources within, between and beyond nations, and is "often obscured by appeals to collective identity and imagined communities."[64] Thus, Hansen and Machin argue that broader cultural and historical contexts are important to interpreting environmental imagery, and they call for studies into how these repeated representations connect to greater political and economic forces.[65] Addressing the need to unmask, locate and connect such representations to specific political, economic and cultural forces and interests is part of the inspiration for, and intended outcomes of, this project.

These aims engage the critical approach advocated by visual-studies scholars to challenge master narratives that become so dominant that we take them for granted.[66] On a critical view, then, visualization becomes "a specific technique of colonial and imperial practice, operating both at

home and abroad, by which power visualizes History to itself," and so the image "demonstrates authority, which produces consent."[67] This invites us to look beyond the image to ask if a visual work has "exceeded its essence as the documentation of memory and acquired other values as a symbolic resource for imagination" in constructing a sense of one's heritage[68] or identity.

In a critical approach to visual environmental communication, the issue is neither whose competing images prevail nor whose images are more compelling, but what the images leave unseen.[69] For example, the use of pristine images of the Rocky Mountains in a video promoting tourism in a resource-based jurisdiction like Alberta may suggest reverence for nature and thus a preservationist view of the environment. However, this may be more a part of a tradition dating back to Romantic landscape painting that views nature as unspoiled, separate from humanity and, as rhetoricians argue, thus open for human conquest.[70] On a critical reading, these apparently opposite gazes—Romantic and "extractive"— are both consumptive and so two sides of the same coin.[71]

Although popular culture often shows Earth's beauty, nature is more typically shown as a commodity for human consumption, subordinate to (ideological) images of the good life in the foreground.[72] This is where "commodification [...] ironically transcends and unites the nature–culture dichotomy."[73] This dichotomy becomes more pronounced in images of industrializing nature: for example, the historical photographic record of developing the bit-sands can be read either as "a narrative about nature's stubborn resistance, matched by an equally stubborn and ultimately prevailing human ingenuity" that is "celebrated as Alberta's heritage and culture," or alternatively as "the normalization of mass destruction."[74]

The prevalence of the anthropocentric view of nature as something to be mined, packaged and sold—or even conserved—for purely human use is suggested by communicative practices in such ubiquitous areas of daily social life as journalism,[75] advertising,[76] tourism,[77] politics,[78] entertainment and specifically films.[79] Thus, neoliberalism works not merely to naturalize consumption but also to eliminate the suggestion of contradiction or conflict in presenting nature and (audaciously) even

environmental causes in furtherance of consumer lifestyles and the industrial economies that feed them.[80] These anthropocentric assumptions, values and expectations underlying a consumer society "become an uncritical and unconscious dimension of our cultural identity."[81]

Bottom Line: Vision and visual media have become a primary way to exercise power in society, and notably on the environment.[82]

PRINCIPLE 4: Place Branding Matters

As a way to express the identity of a place, images and communal symbols reinforce cohesion and affect the nature and duration of the dominant interests deploying them; as such, images become central to the power of a state, and thus "the instruments of imagery, as much as weapons of destruction, will be a threat of the 21st century."[83] But far beyond domestic application, images also position a state in the global marketplace as an instrument of "soft power," contrasted with the time-honoured exercise of military force.[84]

The globally deepening green consciousness and our understanding of its communicative contexts have powerful practical applications with immense stakes. For example, rising environmental concerns have further politicized dealings among nations and regions, and even *within* regions. National, regional and local authorities are jostling to position their jurisdictions for further economic gain in the global marketplace, while addressing questions of environmental responsibility—and of equal significance in our media-saturated age, *perceptions* of being "environmentally friendly." This has led to fundamental issues of self-definition and representations of place in the world today.

Representing place-identity—that is, constructing a unique sense or essence of a place comprising its social and symbolic capital and expressing it in "a coherent, convincing and comprehensive rhetoric" occurs through place branding.[85] This involves representing a favourable, shorthand image of what a place is and for what it wants to be known.[86] This follows a long tradition of reputation management and propaganda, and belongs to a broader discourse involving public relations.[87] Place branding is important to this study for four reasons.

First, rather than minimizing national, regional or local identities as one might first suspect, globalization has arguably re-emphasized the importance of defining and marketing place-identities, given the rising competition for human, physical and financial resources in the international marketplace.[88]

Second, because place-identity boosts citizens' confidence—a greater sense of belonging and a clear self-concept—it involves issues of power,[89] the power to set norms and standards to determine what is socially acceptable and desirable. As such, representing place-identity can become an instrument of maintaining political and economic dominance.[90]

Third, place-identity may be the strongest link between a collective culture and a sense of individual and group agency that can help engage citizens politically on issues of public importance,[91] such as environmental concerns.

Finally, given the significant (if not determinative) role of the natural landscape in producing place-identity,[92] how we represent our environment can reflect our relationship to it and thereby reveal some of our deepest values as a collectivity, as noted earlier. These values can be expressed on spectra such as utilitarianism vs. ecocentricism,[93] technological vs. moral imperatives,[94] liberal individualism/ethno-nationalism vs. harmony with nature,[95] and societal and media biases toward either space or time.[96]

Seen from a critical perspective, such representations of community and place can seal social fissures under the glue of a singular culture, and the resulting dominant vision of the state shapes the production and dissemination of images and meanings associated with that identity.[97] These images and meanings become a complex, evolving, public discourse, and as such, an object of appropriation in the struggle for political and economic power in the state,[98] as well as in the global marketplace.[99]

Because the media are central in constructing and circulating representations of place through place branding,[100] the mediated depiction of an organization (or place) becomes the critical influence on the (de)construction of its identity; so "practices of mediated communication do not simply disseminate a pre-existing identity, but rather, produce this identity in the course of mediation."[101] Thus, place branding

"implies a shift in political paradigms, a shift from the modern world of geopolitics and power to the postmodern world of images and influence," where place-identity is formed by strategic positioning rather than "romantic notions of a nation's exceptionalism and essentialism."[102]

This is a complex and political process. Place branding is inherently contradictory as it negotiates tensions between utopian ideals of what we are and what we want to show the world, and the pragmatic need to differentiate ourselves in a competitive, global market in which capital is mobile and privileged by the capitalist system.[103]

All of these aspects of place-identity prioritize its importance in political discourse, attracting the protective interest of the state.[104] This may explain why governments defend their constructed place-identities from attack, alongside powerful corporations with vested economic interests in maintaining those identities. Viewed critically, place-branding discourse can be seen as embodying the prevailing, neoliberal premise of the primacy of the market economy in human organization, while masking the "greater truth" of the need to preserve the natural environment and its biodiversity, a collective, "public good."[105] Yet much of the more ecocentric positioning over the last two decades, through place branding and generally, may be open to critique as well. For example, one might take issue, as even ecocentric advocates have, with the unwaveringly rationalist precept that masses of people will change their behaviour if only they can be made to comprehend the scientific severity of human harm to Earth.[106]

Bottom Line: Place branding is a pressing economic priority for government and industry in the global marketplace.

3
Images
and Frames
of Alberta

IMAGES HAVE PLAYED A FORMATIVE ROLE in the evolution and
mythology of Alberta and its identity since European contact,[1] which
followed about 10,000 years of Aboriginal habitation.[2] These images
mirror both popular perceptions of nature and the environment held by
the French and English powers that colonized western Canada, and the
understandings and experiences of its visitors and residents; historian R.
Douglas Francis categorizes these images in five overlapping periods as
an evolution from a barren, inhospitable wasteland (perceived from
approximately the years 1650–1850) to both a Romantic, Edenic wilder-
ness and the breadbasket of the British Empire (1845–1885), then a
utopian promised land for settlers (1880–1920), a harsh place to be
conquered in asserting Canadian nationhood (1880–1940), and a myth-
ical "region of the mind" (after 1945).[3] Uniting these five periods is a
view of Alberta's vast wilderness as grist for empire, a colonialist idea
that attracted foreign trade and investment by way of fur traders and, by

the 1870s, ranchers. Then came the farmers and tourists, responding to aggressive marketing campaigns by the federal government (seeking a human land bridge to British Columbia, for reasons including nation building and preventing American expansion) and the then-new Canadian Pacific Railway (seeking profits) in the 1880s and beyond.[4]

Popular images of the open range, golden wheat fields and soaring Rocky Mountain peaks framing impossibly azure lakes have beckoned scores of settlers and visitors ever since. The Rockies' vaunted potential for tourism led to the creation of Canada's National Parks system,[5] and their majesty has inspired great bursts of literary, painterly and other artistic creation addressing perceived essences of Alberta through representations of its landscape.[6] These images tend to trade on popular, deeply entrenched ideas of the West in general[7] and Alberta in particular[8] as bastions of rugged individualism, free enterprise and unlimited opportunity.

The major discovery of oil at Leduc, which swept Alberta from an indebted byway of the nation into modernity and prosperity, was emblazoned into provincial lore by a carefully crafted spudding ceremony on February 13, 1947, complete with dramatic gas flare. This event, staged for reporters and public officials, was captured and widely disseminated in photographs and film footage that came to symbolize Alberta's identity as an oil producer. These images projected the ingenuity, hard work and masculinity of resource extraction, declaring "in no uncertain terms that human industry can control or bend nature to our economic purposes"; linking "entrepreneurship and resource exploitation as interrelated virtues"; and establishing "a singular, utilitarian vision of nature that becomes unquestioned..."[9] Resource extraction became heroic.[10]

Today—in the wake of rising international attention focused on the bit-sands—these traditional images of Alberta are being repositioned and contested via conflicting visuals related to resource extraction in representations of Alberta's place-identity. Key reasons for this are highlighted briefly here.

On the visual front, images of the bit-sands follow the tradition of representing Canadian landscapes as sites of exploiting natural resources and "as part of the industrial and cultural aesthetic of the

nation."[11] In their discursive study of the bit-sands, Davidson and Gismondi read two major visual trends from 1900 to the 1970s: the scientific and technological struggle to tap the resource riches, and the resolve of private and public interests to open the northern frontier to unconventional oil extraction. They position visual representations of extracting bitumen, sanctioned by the state as an active promoter of the oil industry, as "in essence, the normalization of mass destruction."[12]

Seen from the perspectives of a broader public engaged through the mass media, we may isolate a seminal point in the visual discourse around Alberta and the bit-sands as occurring back in 1977, when the Canadian Broadcasting Corporation (CBC) produced a one-hour TV movie called *The Tar Sands*[13] as part of its docudrama anthology series, *For the Record* (1976–1985). This film presents what the CBC's opening disclaimer calls "an imagined recreation of negotiations," which led to an agreement among the governments of Alberta, Canada and Ontario, and three multinational oil companies launching the Syncrude consortium's flagship extraction project in the bit-sands. As the negotiations were held privately, the public broadcaster presented "a fictional work based on certain known events" with the characters identified as played by actors representing either real people or fictional composites.

In my reading of *The Tar Sands*, the Alberta government, led by a well-meaning but pragmatic Premier Peter Lougheed, defied the cautions of its dedicated public servants to compromise the province both environmentally and financially in acceding to the demands of shady, profiteering oil executives. The Toronto International Film Festival's *Canadian Film Encyclopedia* says the film "raises important ethical issues—not least in its (characteristically Canadian) portrayal of Lougheed as the 'little man' destroyed by a system he can never begin to understand."[14] My impression of Albertans from the film, as manifested in the dramatized actions of the provincial executive presumably representing them, is that they ultimately privilege economic development and job creation over ecological and human (specifically labour) concerns, and perhaps even fairness in general. Loughheed may have received that same impression, as he sued the CBC—which had delayed broadcasting the film due to legal concerns[15]—and settled out of court for an undisclosed sum.

Other pertinent investigations of the bit-sands by the CBC, not strictly via film or video but in television programs, occurred on its long-standing scientific series, *The Nature of Things*, hosted by well-known biologist and environmentalist Dr. David Suzuki. The public broadcaster aired "When is Enough, Enough?"[16] a critical look at the bit-sands from the perspective of members of the Mikisew Cree First Nation in Fort Chipewyan, located two hundred kilometres downstream from the project. The program depicted despoiled, once-pristine landscapes while exploring themes of environmental justice, along with the greed and what economic historian Harold Innis[17] might call the present-mindedness of the proponents of exploiting the bit-sands at a record pace. Two years later, the CBC aired an updated episode of *The Nature of Things* titled "When Less is More,"[18] followed by a documentary news report for its flagship news program, *The National*, called "Crude Awakening: Alberta's Oil Patch."[19] These two productions echoed their predecessor's visual and narrative themes in, respectively, questioning the duties of government, industry and consumers in light of the deadly effects of the bit-sands on local and global environments, and presenting concerned Albertans' calls to decelerate development and reduce those effects.

The CBC has a well-entrenched reputation in some circles of Canadian popular culture for a leftist bias,[20] and had a notoriously antagonistic relationship with the Conservative governments in power both federally and in Alberta while two of the latter three television projects were released. In fact, Hubert Lacroix, the broadcaster's CEO, ordered an investigation into federal Conservative allegations that the CBC was biased toward the opposition Liberals.[21] Perceptions of bias might seem consistent with the highly critical position taken in those three CBC productions toward accelerated development of the bit-sands under the stewardship of the former Alberta and federal governments, as well as in the CBC's 1977 docudrama, *The Tar Sands*, when the Liberals held power federally.

However, none of this diminishes the notion that broadcasting the four programs on a subject of public interest and concern falls within the CBC's mandate, which includes duties to inform, enlighten, entertain and "contribute to shared national consciousness and identity."[22] Also, "critical" is not necessarily "leftist" nor "biased." Moreover, the 2010

investigation ordered by the CBC and conducted by five media scholars, which examined some 16,000 radio, TV and online news stories from 2009–2010,[23] revealed, in the reading of the CBC's CEO who commissioned it, that the public broadcaster not only allocated *more* time to the then-governing federal Tories than its private competitors, CTV and Global, but also tended to treat them more positively. While the CBC's news editor called that reading likely a simplification of the results, perceptions of a leftist bias at the CBC persist.[24]

The public broadcaster's role in storytelling around the bit-sands in the prevalent popular visual medium of television, while significant, is part of a broader, polyphonic discourse. Thus, our last stop before investigating leading, current participants in that discourse is to situate views of Alberta and the bit-sands in specific political, economic, social and historical contexts, expressed as perspectives called *frames*.

Alberta and the Bit-Sands

The concept of *framing* has roots in the disciplines of psychology and psychiatry. When we frame something, we make meaning of it as we locate, perceive, identify and label it.[25] We do this by connecting an activity to the body of our individual or social experience, which sociologist Erving Goffman calls our "primary framework," aided by indexical cues to meaning such as the tone of a message and actions accompanying it, and by different slants on the message's meaning, such as irony and deception.[26] Framing has been defined as "making a piece of information more noticeable, meaningful or memorable for audiences" while "simultaneously direct[ing] attention away from other aspects."[27] So framing in a text "is really the imprint of power—it registers the identity of actors or interests that competed to dominate the text."[28] Framing can occur at any or all of four sites: the communicator, the text of the message, the audience and the broader culture in which they all operate.[29]

Borrowing from, expanding on and adapting a study of best practices in framing analysis,[30] this chapter concludes with three steps: first, identifying an initial set of leading, "culturally available" frames[31] based on

an extensive scan of media reports and other publications on the bit-sands from 2005–2014; second, naming prominent purveyors of those frames and the attitudes that they exhibit in the discourse about Alberta and the bit-sands, to suggest reasons for their particular positioning; and third, situating the frames on a continuum of environmental ideologies to reflect the polarized, competing ends of anthropocentric and ecocentric interests.

I have identified and titled the following fifteen initial frames for positioning and contesting Alberta in negotiating environmental issues concerning the bit-sands.

Pride

Alberta *is* energy,[32] so opposing development of the bit-sands is un-Albertan.[33] Taking its name from an ad campaign by the Canadian Association of Petroleum Producers (CAPP), this frame is used by advocates of accelerating the extraction of bitumen and maximizing the economic benefits of the resource to: (a) government by way of royalties on non-renewable resources, taxes and such; (b) investors in government bonds and particularly in ventures and corporations involved in extraction; and (c) people working directly in extraction or benefitting from it indirectly through the income that it generates. The frame conflates Albertans' identity with their largest economic sector, trading on the colonialist pride that comes with taming the harsh obstacles of the frontier, be they vast distances, a fierce climate, the technological challenges of extraction, or Aboriginal and other dissenters found blocking the path to extraction. Critics would see that pride more as either bullying, greed or arrogance, or, read more clinically, as defensiveness or self-doubt rooted in a fear of losing an economic privilege or livelihood.[34]

Green

Alberta's bitumen is "green"[35] and the environmental impact of the bit-sands is negligible or manageable.[36] This frame combines a variety of emotional and mental roots—fear and denial, among many others—and expressly minimizes ecological concerns over extracting the bit-sands

out of either genuine conviction or, in the eyes of critics, willful blindness or fraud. It is favoured by proponents of developing the bit-sands. A more generic and extreme variant of this frame is denying that global warming is scientifically settled.[37] One-time provincial opposition leader Danielle Smith used such a *denial* frame,[38] and former premier Ed Stelmach says it cost her Wildrose Party the 2012 provincial election.[39]

Ethical Oil

Alberta is a safer, friendlier and more democratic source of oil than petro-dictatorships.[40] This frame is used by advocates of developing the bit-sands to suggest that as a liberal democracy, Alberta/Canada is more "ethical" than such quintessential petrostates as Saudi Arabia, Venezuela and Iran, which are seen as suspending democratic values and human rights. Coined by a former tobacco lobbyist who took up arch-rightist neoliberal punditry,[41] the "ethical oil" argument has been rejected as more rhetoric than actual ethics,[42] as it purports to define our standards against the world's worst rather than an idea of the best.[43] Yet this frame has been routinely invoked, if not in name, by the oil industry[44] and its greatest cheerleaders traditionally, the federal and Alberta governments.[45]

Money

The bit-sands generate jobs, investment, wealth and taxes, so everybody wins.[46] Read critically, this frame is likely the one advanced most honestly by proponents of developing the bit-sands, whether at an accelerated rate or otherwise. Because the provincial government collects royalties on all publicly owned natural resources in the province, and the bit-sands generate a staggering level of economic activity and wealth,[47] all Albertans might be said to benefit from exploiting the resource—though the increasing marginalization of less wealthy Albertans[48] seems to disprove that. The underside of this frame begs what one of my interviewees suggests is a major issue concerning the bit-sands, beyond environment vs. economy: whom its related, periodic booms are ignoring, leaving behind or harming.[49] Thus, this frame tends to dominate the discourse on the bit-sands as much as it has prior federal and provincial government policy on developing the resource.

Progress

Alberta's initiative, technology and knowhow will see us through the environmental challenges associated with extracting the bit-sands.[50] This frame is also advanced by diverse sources, from the most zealous proponents of extracting bitumen to passive worriers who hope that all of the concerns associated with that enterprise will simply vanish. For example, this frame appears in a report on the bit-sands from an institute based in Québec,[51] a province that also benefits significantly from the economic activity generated by the resource and has reflected negative attitudes toward the bit-sands.[52] Read critically, the widespread adoption of this frame reflects not just a broader faith in science as a panacea for the ills inflicted by humanity on the planet and itself, but at least a partial abdication of the responsibility to help to alleviate those ills, if not cure them.

Status Quo

Albertans are doing their best on the bit-sands, so let's just keep working and get 'er done.[53] This frame is a more implicit and populist version of the *green* or *denial* frames. Read critically, it is deployed either intentionally, unconsciously or deviously to avoid addressing the ecological, social, cultural, political or other impacts of exploiting the bit-sands. Its use transcends the most vocal proponents of the project to embrace the culture of affluence and indifference among Albertans—manifested in the nation's highest standards of living and record-low voter turnouts— that some suggest has muted Alberta's earlier, more radical impulses.[54]

Bridging

The bit-sands (and oil generally) are a temporary solution but necessary to run society until we find alternatives.[55] Ostensibly presented as a voice of reason and balance, this frame seems eminently logical, as most Canadians' lives would grind to a jarring halt without oil. However, in light of concerns about the bit-sands' implications on the health of local Aboriginal inhabitants, for example, it seems to be overreaching to use this frame as automatic justification for a forecasted tripling of bituminous production levels between 2010 and 2035.[56] In invoking the

possibility of alternatives to fossil fuels, this frame reveals its kinship to the *progress* frame, although the former positions our use of oil as an ecological problem while the latter focuses on our rescue by technology. In the end, it is a universal, gentler version of the *status quo* frame and hardly unique to Alberta.

Compromise

We still need oil, but we must brake the unsustainable pace of extraction of the bit-sands.[57] Closely related to the *bridging* frame but taking a more ecocentric turn, this frame seems to put a moderate face on ecological concerns about developing the bit-sands. Yet deep-green critics would argue that it does not do enough to alleviate the ecological and other problems of the project. Ardent advocates of extraction would counter that all Albertans and others use products from oil produced from the bit-sands. They cite the world's increasing demand for energy as the global population and consumer demand keep growing, particularly in rapidly developing states like India and China. Notably, the frame is used by different parties for sometimes opposite reasons: for example, Andrew Nikiforuk, an environmental writer and advocate, calls for a slowdown mainly for social and ecological reasons;[58] Andrew Leach, a business professor, does so to maximize the province's economic competitiveness over the long term;[59] and even voices from the oil industry invoke it, to cite the challenges of rising costs and labour shortages.[60] Thus, using this frame risks the fate of many compromises in ultimately satisfying no one.

Sellout

As 71 per cent of all bit-sands production is foreign-owned,[61] Albertans/ Canadians are prostituting their birthright to external profiteers[62]—and at fire-sale prices.[63] This frame imports tribal concerns into the discourse, shifting the focus to a point of national pride that finds intellectual ballast in political economy and particularly in the early works of Harold Innis.[64] It is invoked by nationalists concerned with the so-called "Dutch disease," or depending too much on a single-resource commodity to fuel an economy. While apparently critical in its orientation, it is open to criticism for denying the bit-sands' threats to social, cultural, political,

ecological and other aspects of life. An attack on Alberta's management of the project as giving away our bitumen to largely foreign enterprises at appallingly low royalty rates[65] is bolstered by tossing into our largesse the boreal forest, clean air and fresh water in the province, not to mention the health of its residents, both human and non.

Rogue

Alberta's/Canada's inaction on climate change in general and the bit-sands in particular is tarring the nation's international reputation.[66] This echoes the *sellout* frame in its appeal to national pride and adds a sense of shame that draws on Canada's prior, sterling reputation for peacekeeping, moderation and politeness in the eyes of the world. Advanced by advocates for decelerating or ceasing development of the bit-sands, *rogue* can be taken as a converse of the *pride* frame in approaching Alberta's management of the resource tactically as an attack rather than a defence. This frame plays off fears about Canada's tarnished reputation on the global stage, exemplified by its being the first nation to pull out of the Kyoto Protocol,[67] and its subsequent, and partly consequent, failed bid for a seat on the UN Security Council.[68] The battles over the proposed Northern Gateway and Keystone XL pipelines to carry Alberta's dirty oil into the United States, as well as the EU's singling out the bit-sands for potential censure, suggest that this frame has made a mark in international politics.

Greed

Albertans have been bought off by affluence and look the other way when it comes to the bit-sands.[69] This expresses the evil underbelly of the *money* frame in the same, direct way. Consequently, in my perception, it is proffered by opponents of Alberta's management of the resource more commonly than other frames, as is its converse frame by those who support accelerating the extraction of the bit-sands. Money remains a deeply resonant theme in the capitalist system, particularly under neoliberal imperatives that have characterized Western political regimes in recent decades and certainly Alberta since the oil strike at Leduc in 1947.

Eco-Justice

Northern Alberta and downstream Aboriginal populations are being sacrificed for economic interests in the bit-sands.[70] Rooted in countering environmental racism—that is, ecological harm levelled at an identifiable racial group—this frame finds rising support as the rights of indigenous citizens gain greater profile in the public sphere. The UN has held annual meetings of its Permanent Forum on Indigenous Issues since 2002,[71] and environmental justice has emerged as a social movement since the 1970s[72] and more recently as an area of pedagogical concern.[73] This frame appeals to our guilt and moral outrage at people being treated unfairly, particularly those who are already disadvantaged socially, economically and otherwise in colonialist society's extended stampede to progress. While many would not argue with such a frame in polite society, its greatest opposition in the context of Alberta and the bit-sands is the routine practice of entirely ignoring the issue (along with federal treaty obligations), at the expense of citizens and traditions in communities like Fort Chipewyan and Fort McKay.

Health

Albertans are making themselves and the planet sick by extracting the bit-sands.[74] This transcends the *eco-justice* frame in positioning the resource as a threat to Earth and all of its inhabitants. Its breadth and universality let it express the diverse attitudes—guilt, concern, shame, fear, outrage and panic—felt by advocates of decelerating Alberta's unbridled extraction on health-related grounds. This frame has been hotly contested, at least in Canada, as, until recently, both previous federal and provincial governments repeatedly denied any links between the bit-sands and rare cancers diagnosed in downstream, Aboriginal communities—and in the eyes of critics, failed to monitor local air and water quality properly.[75] Scholars call for reframing climate change as a public-health issue to stoke behavioural change.[76]

Present-Minded

Albertans are immorally sacrificing the future of our planet and our descendants.[77] Extending Innis's notion of societal short-sightedness[78]

to the ecological sphere, *present-minded* transcends even the *health* frame in invoking a responsibility not merely to the living but also to the unborn and therefore to the survival of life on Earth. It remains a staple among the most ardently ecocentric opponents of the bit-sands and thus typically outside of the flow of the mainstream (corporate-owned) media, and its expression is overwhelmed by that of frames such as *status quo*. However, its invocation by religious authorities such as Bishop Luc Bouchard[79] of St. Paul, Alberta, and retired South African Archbishop Desmond Tutu[80] opens up possibilities for new avenues and new (and perhaps more culturally diverse) participants in the discourse. Ultimately, Alberta's management of the bit-sands may well be the greatest moral issue to face any Canadian province in terms of the global attention that it attracts; the project's immense ecological, economic and other consequences; and its serving as a bellwether in the emerging clash of values over those consequences. In this light, this frame could serve as a valuable focal point for dialogue among the diverse interests in the resource, one that could transcend political partisanship, at least in theory.

Ecocide

Alberta's management of the bit-sands is an unsustainable ecological disaster that must stop entirely and immediately.[81] This frame marks the apogee of the deep-green, ecocentric end of Corbett's spectrum of ecological values.[82] Unsurprisingly, then, it is marginalized in the overall discourse, although high-profile adherents such as Greenpeace and the UK Tar Sands Network maintain its presence in the public sphere, particularly with creative media stunts or "actions." *Ecocide* may be the antithesis of the *pride* frame, in this case, as it stands to disrupt not only Alberta's largest industry but also the one most strongly conflated with the province's place-identity, at least as perceived by its political and economic elites. Thus, the frame can be read to counterbalance apparent excesses of more economically aggressive frames like *green* and *money*.

| Having catalogued these fifteen initial frames, let's situate them on the spectrum of ecological attitudes posited by Corbett. With mildly modified labelling, this exercise results in the following subjective alignment

of frames (Figure 3.1), ranging from anthropocentric (instrumentalist) to ecocentric (transformational) ideologies.

FIGURE 3.1: Alignment of Frames

Instrumentalist	Conservationist/ Preservationist	Moralist	Transformational
Pride	Compromise	Rogue	Present-Minded
Green	Sellout	Greed	Ecocide
Ethical Oil		Eco-Justice	
Money		Health	
Progress			
Status Quo			
Bridging			

From highlighting the historical, political, economic, cultural and ideological contexts of the rising international PR battle over Alberta and the bit-sands, we turn next to a prominent front in that battle, the visual discourse led by independent documentary filmmakers challenging Albertans' stewardship of the resource, and government and industry communicators defending it.

4
Positioning and Contesting Alberta

Pay Dirt (2005)

THE FIRST PRODUCTION under study is *Pay Dirt: Making the Unconventional Conventional*,[1] a forty-eight-minute documentary film directed and co-produced by Matt Palmer, a twenty-year veteran of the film industry.[2] Inspired by a book, *The End of Oil*,[3] Palmer addresses his view of the real question for debate: not the polarized issue of whether or not to exploit the bit-sands, but how to transition from our hydro-carbon-based economy before the apparent onset of political, economic and ecological chaos precipitated by present paths of consumption. Motivated by curiosity and the need to produce a fundable project, Palmer singularly secured two-thirds of his $600,000 budget from the oil industry and struck an advisory board comprising representatives from that industry and from the Pembina Institute, a clean-energy think tank, and the Canada West Foundation, self-described as "the only think tank dedicated to being the objective, nonpartisan voice for issues of vital concern for Western Canadians."[4] (One might question the

foundation's assertion, given, for example, its positioning of environmental concerns as an incident of the industry's "social licence" to extract the resource—all while calling on government to streamline regulatory and environmental approvals to *accelerate* extraction.[5]) Palmer's board provided advice during scripting and editing, giving him "the best stories from both sides" while serving his primary goal "to ensure that the content of the film was accurate, fair and balanced."

The film includes images of sped-up highway and freeway traffic, the Calgary and Edmonton skylines, the boreal forest, Fort McMurray, bit-sands workers and equipment, and aerial views of unfathomably vast, terraced, open-pit mining, all of which have since become a hallmark of the genre that this film helped to create. Palmer obtained cutting-edge, HD camera equipment to try to depict the immensity of open-pit mining and the world's largest trucks, other advanced equipment and sophisticated plant operations employed to extract bitumen. These images are counterpointed by interviewees addressing social, environmental and technological issues around the bit-sands. Palmer explains, "I was trying to give the scale of the oil sands...to show it from the ground and the air. You don't understand the scale until you see the size and complexity of the trucks, upgraders, etc." In positioning Alberta within an international economic web, the film offers images of Iraqi oilfields, the US Capitol, and US officials declaring their need for the bit-sands. These, too, have become commonplace in documentaries related to the resource.

Pay Dirt premiered before a crowd of 1,200 at Jack Singer Concert Hall in Calgary in 2005, followed by television broadcasts on the CBC in 2006 and later on ACCESS and Canadian Learning Television. Palmer attributes his failure to place the film in film festivals to its lacking sufficient controversy, opining that films opposing the bit-sands will "go everywhere" while pro-bit-sands and balanced films will "go nowhere." Palmer declares that the polarization, anger and conflict driving media coverage of the resource make it challenging to have "middle-of-the-road, rational discussions." Although he and his creative team were unknown in the screen trade when they pitched *Pay Dirt* to broadcasters and funders, they "benefitted as the first ones out of the gate."

In striving to achieve Archimedean equilibrium, *Pay Dirt* makes no specific claims about the identity of the province and its citizens. The film positions the bit-sands at the vortex of a rising, worldwide debate on the future of energy and its use in industrial society. Fort McMurray is presented as an archetypical boomtown testing the limits of the widely held notion that growth benefits society. An environmentalist appears onscreen and politely doubts industry's claims of responsible development, but a member of the Pembina Institute sees mutual respect between environmentalists and industry. The moderate opinions in the latter two scenes stand out in the commonly polarized discourse on the bit-sands.

Reflecting Alberta's vital and deeply entrenched ties to the US, both as a source of expertise and investment in the local oil industry and as the unquestioned dominant market for its products, the film captures Alberta's positioning as a safe, friendly and neighbourly supplier of oil (the *ethical oil* frame). Alberta's importance as the source of one-quarter of America's oil is echoed onscreen by assertions by Paul Roberts, the author of *The End of Oil*,[6] that an oil shortage would shake the foundation of the economy and that no viable alternatives exist yet.

In advancing Palmer's goal "to reframe the conversation by asking what is fundamentally important to us" and how best to use our finite energy resources, *Pay Dirt* employs the *bridging* frame—oil is a temporary solution but still needed to run society—and the *progress* frame, invoking technological ingenuity as the primary avenue to solutions to problems associated with oil. *Progress* is also evident—and dominant— in a companion one-hour film, *Pay Dirt: Alberta's Oil Sands: Centuries in the Making*,[7] a history of the development of the bit-sands. However, this perspective is tempered somewhat by a penultimate interview clip of Mary Clark Sheppard, daughter of Karl Clark, the scientist credited with pioneering bitumen extraction. She reveals that the bulldozing of trees for the first bit-sands production plant broke her father's heart and that he would be dumbfounded by bit-sands operations today.

Through a critical lens informed by the thought of Harold Innis, one could read the film, despite its singular and scrupulous attempts at neutrality, as positioning Alberta at two levels: first, broadly as a bellwether

of the tensions and challenges facing global producers and consumers of oil, and, second, as a geologically fortuitous branch plant of the world's largest economy, the USA's. This was evidently not the filmmaker's intention, and positioning Alberta was never the focus of his project. However, by omission of any direct discussion in the film, Alberta's identity (whatever it may be) seems to be subjugated to forces of global capitalism and whatever collateral damage that may cause. A critical reading suggests that in presenting a massive, international economic apparatus—even combined with the inevitable collapse of its oily foundation—the film questions neither the privileging of the primacy of the market nor Albertans' attitudes toward balancing economic, environmental and other considerations raised by resource extraction. Such a reading seems consistent with neoliberalism's denial of voice[8] and its reducing our identities to marketplace consumers.[9]

Nor can one ignore the significant funding contribution to *Pay Dirt* by the oil industry. This could well undermine Palmer's laudable aspirations of fairness, balance and "middle-of-the road, rational discussions," which, read critically in their execution in his film, seem on the whole to reflect the social values of the political and economic elites whose privileges are vested in maintaining the status quo of full-bore extraction. In this light, Palmer's claim of film festivals privileging the exhibition of films opposing rather than supporting Alberta's management of the bit-sands underscores the argument that oppositional documentary films may be more likely to be funded primarily by public-interest sources like peer juries serving arts-granting agencies. This is in contrast to video campaigns promoting extraction and its economic benefits, which tend to be sponsored by private interests in the energy industry, or produced by the provincial government's communications arm, the Alberta Public Affairs Bureau, to advance economic-development imperatives.

CONTEXT I: The Bit-Sands Get More Engrained (2006–2007)

Pay Dirt's release was followed by a surge in the profile of the bit-sands, particularly in the United States. In January 2006, the *60 Minutes* news program, American primetime TV's longest-running offering and most

frequent Nielsen-ratings champion,[10] aired a thirteen-minute segment called "The Oil Sands of Alberta." It positions Alberta as part of "the solution to America's energy needs for the next century."[11]

Over soon-to-be well-known images of vast open-pit mines, the world's largest trucks and the lively bar and casino scenes in Fort McMurray, a "boomtown" that "isn't in the middle of nowhere, but north of nowhere and colder than the Klondike," the voice-over narration gushes, "There is so much to scoop, so much money to be made." Shell Canada's CEO, a local MP and a VP from the Canadian Association of Petroleum Producers (CAPP) all extol the low risks and formidable potential for investment—$100 billion over the next ten years, "bigger than a gold rush," booms the MP. The narrator calls Albertans "blue-eyed sheiks [who] took to Wall Street...in their Stetsons to drum up support for the oil sands," and are keen to "step up production quickly."

The only perceived impediment to developing the bit-sands is a shortage of labour. Ecological concerns are raised near the end of the program: T. Boone Pickens, described as "a legendary Texas oil tycoon," states, "There's no question that they've got a mess up there. But I do think they'll take care of it over time." The lone environmentalist voice is the executive director of the Sierra Club, Elizabeth May (later Canada's first and only Green MP), who tellingly observes of the bit-sands, "One of the reasons they can be mined the way they've been mined is the out-of-sight, out-of-mind aspect of it. And your film crew is one of the few that's gone in there to look at how devastating this is." This visual emergence of the project in the wider public consciousness is reinforced by CAPP VP Greg Stringham when he states that decision makers in the US Capitol were much more aware of the bit-sands then (in 2006) than a couple of years earlier. As Bill McKibben tells me, "Without films...and images... people would have little conception of what's happening with things like the tar sands and what needs to be done about them."[12]

Read critically, the program's narration echoes Alberta's historical, rhetorical twinning to extractive capitalism and the larger-than-life ethos enabled by high commodity prices: "Everything about the oil industry has always been big...from the pumps to the personalities. But up here in Alberta, it's frankly ridiculous."[13] Thus, 60 Minutes trumpets

47

the *money* and *progress* frames, and implies the *pride* frame in positioning oil as central to Albertan life. The Alberta government's approval of the segment is suggested by its appearance on the province's Municipal Affairs website almost six years after it aired.[14]

The profile of the bit-sands rose again during the summer of 2006, with Alberta showcased at the Smithsonian Folklife Festival, "an international exposition of living cultural heritage annually produced outdoors on the National Mall...[and]...an educational presentation that features community-based cultural exemplars."[15] Featuring only part of a country beyond the United States is unique since the festival began in 1967. Critical readings point to extra-cultural imperatives. In the second of two studies of Alberta at the Smithsonian in Washington[16]—which included a parallel trade mission—Jennifer Gauthier finds:

> It is as if the Folklife Festival were simply an excuse for Alberta government ministers and lobbyists to storm the American capital and get face time with lawmakers and industry insiders. The Smithsonian Institution's prestige provided the stamp of legitimacy for this diplomatic mission, and for some observers masked the heavily industrial focus of the Alberta program. However, for others, it was quite obvious that the objectives of cultural conservation were overshadowed by business and technology, much like the shadow cast on the Mall by the giant Caterpillar truck.[17]

Such a reading is supported by the government's own reports of the two events,[18] all of which expressly prioritize using the "the profile Alberta will have in Washington to reinforce our key messages in the US" and which quantify the financial benefits of promoting the province there. Similarly, in a critical discourse analysis of eight speeches made by Alberta government officials during the Smithsonian Folklife Festival, William Whitelaw finds three key themes that indicate how the government sought to represent Alberta's identity: that Alberta and America are (a) stable and secure trade partners; (b) a lot alike (independent, self-reliant and determined, with a common pioneering spirit); and (c) able to get along quite nicely without Canada. There, the iconic cowboy ethos was co-opted to depict the province as a bastion of rugged individualism,

industry and independence.[19] This argument is buttressed in *Alberta's Integrated Energy Vision*, a document released shortly after the festival, which proclaims, "There is a new attitude emerging, with Albertans experiencing a difference in how they view themselves and their province in light of its natural resource assets and the associated benefits."[20] In Whitelaw's eyes, both the government's discursive power play at the festival and its embracing this "new attitude" are not only ironic but also a cause for concern. "In Alberta," he asserts, "the collectivization of identity, while appearing to condone individualism, in fact, creates the opposite effect: the state effects discursive closure around matters of citizenship" so that only its neoliberal version of identity counts.[21] While not shown in a film or video—though likely on TV news clips— representations of Alberta in Washington, DC, seem to advance the *pride*, *ethical oil* and *progress* frames.

The *60 Minutes* segment and the Smithsonian experience were followed by the onset of more critical representations of Alberta and the bit-sands at home. A month after the festival, the CBC aired "When Less is More," an episode of its popular science program, *The Nature of Things*,[22] following up on an earlier episode, "When is Enough, Enough?"[23] Later came "Crude Awakening: Alberta's Oil Patch,"[24] a news report for the CBC's flagship nightly news program, *The National*. These programs emphasize the massive environmental and social impact of the bit-sands in both images and words. The former focuses on the plight of the Mikisew Cree living in Fort Chipewyan, some two hundred kilometres downstream from bit-sands operations and the oldest continuing European settlement in the province: residents find their air and water poisoned and their rate of cancer abnormally high, and they seek a moratorium on new developments there. The latter depicts concerned Albertans, notably renowned water scientist David Schindler, who cite well-documented health risks (long denied by the former Alberta and federal governments) in calling for decelerated development of the bit-sands.

Between them, these programs depict a colossal industrial process, with images of stripped boreal forest; vast, open-pit mines; hundred-ton shovels feeding black sand into the world's largest trucks (yellow monsters, 380-ton payload, three storeys high); conveyor belts that seem endless;

smokestacks belching grey exhaust; and pipes spewing torrents of toxic, industrial sewage into tailings lakes. These are contrasted with bucolic scenes along the Athabasca River that belie the damage and show viewers Aboriginal ways of living that have been disrupted by the bit-sands, likely irreparably.

These two CBC programs position Alberta as a place where people say and do nothing about industrial pollution. Biologist Kevin Timoney explains in the "Crude Awakening" news report, "Up in Fort Chipewyan, regardless of what science tells us, [then-Premier Ed] Stelmach tells us, 'We're going to do this, so get out of our way.'"[25] With the bit-sands, now Canada's largest source of greenhouse-gas emissions, Alberta is presented as turning the nation into not only an "energy superpower," but also "one of the most polluting countries in the world,"[26] blackening Canada's reputation abroad (the *rogue* frame). Hauntingly, Dr. Schindler muses that if he had the money, he would fly all Canadians over the bit-sands, because if they saw the project, they would not permit it.[27] This echoes Elizabeth May's comment on 60 *Minutes* that the bit-sands are out of sight, out of mind for most of us[28]—a reminder of the power of imagery. Thus, these first overtly critical productions examined here focus on the *eco-justice*, *health* and *present-minded* frames in raising concerns about Albertans' management of the project.

Tar Sands: The Selling of Alberta (2008)

Tar Sands: The Selling of Alberta[29] was directed by the province's senior and most eminent filmmaker, Tom Radford, hired by a Toronto production company. The forty-one-minute film was commissioned by the CBC and broadcast in March 2008. Radford has deep roots in the province and follows a tradition of challenging abuses of power: his grandfather helmed the *Edmonton Journal* as it opposed the legislative excesses of the Social Credit regime in the 1930s. Radford has written, directed and produced over fifty films on the history and culture of the West, receiving domestic and international honours. He also co-founded a landmark production and distribution company in Alberta in 1971 that continues to distribute independent and educational films, and the

National Film Board's Northwest studio in 1980. He has exhibited his photography at the National Gallery of Canada and co-edited two popular books on Alberta.[30] *The Canadian Encyclopedia* notes, "Tom Radford's influence on the provincial and national film scene has been considerable, both artistically and as an example for filmmakers working outside of the mainstream."[31]

Tar Sands revives Radford's storytelling about Aboriginal life in the Athabasca River delta. His second film, *Death of a Delta* (1971), chronicles the Mikisew Cree's fight to stop the building of the W.A.C. Bennett Dam, called one of the world's largest earthfill structures.[32] Shortly after that, he was hired by Syncrude to make a film, *Trade-Off*, on its environmental policies on extracting the bit-sands, but the project was never released, and he returned to the Fort Chipewyan area to make two other documentary films: *The Man Who Chooses the Bush* (1975), about Métis trapper Frank Ladouceur, and *Mother Tongue* (1991), about Dr. Anne Anderson, who taught and preserved Cree language and culture.

Trained in history and informed by the political-economic thought of Harold Innis, Radford sees Alberta and Canada as returning to the Hudson's Bay Company model, in which the colonizers—today, the foreign owners of multinational companies extracting the bit-sands—live far away from the land that they plunder.[33] He summarizes an overarching theme of his work as the need to preserve disappearing things in Alberta, and his mission in general and in *Tar Sands* as asking, "How does a community fight back in the emerging global world?" He sees Alberta as overcome by "an incredibly strong American influence, basically an imperial model concerned with security of energy supply and economic interests," leading to "a re-colonization of Alberta." He finds "a deep insecurity in the province" and Albertans "not wanting to rock the boat" because they "are paid very well to forget about the discourse," to the extent that "denial comes to define an entire culture." He finds it "telling that [then-Premier Ralph] Klein shut down one of the best public television stations in the country, ACCESS, and [then–Prime Minister Stephen] Harper is dismembering the CBC now [through annual 10 per cent budget cuts]. People don't want to talk about these issues in a colonial society."

Reflecting this critical perspective, *Tar Sands* portrays the dark side of the oil boom hailed so vigorously on *60 Minutes*,[34] and the technical advances featured in *Pay Dirt*.[35] As its subtitle, *The Selling of Alberta*, suggests, *Tar Sands* depicts a province besotted by "a $100-billion energy bonanza" centred in "tar-soaked 'Fort McMoney,' a modern-day Eldorado where rents are skyrocketing and cocaine abuse is four times the provincial average,"[36] and where global investors are buying up Canadian sovereignty and poisoning Native communities. For Radford, the key story is "that Alberta is *not* to be thought of as a hinterland where we import tens of thousands of workers, tear apart the land and everybody goes home richer." He challenges the government's claim that the bitsands are "building our province," finding it "doubly tragic" to see the Albertan ethic of pioneering and legacy-building "get lost at this exciting point in Alberta's history, and see it selling out its culture for its resources."

With this framework, it is unsurprising to find the imagery in *Tar Sands* tending to be more apocalyptic than that seen earlier in this discourse. The world's largest trucks, depicted as marvels of industrial power and efficiency in *60 Minutes* and *Pay Dirt*, become colossal scavengers scraping the enormous, scarred expanse of earth left after a battalion of trucks brutally strip away the virgin boreal forest. We see migrant workers forced to live in tents, in contrast to well-heeled Washington lobbyists and investors giddily flying in from Norway, China, etc. to cash in on Alberta's bounty, all prodded by a provincial government that, in the words of people in the film, sees the land as "a sacrifice zone" and its indigenous inhabitants like the Mikisew Cree as "collateral damage."

After the film's national broadcast on the CBC's *Doc Zone*, the *Edmonton Journal*'s business columnist ventured into cinecriticism in dismissing *Tar Sands* as "pure fiction," "featuring the usual assortment of capitalist-bashing, America-loathing lefty ideologues" and "merely the latest in a string of sensationalist hatchet jobs on Alberta's key industry, courtesy of the national media."[37] This follows a tradition, common among those expressing "western alienation" from Central Canada's corridors of power, to position the CBC as leftist, and evinced in some of the comments on *Tar Sands*, posted on the CBC's website, expressing disdain at the film's leftist and/or eastern biases in singling

out Alberta for opprobrium.[38] The business columnist's critique was rebutted in the *Journal*'s editorial pages, in a letter to the editor from Niobe Thompson, the film's associate producer, listing the preponderance of local creators and interviewees in the documentary.[39] Thompson belies the business columnist's positioning of the film as an attack on the province by "the national media" even if it was broadcast on national television. Such a positioning by the business columnist—adopting the *pride, money* and *ethical oil* frames—reprises the time-honoured tactic of Albertan politicians to deflect criticisms of the government's management of local issues by attacking critics personally and circling the wagons against the national media, federal government, or other actual or perceived threats from beyond the province.[40]

Thus, the film adopts five key frames: *greed, sellout, health, eco-justice* and *present-mindedness*. Radford's critical approach presents a province in serious danger of losing its soul in a myopic and increasingly ardent effort to gain the world. *Tar Sands* stands as a keystone in the positioning of Alberta in the discourse as the first openly critical work on the bit-sands from an Albertan filmmaker challenging the status quo in a province deeply invested in extractive capitalism. But judging by viewers' feedback to the CBC, the film is also remarkable for the volume and intensity of the public reaction that it precipitated. This is likely to have been bolstered by the rising domestic and international profile of the bit-sands and its consequences since 2004. In its dramatic contribution to this, *Tar Sands* seems to have increased the criticism and thus the discursive polarization around the resource.

CONTEXT II: 1,606 Dead Ducks (2008)

Six weeks after *Tar Sands* aired, the bit-sands became etched into the global visual palette. When the usual deterrents failed to operate, 1,606 ducks landed in a tailings lake operated by Syncrude, and perished. Covering 37 square kilometres along the Athabasca River (about the size of Manhattan), these toxic expanses of contaminated water, sand and bitumen are the endpoint for 90 per cent of the water that industry draws from the river. They grow by 1,520,000 litres per day, enough to

fill 720 Olympic swimming pools, and they also leak.[41] Syncrude did not report the mass demise of the ducks, but a whistleblower alerted the authorities and Greenpeace. Syncrude was fined $800,000 and ordered to pay another $2.2 million toward avian research, conservation and education projects,[42] which was less than half of the company's daily profit of $7 million in that quarter.[43] Although some 458 to 5,029 birds die in tailings lakes each year[44] and 125,000 ducks are dispatched by Albertan hunters annually,[45] videos of these particular trapped, doomed birds and their sludgy corpses went viral on the Internet,[46] causing the prime minister to call it a PR disaster for Canada.[47] Both a film studied here[48] and Roxanna Bénoit, then responsible for the Alberta government's communications,[49] cite the incident as a significant point in already worsening public perceptions of the province.

Downstream (2008)

Downstream[50] is thirty-three-minute film by Leslie Iwerks, an acclaimed American filmmaker whose father and grandfather were Oscar-winning Hollywood insiders. Based in Los Angeles, Iwerks has produced documentary films, television specials, live webisodes and digital content for large American TV networks,[51] and her documentaries have screened at international film festivals.

Downstream springs from a documentary that was the first original feature film commissioned by Babelgum, a British online service that sought a feature on the bit-sands to launch a series on global warming; Babelgum approached an LA-based agent, a native Albertan who suggested Iwerks.[52] The bit-sands attracted her as a story relatively unknown in the United States, "And being an American, I felt sort of responsible, as we're the number-one consumer of Canadian oil...a huge pollutant."[53] She aimed to show Americans that their largest oil supply was dirty oil from across the border, and to spark questions, discussions and action on ecological and human-rights concerns about the bit-sands.[54]

While researching her feature, Iwerks discovered John O'Connor, a soft-spoken physician in Fort Chipewyan who had voiced his concerns over the abnormally high number of rare cancers and other health issues

that he observed—concerns ignored or denied by provincial and federal authorities. She got Babelgum's consent to make a short film about Dr. O'Connor's concerns and submitted it to the Academy Awards. She sees Fort Chip's story as "a microcosm of a larger issue...going on all over the world."[55] She finds the government's denying that local water is polluted even as its officials fly into Aboriginal communities with cases of bottled water to be "kind of a funny visual." Noting this expression of what Radford calls the culture of denial in Alberta,[56] Iwerks observes:

> A lot of people from companies didn't want to speak. And John O'Connor had threats.[57] So, that's a prime example of...a dangerous place to create waves when there's so much money at stake. You wouldn't think that about Canada—but when you're talking about big oil and big money, you're back in Russia! It's like the Mafia![58]

Downstream shows "the destruction from the point of view of those who are affected by it."[59] We see ancient forests and the Athabasca River in contrast to sped-up images of highway gridlock, monstrous trucks in open-pit mines, and toxic sludge cascading into a tailings lake; some of these images are recognizable from *Pay Dirt*.[60] Rustic community life foregrounds an intimate study of Dr. O'Connor as he caringly counsels patients at his clinic and in their homes; as he explains the horrific illnesses that are devastating Fort Chipewyan; and as he humbly shows the camera a large quilt that locals created for him as a parting gift.

Contrasted with these intimate moments of compassion are inter-views with officials from government and industry who cite the stringency of Alberta's environmental standards and their enforcement with what I read as almost clinical detachment. Water scientist David Schindler, biologist Kevin Timoney and environmental writer Andrew Nikiforuk—all of whom appear in various critical films studied here—assert a contrary view with passion and conviction. While Iwerks sought to present a balanced perspective,[61] she found it very difficult to access the oil industry,[62] echoing Palmer's note on industry becoming more cautious since the bit-sands have gained more profile.[63] The overall impression is one of fragile communities and traditional, Native lifestyles being

callously sacrificed to a distant political and economic juggernaut, chan-nelled by government and industry in Alberta.

As for impact, the Alberta Environmental Network[64] declared that *Downstream* has "raised unprecedented awareness in Canada and the US regarding the environmental and social impacts of the tar sands," and reported that the film was screened for members of the Obama administration by members of the Natural Resources Defense Council, a powerful American environmental-action group boasting more than two million members.[65] The film was shortlisted for Best Documentary Short Subject at the Academy Awards in 2009, but it was not nominated. The ensuing publicity, noted as unusual for a film seen by relatively few people,[66] undercut Alberta's efforts to boost production and sales of its bitumen, and also to manage its environmental reputation. In fact, the negative spotlight arising from audiences' reaction to *Downstream* compounded the mounting criticisms following Radford's film, *Tar Sands*, and the tragic, visually potent and highly inconvenient demise of those 1,606 ducks.

To make matters worse for the Alberta government, its then-minister of culture, Lindsay Blackett, mused that he might have withheld funding from Alberta's film-development program had he known how critical Iwerks's work would be. He declared, "Because if I'm going to actually invest money on behalf of Albertans into a film, the whole idea is to show Alberta in a better light, to create an economic diversification to help them."[67] In reality, he had no discretion over funding, which is automatic if specific criteria (for example, using local personnel and locations) are met. The ensuing backlash from parties like the Council of Canadians[68] and even the *Los Angeles Times*[69] attacked Alberta for censorship, reinfor-cing the very point that *Downstream* makes: that in supplying the world's largest market for oil, Alberta tramples on human rights as well as human and environmental health. Blackett hastily backtracked and "reaffirmed his commitment to local filmmakers, free speech and artistic freedom."[70]

Despite *Downstream*'s splash in positioning Alberta as extractive capitalism at its callous apogee through the *rogue, eco-justice, health,*

present-minded and *ecocide* frames, Iwerks is disappointed in its dissemination. The film was screened in Fort Chipewyan, Edmonton and Calgary and at international film festivals, but not in theatres, although it is available on DVD. "It's very challenging for environmental documentary films to get distribution," she observes, "especially short films." Yet in raising awareness of Canada's dirty oil among an American populace that her film depicts as uninformed on the issue—despite the glowing *60 Minutes* segment[71] and Alberta's PR efforts in Washington, DC— Iwerks's work apparently helped to precipitate a concerted reply.

An Open Door (2009)

Faced with increasing, unflattering representations of Alberta, the government assigned its response to its communications arm, the Public Affairs Bureau (PAB). The PAB has been criticized in the Legislature,[72] the academy,[73] the media[74] and popular literature[75] as a propaganda vehicle. Roxanna Benoit, a senior lawyer versed in government and public policy, at the time recently returned to her native Alberta to serve as the PAB's managing director, summarizes the situation:

There was high-level recognition that the province was changing, the population was growing and people were coming here from all over the world. The province was in the middle of a high economic upswing. We felt we needed to help Albertans understand their problems and help reflect this new reality....

Albertans have a tendency to keep their heads down and do their own thing. But we realized that the whole world was watching us and not liking what they saw. Then came the day the ducks died. It was clear that this would impact business and immigration coming into Alberta. We wanted to explain how our values drive our decisions.

We found a positive perception of the place and the people, although it was a little stereotyped. We broke from this when we asked about Albertans' values on energy and the economy. We found a disconnect between the values that Albertans felt they had and the values perceived to be driving our decision making. We had to address this gap. There is

value placed on the environment in Alberta, and we needed to show how those values would let us make decisions about this place.[76]

Thus, in March 2008, the government began a $25-million campaign to rebrand the province, changing its long-standing economic-development slogan, "the Alberta Advantage." As Benoit recalls, the new brand was to be an open one, comprising a slogan and images that anyone could use. Following the usual government vendor-selection process, the PAB chose a consortium led by Calder Bateman, a leading Edmonton-based firm, and including Identica, the branding subsidiary of Cossette, the largest communications firm in Canada,[77] and researchers, experts in branding, advertising and social media, communications strategists and a pollster. The supporting research used 33 focus groups with "informed citizens," young adults and business leaders, plus telephone surveys of 800 Albertans, 800 Americans and 1,200 Canadians. Brand testing followed in 8 focus groups held in Edmonton, Calgary, Stettler and Toronto, plus 250 online interviews. The findings confirmed perceptions of Alberta as a place of natural beauty, but needing work in the areas of openness, compassion and environmental stewardship.[78]

Benoit notes that the place-branding campaign concerned more than advertising, the environment or the bit-sands,[79] or taxes and money.[80] For its part, the premier's office declared at the time that the project aimed beyond the habitual goal of place-branding exercises— to attract skilled workers, investment and tourism to the province and to market local products and services—to negate perceptions of Alberta as a producer of dirty oil.[81] Benoit suggests that there were two primary target audiences for the rebranding campaign, Albertans and other Canadians, as affecting other intended markets like the United States was a huge undertaking.

Other indications point to the United States as a key, if collateral, target. First, the American market is crucial to Alberta's economy, buying almost 90 per cent of the province's exports and delivering two-thirds of its foreign investment and 60 per cent of its foreign tourists.[82] Second, almost 30 per cent of the participants in the Alberta government's branding survey were Americans. Third, ads in American

publications[83] and an announcement of the pending release of the video a week before President Barack Obama's visit to Canada[84] further suggest US audiencing, as does a subsequent ad in the *Washington Post* (at a cost of $55,800) that was originally intended as an opinion column defending the bitumen industry, but rejected by that newspaper.[85] Finally, Alberta had already opened an office in Washington in 2004 to "promote Alberta's economic and policy interests in key areas such as energy, environment and agriculture."[86] That motives for the branding were economic as well as cultural was affirmed by then-premier Ed Stelmach's justifying the $25-million rebranding campaign relative to an anticipated return of $40 billion in economic benefits.[87]

The PAB spent $4 million on three fronts: research, a branding slogan ("Freedom to create, spirit to achieve") and a 2.5-minute video slideshow called *An Open Door*.[88] A principal of the Edmonton-based firm leading the branding consortium, Frank Calder—a senior leader in Alberta's marketing and communications sector—recalls that the branding video was intended to be ancillary to the larger, external marketing campaign. But due to declining oil prices (and consequently, provincial royalty revenues) and the economic downturn, the rest of the $25 million was abandoned, leaving the video as the campaign's flagship. "When we decided to do it, a $12-billion surplus was forecast," recalls Benoit, "but by the time it was launched, there was a deficit. There was political turmoil inside the government at the time. All of these factors affected the outcome."

The video was designed "to round out the perspective of Alberta, and reflects some traditional imagery of Alberta," notes Calder, "rounded out with some urbane, urban, cultural, multi-ethnic images." It unfolds in thirty-six frames, brimming with panoramas of the province's natural splendour. Reflecting the title, about half of the shots depict wide-open spaces under expansive, azure skies, including such iconic Albertan tourist-marketing subjects as the Rocky Mountains, fields of grain and the eerie badlands. Voice-over narration accompanies each image, repeating text that appears onscreen in some cases, contributing to positioning Alberta as open for people to pursue unlimited opportunities and realize their dreams. An anthemic conclusion echoes American

political rhetoric: "We hold true to the belief that our path from the past to the future can be made wide enough to carry the dreams of all Alberta...of all Albertans." The province is presented as a beautiful backdrop for any human endeavour, suggesting an ecocentric gloss on an anthropocentric core.[89]

The only reference in *An Open Door* to Alberta being a producer of energy is a backlit shot of a pumpjack at sunset, which also appears in a fleeting, briskly converging quilt of sixteen images comprising a later frame that also includes a shot of wind turbines foregrounding a grain field and the Rockies. Read critically, this invokes Nicholas Mirzoeff's observation of neoliberal positioning: "The numerical majority finds itself in the position of Minority, unable to influence the key practices of security, finance, and ecology that determine their conditions of existence. This new Minority requires a new claim to rights, especially visual rights, because so much of globalization is conducted as a form of invisibility, in which the citizen has no right to look but is asked to 'move on, there's nothing to see.'"[90] To which citing of Jacques Rancière's policing analogy,[91] Mirzoeff later adds, "Only there is, and we know it and so do they. Critical visuality studies claims the right to look at that which authority wishes to conceal."[92]

Thus, in considering the political, economic and environmental contexts in which it was produced and a likely key audience (the American market for oil), *An Open Door* uses the *status quo* frame, suggesting that all is well in Alberta—as all place branding must do.

For branding purposes, then, when it comes to the bit-sands, there may indeed be "nothing to see." However, this approach is belied by five significant factors suggesting that the project has become an indelible aspect of who Albertans are, as an expression of their most profound beliefs, values and priorities. First, the bit-sands ground what has been called the largest industrial project on Earth;[93] can that be ignored outright? Second, revenues from non-renewable energy resources averaged 29 per cent of Alberta's total revenue from 2002–2003 to 2013–2014;[94] 60 per cent of energy revenues came from the bit-sands in 2013;[95] and bitumen royalties were forecast to rise to 70 per cent of total resource revenue by

2016–2017.[96] Third, the proportion of revenue from the resource is expected to keep climbing due to the ongoing decline in conventional oil production in the province.[97] Fourth, the province boasts a strong visual tradition foregrounding the oil industry, as noted in Chapter 3. Finally, for the province's largest and certainly most powerful industry, "Alberta Is Energy."[98]

So there is a substantial disconnect between the positioning of Alberta in *An Open Door* and in other productions and events considered here. The former deals with environmental concerns by ignoring them—the *green* frame—despite assertions by the premier's office that it was produced to counter negative perceptions of the province due to its management of the bit-sands.[99] Ironically, the video seems to reinforce the very stereotypes that the PAB's research indicated needed improvement: perceptions of Alberta as a beautiful place, but lacking in compassion for its people and respect for its natural environment.[100] When asked about this apparent disconnect, Benoit explains:

> There was no ecological piece because the video was supposed to be about us and our values, as opposed to only about energy. Albertans' values towards this place would not allow us to do what some are alleging we were doing. We planned to build on that in the ensuing branding campaign and use it as a basis for explaining why we were doing what we did and how it would affect what we do in the future...
>
> This was such a change, so different from what people had seen government do. It wasn't understandable in five seconds looking at a picture. We needed to get people to think, and there is no time for that anymore.

An Open Door became a public-relations debacle, panned by critics, columnists and the blogosphere, not least for its initial version featuring an image taken not in Alberta, but in northeastern England.[101] The director of the Canadian Taxpayers Federation stated, "Don't try to pretend that we don't have the oil sands and we simply are just a bunch of parks and people who are out there to achieve and create or whatever the words

were."[102] When PremierAlison Redford took office upon Ed Stelmach's retirement, she declared the rebranding defunct,[103] and the slideshow subsequently vanished from the government's website.[104]

So *An Open Door* was produced as part of a larger, incomplete project. But beyond the PAB's focus testing, its "soft launch" at a conference by the then-premier and favourable anecdotal accounts from government,[105] its largely negative reception in the public forum suggests that this explanatory context remains lost on the wider public and thus also on the discourse of place-identity about Alberta and the bit-sands.

Petropolis (2009)

When the Alberta government launched its rebranding campaign, the premier's director of communications told the media that the rebranding campaign aimed "to tell the world that we're producing clean energy," adding, "I don't think we can leave that job to Greenpeace and the Sierra Club."[106] By that time, in fact, Greenpeace, probably the world's most prominent environmental-activist organization, had already contacted Peter Mettler, an acclaimed Toronto-based cinematographer, filmmaker and experimental artist working in sound and image, whose work is featured in two books.[107] In 2008 Mettler was researching and exploring the contents and flight paths of clouds for his latest project, and having seen images, and heard, of the bit-sands, he was interested to see what rises into the atmosphere there.[108] So he volunteered to shoot Greenpeace's film in return for consent to use any of the footage in his new film. His contact at Greenpeace Canada "had a Greenpeace-type project in mind where we would go and interview people and different experts, and it would be very interview-based, information-based."

They started filming interviews at locations around the bit-sands but were shut down by extraction companies' security forces. Mettler was struck by, first, "a kind of an uneasiness and possibly also a bit of the feel of the gold rush, a temporary state, where the whole thing could go in several directions at any time," and second, by the contrast between the visible "money grabbing" in Fort McMurray and the Aboriginal community in Fort Chipewyan, with its residents' traditional way of life, livelihood

and health threatened by the toxic fallout of bitumen extraction. After an exploratory helicopter flight and cued by Mettler's work on clouds, the crew settled on aerial photography to show the panorama of the bit-sands. Fine-quality camera equipment was needed to capture a steady image, which was required from altitudes over 305 metres (1,000 feet), ostensibly the legal limit of the extraction companies' airspace. Mettler recalls his epiphany:

> So when I saw that footage...I thought, "Wow, this would make an amazing kind of film in its own right." And I proposed to Greenpeace that we do that and that I be allowed to make a film on my terms...and that it would not a typical Greenpeace-style film, but that interview footage that we shot could be a backup on the website.

The resulting forty-three-minute film, *Petropolis: Aerial Perspectives on the Alberta Tar Sands*,[109] became a landmark in filmic discourse about the resource. It blends documentary with a critical genre of environmental photography known as the "toxic sublime,"[110] epitomized in the work of Edward Burtynsky in exhibitions and books like *Burtynsky Oil* (2009),[111] and featured in a well-known film, *Manufactured Landscapes* (2006),[112] on which Mettler served as cinematographer. The toxic sublime "produces dissonance by simultaneously showing beauty and ugliness, the magnitude of the projects and the insignificance of humans...[and] questions the role of the individual in the toxic landscape while simultaneously eliciting the feelings of security and risk, power and powerlessness."[113]

In keeping with Mettler's experimental style, *Petropolis* is an extended aerial tour of the bit-sands region in conspicuously long shots, accompanied occasionally by onscreen text culled from work by Nikiforuk[114] and by a haunting, tonal soundscape with a rhythm suggesting a heartbeat, co-created by Mettler. That we can see the helicopter's shadow and hear it in the background reflects Mettler's aim to show that we are all implicated in the use of oil-fuelled technologies, even filmmakers who use it in helicopters, their cameras and so on.

The film opens on a fly-over of the Athabasca River, which winds through immense, green boreal forest. Eventually, extraction plants and

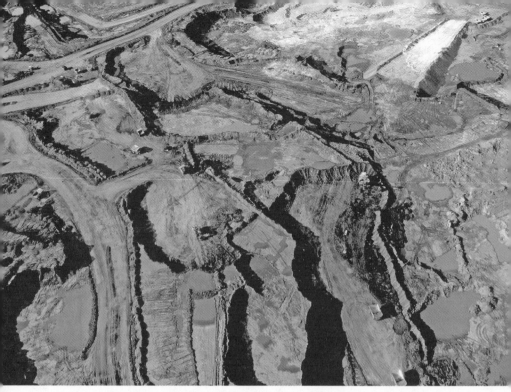

The bit-sands from the air, from Petropolis *(Mettler, 2009).*

[Photo by Eamon MacMahon/Greenpeace]

their fumes appear in the distance. We are flown over the Brobdingnagian bit-sands operations: mines and tailings lakes, plus the steam-assisted gravity drainage side, which Mettler notes "wasn't really possible to show because it's invisible, even though in some ways it hurts the environment more than the other processes." The camera follows the eerie, repetitive action of a bulldozer-style behemoth, scooping out bitumen-soaked sand and dumping it into the beds of a fleet of the world's largest trucks, which haul it away for separation. Finally, we see the aftermath of extraction: the eviscerated, seemingly endless, open-pit mines. The camera links air to ground by agilely zooming in and out.

Mettler originally planned to include voice-overs but cut them to a few onscreen titles so viewers could focus on relationships within the landscapes and the grand scale of extraction from the perspective of "a technological robot...run by three people in this helicopter, like two eyes in the sky." Beyond logistic and aesthetic factors leading to the aerial shoot,

a key factor was financial. As *Petropolis* "didn't really have a budget," more elaborate filming "would've meant a whole other level of strategy and fundraising and preparation to make the film."

In positioning Alberta's natural and industrial landscape in relation to the bit-sands, Mettler did not so much "have a blueprint ahead of time" as follow his artistic practice of "discovering the images I want to show as I'm making them." He resists the archetypical polarization of depicting "the evil corporations versus the environmentalists" and believes that we humans try to improve our lives with technology but don't understand its long-term implications. He illustrates this Frankenstein effect in closing, voice-over narration by citing the story of Karl Clark's horror at where his work had led—presented earlier in *Pay Dirt*[115]—and inviting us to ponder, "What will we do next?" This finale, even with its question read as an inquiry rather than an indictment,[116] coupled with the titles, help posit the film's frames as *health* and *present-minded*. On viewing the initial interviews, particularly those with residents of Fort Chipewyan— never included in the film but added to the film's DVD release and website—a critical reading can add the *greed*, *eco-justice* and *ecocide* frames. These are exemplified when Marie Adam, an elderly Aboriginal resident of Fort McMurray, remarks on the rampant destruction of water and air, and the cancers caused by the bit-sands, reminding us that "money can't be eaten."[117] Mettler sees the film "as a story about greed, the economy and the systems we have in place to run the show."

Petropolis premiered in Nyon, Switzerland, in April 2009, within a month of the launch of *An Open Door*,[118] the Alberta government's declared effort to pre-empt *Petropolis*'s producer, Greenpeace. Mettler's film travelled to many festivals domestically and abroad, enjoyed a domestic theatrical release, secured an American distributor and was televised by Europe R2 Television, a large broadcaster. It is released on DVD and downloadable on the iTunes music service. Mettler sees a synergy in making a film that would appeal not only to "Greenpeace people, the already converted," but also, because he is considered an art and documentary filmmaker, to "a whole different circuit of exhibition and festivals than anything that they ever made would because their films tend to be more agitprop."

Aided by sponsorship from Greenpeace (for the film) and the Oak Foundation, an international group of charities (for the webisodes), *Petropolis* bridges online, festival, cinema and home (TV, DVD) viewing audiences with singular breadth. With sparse titles, only a brief epilogue and no customary chorus of documentary talking heads, the film's predominant reliance on imagery stands to make it more portable globally than any other film in this study; in fact, more of my interviewees (five) mention it than any other work. Thus, *Petropolis* singularly positions Alberta as the site of humanity's mighty assault on nature in a spectacle that *The Guardian* called "beautifully apocalyptic."[119] Mettler's prior work in progress involving clouds was released later as a feature-length documentary, *The End of Time*.[120] Despite his original plan to include his footage of the bit-sands in that film, "*Petropolis* became, shall we say, so profound or defined in its own right that putting shots of it into the new film didn't make sense anymore; it just didn't feel right. I never ended up doing that."

H_2Oil (2009)

Two weeks after *Petropolis* debuted abroad, a seventy-six-minute documentary, H_2Oil,[121] premiered at Toronto's Hot Docs, the largest documentary-film festival in North America. The filmmaker, Shannon Walsh, was then a PHD student in education, based in Montréal. She had made a few short agitprop films by 2006, when two friends sought filmmakers to help probe the fate of their third-generation water business in Alberta. Contemplating a short advocacy piece on water, Walsh went west and "watched the diminution of their well with the camera and started seeing the effects of the tar sands. It was like walking into a film already being made."[122]

Her goal for H_2Oil became to "produce a tool for further movement building, to question the logic and trajectory of proceeding with the tar-sands project, and to slow it down and stop it." She sees the film as bringing "the indigenous struggle" to people and reducing racism, as "communities are all downstream [from the bit-sands] through the Athabasca River delta." She situates her film as "about real people, not

abstract impacts" and, echoing Radford's preservationist plea,[123] "built on the sounds and the images that are quickly diminishing in Alberta [...] not with nostalgia, but with hope, that we will attempt to make this place, and the people within it, come alive."[124]

Walsh draws on diverse documentary styles. TV images provide geopolitical context, such as then-PM Harper waxing rhapsodic about the epic size of the bit-sands, which the narration states is "quickly becoming the largest industrialized project in human history, with a proposed fivefold increase in production." Aerial footage of open-pit mines and industrial activity show the scope. But the intimacy of the struggle against the project is illustrated via cinéma vérité. A handheld camera follows Walsh's friends to their water well and in their quest for answers from government authorities, and also Aboriginal residents in Fort Chipewyan, facing what one local leader calls genocide by government and industry. Emotional shots of her friends reacting to their nearly empty well (which she says inspired H_2Oil, after which they "all went home and cried") and of a young woman stricken by cancer (one of many unusual local health tragedies, summarized in a shot of a local graveyard), impress that the province has sold its soul for oil money.

Walsh also includes three short "Tar Sands 101"–style sequences because "in 2006, there was no knowledge of the tar sands back East." Characterized by inky spills seeping across maps and landscapes, these set the tone for later image makers in depicting the vast reach of the bit-sands through pipeline networks and ecological devastation, particularly of the fragile supply of fresh water. The animation also illustrates the prostitution of the nation's sovereignty under trade agreements designed to secure American energy needs without retaining a secure supply for Canadians.

Although the industrial apocalypse looms large in the film, Walsh also shows the natural landscape devastated by the accelerated extraction of the bit-sands.

> One thing I tried to show was that Alberta is so beautiful. Many in the
> East perceive that the oil patch is a desert....Alberta also has an image of
> ranching like the American Midwest, when in fact Alberta has one of the

largest freshwater deltas in the world, this giant sponge holding water in a lush forest and then releasing it gradually into the atmosphere. That's impossible to replace....It's not just a field that you can put some sweet-grass and a fucking couple of buffalos on (pardon my language), as government and industry would have us believe. I had to try to represent that in some way.

Ultimately, Walsh feels that the film is about "oil extraction versus water in stark opposition, water representing actual life and the world we live in, the trees, animals and air, versus something frivolous, greedy and expendable." She struggled with cutting her friends' story from the film, fearing that it distracted from her focus on the bit-sands. But she retained them as "Joe and Jane Everyone, average, Albertan White people" to whom viewers could relate and without whom audiences would discount the film "as another unfortunate contextualization of the deeply racist society in which we live, another unfortunate Aboriginal story." As in other documentary films on the bit-sands, the intimacy with which we meet Walsh's protagonists contrasts with our engagement with the oil interests, whom we see at a distance,[125] be it in news clips or personified by massive machinery. As in *Tar Sands*[126] and *Downstream*,[127] Alberta is characterized as a puppet of globalization in general and the United States in particular. Thus, the film employs *sellout, greed, eco-justice, health, present-minded* and *ecocide*, the full gamut of the most ecocentric frames.

The film had a theatrical release in Canada—no small achievement in a nation in which English-language filmmakers enjoy a minute portion of the theatrical distribution and box-office receipts[128]—and screenings at film festivals, community events and classrooms, as well as shorter, edited versions broadcast on Global TV and Télé-Québec.[129] Walsh is surprised at the minimal editorial interference that she encountered from broadcasters taking political sides on the bit-sands; she attributes this to the novelty of the topic in 2009. H_2Oil also has a DVD release. She cites industry blogs criticizing the film as "not providing the whole story" and agrees, noting the challenges of addressing the depth and complexity of details about the bit-sands in a film, and, as to balance, that "the industry's story is being told with million-dollar budgets." She wonders

whether H_2Oil would be more popular if it were less political, but she feels that it is "part of building a movement to oppose the tar sands," though ultimately it is up to citizens to "take up the call, mobilize communities to slow down the process and ensure that it's not just a green-light thing."

In considering the discourse related to Alberta and the bit-sands, Walsh observes, "I think that the propaganda machine of the Government of Alberta is such an important part of the story. Often, we are using the same images that they are. It's really about framing; that's an important part of the story and will be ongoing." In echoing George Lakoff's view that "reframing *is* social change,"[130] Walsh invokes the power of positioning (beyond the representation itself) in informing and potentially shaping public attitudes toward not only issues like exploiting the bit-sands but also toward those responsible for managing the project. As the government's rebranding video[131] shows, place branding and reputation management have assumed paramount importance in an age in which economic power has replaced military force as a means of maintaining and expanding empires.[132]

Land of Oil and Water (2009)

Land of Oil and Water: Aboriginal Voices on Life in the Oil Sands,[133] a forty-four-minute film, premiered at Vancouver's DOXA Documentary Film Festival in May 2009. It is the work of two University of Manitoba professors, Neil McArthur (philosophy), who is also a writer and film-maker, and acclaimed author Warren Cariou (Aboriginal literature). The $10,000 budget was self-financed out of a desire to proceed without waiting on funding applications.[134]

The film follows Cariou (from a family of mixed European and Métis heritage), who, on learning that Alberta-based oil companies are expanding into his native northern Saskatchewan, talks with Cree, Dene and Métis people about their hopes and fears around exploiting the bit-sands there. Then he travels to Fort McKay and Fort Chipewyan to learn of Alberta's experiences after three decades of development. The latter journey became the focus of a fifteen-minute extract from the film, released

separately as a short film, *Overburden*.[135] Curious and concerned about the resource's effect on Aboriginal communities, Cariou sensed "a vacuum in material addressing them visually" and a need "to show the scale of the project." Like his predecessors, he had not seen any documentaries on Alberta's bit-sands. His sense of corporate productions on the bit-sands is that they were "about giant machines and people were miniscule in comparison." Suspicious of development—on which Alberta "puts the pedal to the metal"—he always thought that Albertans' general silence on the oil companies' decades of free rein signalled acquiescence, lack of understanding, or oil being tied into so many people's livelihoods that "they can't step back and question it."

Cariou and McArthur sought to give voice to Aboriginal communities whose members were frustrated by unanswered pleas to stop the rising extraction devastating their health and culture. Yet they worried about whether or not locals would talk on film. They aimed to show, first, "the effect on 'real' people who are not apologizing for, or hugely benefitting from, the tar sands," as opposed to "a canned response...experts, Greenpeace etc." that were already served by news media, and second, the "contrast between the human stories and the...juggernaut going on around them"—a story of human dignity rather than of "another dysfunctional reserve." With Canada being "advertised internationally as a place where human rights are sacrosanct and we have pristine nature," the filmmakers "wanted to show an image that most people don't know about or want to think about."

> We used a [helicopter] fly-over...right into a smokestack. We showed all the machinery and smoke over the camera. We showed Syncrude and the operation...[in] that glow close to the beginning of darkness. There's a nature scene, the camera drops, then comes up again, very menacing. The opening and closing shots were of a fly on a spiderweb in the muskeg. The fly doesn't get stuck. We tucked in symbolism, our little bit of hope at the end that we can escape it all.

Pristine forest and marshland contrast with scarred earth, grey air and toxic sludge that was once water. The film connects viewers to

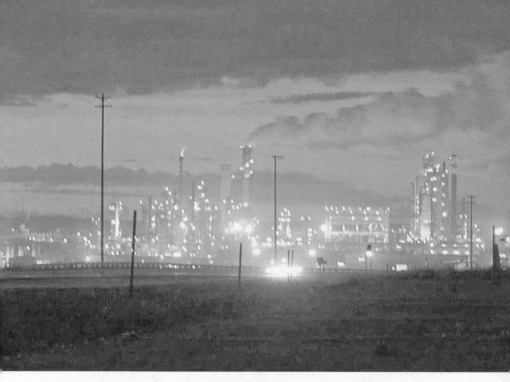

Syncrude sunset, from Land of Oil and Water *(McArthur and Cariou, 2009).*

[Photo by Ryan Herdman]

indigenous locals with diverse views on the bit-sands—for example, a couple of twenty-somethings praise the unlimited economic opportunities, but the Rezz Dawgz, a hip-hop/rap group providing the film's Spartan soundtrack, rap onscreen, "We used to love this land/ But we don't like what's left." One rapper, Blair Faichney, declares, "They've pretty much stripped our land and just fed everybody money to keep their mouths shut." Cariou likens resource extraction to cultural genocide and sees the locals "committed to place, unlike those who work there and live elsewhere or leave after five years" because "[p]lace is not interchangeable for indigenous people."

As in *Tar Sands*,[136] *Land of Oil and Water* presents Alberta as an unfettered colonial enterprise, Canada's own myopic, economic Manifest Destiny of individual enrichment, an infinite, unstoppable reservoir of cultural and ecological plunder. The film's unvarnished and unfailingly eloquent accounts of the Aboriginal communities' defenders, bracketed

by Cariou's sensitive narration, offer an intimacy contrasting sharply with more hard-hitting and better-financed productions. In considering the tensions between economy and environment at Fort Chipewyan, Cariou observes that nature "looked so beautiful and pristine, but it wasn't....The pristine and the tainted are separated, but both are constructs, fictions in a way." He sees "a double-natured identity of Alberta as a pristine, eco-tourist destination and a place where there is destruction." And yet, he states, "I wasn't thinking of presenting an alternate identity on Alberta, but the future of Saskatchewan in terms of the tar sands. I find it interesting that people responded to it as a commentary on Alberta identity."

Thus, the film uses the *eco-justice*, *health*, *greed* and *ecocide* frames, all of which are firmly on the ecocentric side of the spectrum. In its quiet way, the film makes its mark on the discourse with its singular focus on Aboriginal perspectives on the bit-sands. Aboriginal people are presented not simply as they have been portrayed in productions by the oil industry (happy entrepreneurs and employees) and concerned documentarians (victims), but as conflicted citizens on the front line, facing Alberta's massive and rampantly accelerating march of extraction. A teaching resource based on the film was sent to some two hundred schools in Ontario,[137] and Cariou reports that the film has been screened for more than 50,000 students.

Dirty Oil (2009)

In October 2009, Hollywood filmmaker Leslie Iwerks premiered *Dirty Oil*,[138] the seventy-five-minute, expanded version of her earlier, short documentary, *Downstream*,[139] at the Hamptons International Film Festival in New York. While retaining the story of Dr. O'Connor at Fort Chipewyan featured in *Downstream*, *Dirty Oil* also zooms out to examine the role and effect of oil in American society. Beyond footage of increasingly familiar razed forests, open-pit mines and toxic tailings lakes are shots of American presidents, Midwestern refineries, Arab insurgents, Shanghai, calving glaciers, wind turbines, multinational oil-company headquarters and aerials of Earth itself. The bit-sands' global connections and contributions

to poisoned air and water, increased diseases, melting glaciers, rising sea levels, displaced populations, lost fresh water and other horrors are juxtaposed with the genocidal and biocidal effects on Aboriginal populations in Fort Chipewyan and Fort McKay, as recounted by residents.

As in the *60 Minutes* segment,[140] Alberta and especially Fort McMurray are positioned as the world's final frontier for profitable oil extraction, a gold-rush place in which companies reap massive profits, novices can earn six-figure incomes and people are literally dwarfed by the bit-sands and the attendant technologies like the iconic yellow truck. In response, CAPP's vice-president of markets and oil sands, Greg Stringham, expresses his faith in technological improvements to bit-sands operations (the *progress* frame), while scientists David Schindler and Kevin Timoney, and Alberta's Greenpeace rep, detail the ecological devastation caused by extraction.[141] Alberta's then-minister of energy, Mel Knight, declares that Alberta's environmental standards and legislation "lead the world," but he adds that the problem is that this is not communicated well because "it's not flashy or sexy" (the *green* and *denial* frames). As Timoney and writer Andrew Nikiforuk point out, Alberta's laws are rarely enforced, and the monitoring of air and water quality by government and industry is both secretive and suspect. These statements are reinforced by testimony from locals about deformed fish and undrinkable water, and from Dr. O'Connor, whose story graced *Downstream*.

Dirty Oil incorporates elements of most of the productions noted so far: the global and longer-term perspectives of *Pay Dirt*[142] and *Tar Sands*,[143] the ecological conscience of David Suzuki's CBC programs,[144] the intimacy and educational function of *H₂Oil*,[145] the aerials of *Petropolis*[146] and the Aboriginal perspective in *Land of Oil and Water*.[147] In the hands of a well-known, independent American filmmaker with authority and resources to produce and distribute a major film, the overarching portrait of Alberta that emerges is, as Henry Henderson, the regional director of the Natural Resources Defense Council, puts it in *Dirty Oil*, an exemplar of a place where you get:

> Big people picking on small people and assuming they can get away with it, taking what is others' and turning it to their own ends as if they are

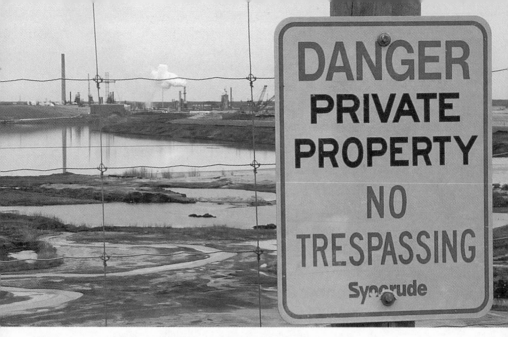

Danger sign, from Dirty Oil *(Iwerks, 2009). [Photo by Leslie Iwerks]*

blessed...It is bullying at the worst level, it puts people who cannot protect themselves in harm's way and that's maddening.[148]

Iwerks sees Alberta as a site for bullying by Big Oil as a key theme of her film. A British review notes the film's exposing corporate bullying, as well as the poisoning of Aboriginal communities, in Alberta in extracting the bit-sands.[149] Referencing Iwerks's main target audience, Nikiforuk muses in the film that rising American resistance to Alberta's "dirty" oil "might actually get us to clean up." Ironically, Alberta is presented as in need of saving from itself—by the principal customers for its bitumen!

Thus, the film deploys the *rogue, greed, eco-justice, health, present-minded* and *ecocide* frames. Iwerks's cinematic sortie illustrates the documentarian's challenge to get different perspectives on controversial issues like the bit-sands. After noting her difficulties in accessing bit-sands operations and sources involved in extraction—difficulties not as evident as when Palmer made *Pay Dirt* in 2005 and also noted by Mettler and Walsh in making their films—Iwerks states:

I might have...my own point of view, but I try and at least bring both sides of the story to the public and let them decide for themselves what they want to believe....So it was fascinating to hear the information that seems so researched on the science and environmental side, versus the regurgitated facts that came from the government and the industry side. Every fact that was spewed out on the government's side was completely torn apart by the other side. There was so much information it was hard to distil it all...[150]

The film's profile was raised with support from Babelgum (the British Internet TV service that commissioned *Dirty Oil* as its first feature), the US-based Natural Resources Defense Council, and the Co-operative Group, a clean-energy consortium working with the World Wildlife Fund. It also found viewers due to the media spotlight on Iwerks's earlier film, *Downstream* (incorporated into *Dirty Oil*), being shortlisted at the 2009 Oscars, and also by the brief brouhaha when Lindsay Blackett, then Alberta's culture minister, mused about withholding government funding from films not portraying the province positively.[151] As the longest work studied to this point and embracing the full gamut of moralistic and transformational frames, the film can be seen as a consolidation of filmic dissent on the bit-sands in late 2009.

CONTEXT III: COP15 and the European Problem (2009)

Growing resistance to the bit-sands coincided with the run-up to the United Nations' Climate Change Conference in Copenhagen in December 2009, attended by 115 leaders, with over 40,000 representatives of governments, NGOs, faith-based groups, media and other agencies applying for accreditation.[152] COP15, the fifteenth session of the Conference of the Parties serving as the Meeting of the Parties to the Kyoto Protocol, continued work begun under the protocol in 1997. Although the ensuing Copenhagen Accord failed to establish a binding consensus on reducing anthropogenic greenhouse gases to replace Kyoto,[153] it did spotlight climate-change issues in the public sphere and consequently may be seen as a further impetus for scrutinizing major industrial projects like

the bit-sands. This was evidenced by a media study by the Canada West Foundation showing a 45 per cent surge in coverage of the project from November to December 2009.[154] The study noted attendance at COP15 "not just by world leaders but by all manner of environmental organizations and militants," and attributed the spike in coverage to "protests by these groups and accusations against the oil sands from government figures, Canadian and otherwise," leading to "environmental stories rather than economic, the vast majority of which were negative."[155] In positioning media attention to ecocentric considerations as at the expense of the economic significance of the bit-sands, the study adopted the *money* frame.

Around the time of COP15, the Canadian government initiated a strategy to combat the "growing reputational problem, with the oil sands defining the Canadian brand," as noted by Canadian diplomat Sushma Gera, who was based in London.[156] This followed developments such as the EU's Fuel Quality Directive aimed at reducing greenhouse-gas emissions; EU-funded research indicating that bit-sands crude was as much as 22 per cent more carbon-intensive than other fuels; and rising pressure from groups like Greenpeace and the Indigenous Environmental Network to compel major companies like Norway's Statoil to pull out of bit-sands operations in Europe. Consequently, the Government of Canada struck a secret "Oil Sands Team," mandated "to reframe the European debate on oil sands in a manner that protects and advances Canadian interests related to the oil sands and broader Canadian interests in Europe." This campaign included monitoring environmental groups; responding to media items protesting the bit-sands; threatening litigation at the World Trade Organization; cooperating more closely with European oil-company executives (including regular meetings with then–Prime Minister Harper and federal and Albertan cabinet ministers); and vigorously lobbying members of the EU Parliament to a point that one legislator deemed unacceptable.[157]

As in Alberta, federal proponents of the bit-sands viewed their primary problem as one of public relations rather than environmental protection.

The stage was set for the oil industry's response through its official voice, the Canadian Association of Petroleum Producers (CAPP). CAPP's member companies produce some 90 per cent of Canada's natural gas and crude oil. Based in Calgary, CAPP exists "to enhance the economic sustainability of the Canadian upstream petroleum industry in a safe and environmentally and socially responsible manner, through constructive engagement and communication with governments, the public and stakeholders in the communities in which we operate."[158] Reflecting a cultural shift from members' concentration in engineering and accounting, by 2012, CAPP's first media-relations hire, Travis Davies, was working on a team of seventeen that served as an internal PR agency. He sees "an intimate relationship between Albertans and the energy industry."[159]

CAPP launched a video campaign to expand its media channels and, in Davies's words, "to build credibility and ensure that all our facts are correct." Following industry practice, CAPP issued a national call for proposals and hired a Toronto agency to produce the videos. In January 2010, CAPP launched its online video campaign with *Canada's Oil Sands: Come See for Yourself* (2010), the sixteen-minute flagship for a series of shorter pieces for different audiences. As Davies observes, these videos "focus on real people in the industry, shooting workers in their natural work environments" and are unscripted to lend "authenticity and an air of credibility." He further notes, "We needed to do it differently, especially for an industry with low credibility; people do not trust us." CAPP "stepped outside the box to make the film, based on research targeted to a specific audience and a specific key message." Perceiving that public discourse on the bit-sands was "polarized in the media," CAPP's approach was surgically focused. As Davies recalls:

> We sought the soft, moderate audience, not necessarily landing on a hard position on the oil sands, one on the periphery and not creating all this noise. To be perfectly specific, we were looking for women aged thirty to fifty-five in urban centres and outside Alberta, as well as influencers: people who are politically active, write letters to the editor and so on.

Canada's Oil Sands is a primer premised on the world's need for "lots" and "secure, responsible supplies" of energy, "developed in the most environmentally responsible and sustainable way that we can," with "Canada's oil sands...uniquely situated to play an increasingly important role." In choosing imagery, Davies says that CAPP sought to show that "smart, passionate people work in the oil sands" and that they "care about the environment" and their work. The video was "less about place and more about the people working there."

Mining is presented in closer, tighter shots relative to the expansive aerials in the critical documentary films, suggesting a process that is carefully managed, thoroughly regulated and scrupulously monitored. We see technology as the solution to reducing greenhouse-gas emissions and the industry's colossal use of water. The newer process of bitumen extraction, steam-assisted gravity drainage, is illustrated in an animation without reference to its more intensive use of energy and its risks to aquifers. The tailings lakes look blue, their toxicity invisible. Talk of land reclamation accompanies footage of lush-looking muskeg and bison. We see flowing rivers and trees aplenty. Fort McMurray appears wholesome, with a family relaxing in a park, cyclists, Ski-Doos, a college, and so on. (An earlier video by CAPP, *A Side of Fort McMurray You Haven't Seen*,[160] includes visuals of a theatre, truckers and a mosque.) A Syncrude VP stresses the company's extensive consultations with every affected Aboriginal community, and a suited Aboriginal man says bitumen companies "wholeheartedly support" Aboriginal-owned businesses.

The bit-sands are described as not merely Albertan but Canadian, with major economic benefits to manufacturing in Ontario and Québec. The video closes with shots of the White House, other US landmarks and the Calgary-based US consul general's observation that "Canada is among the US's safest, most reliable and most significant trading partners," emphasizing the American concern for "national energy security." Citing Canada deviates from the Alberta government's previous messaging tactic, omitting Canada from its discourse of provincehood at the Smithsonian Folklife Festival in 2006. However, it does underscore the undisputed importance to both government and industry of swaying American public opinion to support importing bitumen and building

more pipelines to accelerate that, in the interests of "security." Davies situates CAPP's approach in the following way:

> Our long-term strategy began in a climate of anger and distrust. Our first step was to acknowledge people's concern, take a bit of a beating, say our mea culpas and listen to their anger, following the risk-communication model. At some point, people ask you to talk. We wanted to show that we are accountable and happy to share that data.
>
> We would do the video differently today because we're in a different spot now....Our polling shows that people are aware that CAPP is working on the environment, but the fact that our economic footprint falls across the country is less well-known. [Today, we would include] less fact and more emotion. We would add that emotion and attach it to people and their passion.
>
> Where we were not successful, we tried to fight emotion with fact. Now we use real people, focusing on increasing the base of understanding and instilling a sense of pride in developing our natural resources and a sense of values around the production of resources. We would focus on the environment and the economic benefits to Canada, the US and globally.

Davies observes that social media have become very important in public communications. This was proven with the Alberta government's rebranding slideshow, *An Open Door*, when the Public Affairs Bureau's failure to act quickly on public social-media messaging about its using a non-Albertan image helped to sink the rebranding.[161] Davies adds that attaching video assets to campaigns facilitates forwarding them to others. As of mid-2016, Part 1 of *Canada's Oil Sands* had logged almost 67,000 views, 159 likes and 262 dislikes on YouTube, while Part 2 recorded over 13,600 views, 57 likes and 46 dislikes; this does not include viewings on CAPP's own website, where numbers are not displayed.

In positioning Alberta as a friendly, stable and environmentally responsible neighbour, producer and supplier of oil, the video epitomizes the use of the anthropocentric *ethical oil, money, progress, status quo* and *bridging* frames by those standing to gain financially from

fast-tracking extraction. The video marks a key shift in imagery around the bit-sands, away from privileging mighty machinery—a trend cited by Warren Cariou—to featuring people who run it.

Rethink Alberta (2010)

Six months after CAPP's video launch, Corporate Ethics International (CEI) unleashed its short but explosive video, *Rethink Alberta*,[162] online and a parallel billboard campaign in four American cities and London, England. Founded by "many top environmental and environmental health markets campaigners from the US, Europe, and Canada," the US-based group aimed "to bring corporations back in service to and under the control of the citizenry"[163] and improve business ethics. Its first campaign is said to have led to Wal-Mart's adopting a major sustainability initiative,[164] and in 2008, CEI launched an environmental campaign against the bit-sands, which CEI calls "the poster child for why the US needs to end its addiction to oil."[165] This responded to "pro-oil sands lobbying and advertising in the United States by the Alberta government and the province's oil industry,"[166] epitomized by a $55,800 full-page ad in the *Washington Post* bought by the province two weeks earlier, after that newspaper rejected it as an op-ed piece.[167]

Rethink Alberta opens on classic tourist images of Alberta—wildlife, mountains, lakes, wheat and cowboys—with narrated, rhapsodic prose like "There's a place where snow-capped mountains kiss golden sunsets." Then comes the challenge, "Think you know Alberta? Think again." An image of a deer in nature morphs into quick shots of stripped boreal forest, open-pit mining, toxic waste pouring into a tailings lake and smokestacks spewing bilge, repeating and ending on heart-wrenching photos of dead ducks trapped in oily sludge, invoking that notorious incident in 2008.

Although *Rethink Alberta* invites viewers considering visiting the province to "think again" because of its mismanagement of the bit-sands, CEI's then-executive director suggested that the video was not aimed at tourism (being released in mid-summer, when most travel plans have already been made), fixing its true message as urging the

Alberta government to "stop the public relations and start the dialogue on how to manage the oil sands."[168] The executive director defined the twin needs of a successful boycott as both visibility beyond Alberta and a targeted constituency inside it:

> [Albertans] resented the campaign, but they were paying more attention to the string of bad news that emerged after the boycott...[which] because of its perceive[d] "extreme position" actually created space for moderate politicians and media voices to call for reforms. Government and oil companies were forced to acknowledge the veracity of the criticism.[169]

As for the ninety-eight-second video's potential impact on tourism, one survey revealed that the number of Britons and Americans who considered visiting Alberta (54 per cent of Britons and 49 per cent of Americans) fell by about half after viewing the *Rethink Alberta* video; the stakes are substantial, with 828,000 American visitors spending $583 million and 229,000 Britons spending $260 million in Alberta in 2008.[170]

As of mid-2016, the video had over 104,000 viewings on YouTube (plus another 14,000 of the British version), with several hundred diverse comments, 181 likes and 239 dislikes—compared to 4,716 viewings of the Alberta government's rebranding video before its withdrawal from the site. The high number of viewings of *Rethink Alberta* (all but about 1,500 of which occurred within three years of its launch in July 2010) speaks to the ongoing power of online advocacy. It may also indicate the passion aroused by social dissent, given that within that initial three-year period, the video received almost three times as many viewings on YouTube as did CAPP's defence of the industry, *Canada's Oil Sands* (2010). However, that gap has since narrowed, likely due to ongoing advocacy from CAPP, a powerful industry organization, and silence from CEI, whose web page had disappeared, although its video remains online, as of this writing.

Whatever its effect on tourism, *Rethink Alberta* remains a direct broadside in the visual positioning of Alberta around the bit-sands. Its perversion of Alberta's traditional imagery and use of the moralist *rogue*, *eco-justice* and *health* frames ride the rising tide of concerns expressed

about the province's record on the environment, human rights and Aboriginal issues.

"Alberta. Tell It Like It Is" Campaign (2010)

In September 2010, two months after *Rethink Alberta*'s release, the province launched a video campaign as part of its "Alberta. Tell It Like It Is" campaign, which had begun that June. Unlike its earlier rebranding effort, *An Open Door*,[171] the nine new videos, fronted by *About the Oil Sands*,[172] directly address the bit-sands and the province's management of resource extraction. As one of its creators, an Alberta government employee, explains:

It wasn't just the video landscape, but the whole atmosphere of what was said about Alberta in 2009–2010. There were lots of demonstrations, activists, etc. and it all came to a head when *Avatar* came out and people said Mordor was like the oil sands.[173] ...We got a lot of comments from Albertans who were deeply insulted and wanted to defend themselves, not just about the oil sands but over our reputation as Albertans, which was on the line. Research backs this up, but personally, as an Albertan, I was offended. That's not what Alberta is like....International stakeholders— trade and investment partners—were affected by all of this media talk and activist activity.

...We had seen videos showing the oil sands in a bad light, and that wasn't the whole story. We wanted to show the good work being done up there: reclamation, Aboriginal employment, that's part of the background. It's also innovative and monumental to discover the oil sands in the 1920s and develop them to what they are now. If you listen to the naysayers, you would think that Alberta is one massive mine. We wanted to show a more balanced view. People were reacting to the totality, the buildup of [video] stuff, *Dirty Oil* [(Iwerks 2009)] with an American actress [Neve Campbell, who is Canadian] as host, Lush cosmetics and Walgreen [respectively, large British and American retailers] suggesting a boycott of Alberta oil, the "Rethink Alberta" campaign suggesting that people not visit Alberta because it's one big tar-sands mine. But the oil sands is just a tiny section

of Alberta up in the northeast corner, although you would get a contrary impression because the activists' voices are louder. So then CAPP got involved, then the Government of Alberta got into reputation management, of which the videos are a part.[174]

About the Oil Sands was filmed in a month and filled out with stock footage. Other "Tell It Like It Is" videos cover air, water, biodiversity, site reclamation, Aboriginal workers, life in Fort McMurray, and research on the bit-sands and carbon capture and storage. The visual strategy of the campaign and its flagship video was:

> We wanted to stay with the people. The usual big equipment is shown so much that it is become an iconic image of the oil sands, the great, big truck with the great, big wheels in the great, big mine. We wanted to show a lot of highly educated, highly competent people working in the oil sands, not a faceless, big, black thing with machines all over it...

Albertans are depicted as calm, matter-of-fact and proud of their work in the bit-sands, their responsible management and the technology that they feel will continue to improve the efficiency of production and its ecological impact. For example, in *About the Oil Sands*, a brief aerial shot of a tailings lake, admitted by an onscreen narrator, a government employee, to be "an ugly eyesore," is followed by citing the "fantastic... great progress" on shortening the lifecycle of those lakes, over footage of reclaimed muskeg and nature. The focus of extraction is said to be shifting to in-situ steam-assisted gravity drainage, which is presented as less harmful environmentally than open-pit mining—a claim contested outside of government and industry.[175] The calmness of the narrators, the slower-paced editing and the lower-key background music offer a softer presentation than most of the works studied here. The overriding ethic of the videos is captured by one of its creators:

> Albertans are optimistic, forward-thinking and modern. They're the kind of people who want to keep Alberta beautiful, not just look but keep and improve our good quality of life in everything Alberta does. This is

perceived as arrogant by some. But it's a reaction to caring about what people think about us on the international stage. We want people to come here and see Alberta is a great place. We're always working to keep improving things.

...Albertans are certainly working to make these things right. We're the most regulated place in the world, it's been said, in terms of making sure that things are done to keep things in check so it doesn't ruin the environment and make things unsafe. There is a federal and provincial system to monitor the air and water quality and make it the best in the world.[176]

As well as online, the videos were presented at conferences and tradeshows, and given to visitors touring the bit-sands, accompanied by an e-card campaign and fact sheet, and even an ad in New York's Times Square. *About the Oil Sands* logged over 34,600 viewings, 41 likes and 32 dislikes on YouTube as of mid-2016, and a similar but longer video, *Alberta Oil Sands: About,*[177] was posted on YouTube by the province in June 2010, receiving almost 87,000 viewings, with the (dis)likes tracker disabled. These numbers do not reflect any viewings from the government's own websites.

Exuding initiative, optimism and a restrained confidence and pride in both place and resource extraction, buttressed by the rationality of science and technology, the government's positioning of the province and the bit-sands deploys the anthropocentric frames of *money, progress* and particularly *status quo* to suggest that all is in hand on the project. In moving to a softer approach, *About the Oil Sands* and its ancillary videos follow the strategy, tone and content of CAPP's video work: they humanize the bit-sands by focusing on people rather than on the industrial apparratus (to which critics might add "power relations" and "injustices") that they serve.

Tipping Point: The Age of the Oil Sands (2011)

In January 2011, the CBC re-entered the fray with the most ambitious production undertaken on the bit-sands to date with *Tipping Point: The Age of the Oil Sands.*[178] The ninety-minute film was co-directed

by Alberta's preeminent documentarian, Tom Radford, and Niobe Thompson, an Alberta-based filmmaker whose training includes post-doctoral work in anthropology while co-producing *Tar Sands*[179] with Radford for an earlier episode of CBC's *The Nature of Things*. Thompson surveys the filmic discourse as follows:

> Except for *Pay Dirt*, which positively depicts the engineering challenges of the tar sands, the rest of the films were negative in terms of the effects of development. The filmmakers' intent was to produce a polemic, as in H_2Oil. Including [Athabasca Chipewyan] Chief Allan Adam, David Schindler, Andrew Nikiforuk, emotional sound design, speed-ramps on the tar sands and gritty colour correction show an intent to achieve an effect on the viewer, which succeeded. It's not dishonest to make a film seen as an attack on the tar sands. But if you didn't know differently, it would be astonishing that Albertans would make such a Faustian pact. I have a more nuanced view as an Albertan because oil money funds our films! I have a sense of outrage as an Albertan. Very few of those films are by Albertans, only *Pay Dirt*...[180]

Thompson notes that the world of feature documentaries is "incredibly crowded" and that securing funding to produce them has become increasingly difficult, although, paradoxically, public interest in such films has never been greater. Echoing the shift noted as early as the 60 *Minutes* segment,[181] he sees much more knowledge about and interest in the bit-sands between Radford and his pitching *Tar Sands* in 2006 and *Tipping Point* in 2009 to international broadcasters and film festivals. He believes that the CBC's decision to proceed was probably because the filmmakers were Albertans and the work would feature Albertan voices. David Suzuki, the host of CBC's *The Nature of Things*, wished to do a film on the bit-sands. So the public broadcaster turned Radford and Thompson's proposed one-hour documentary on water and on bitumen extraction—inspired by David Schindler's research into the source of rare cancers in Fort Chipewyan—into a two-hour special airing in the combined time slots of *The Nature of Things* and *Doc Zone*.

Thus, *Tipping Point* became a rare opportunity, made with a $1.2-million budget (huge for a Canadian documentary) that allowed the filmmakers to spend a year deeply following Dr. Schindler's scientific research and the fear and anger in Fort Chipewyan—far longer than the "quick and dirty snapshot" afforded by Iwerks's prior, short "'j'accuse!' movie," *Downstream*.[182] This is interwoven with a parallel story, the fight to stop the killing effects of the bit-sands undertaken by François Paulette, a pioneering advocate for Aboriginal rights in a Canadian Supreme Court case in 1976.[183] His fight includes enlisting the support, on camera, of Canadian-born filmmaker and Hollywood box-office champion James Cameron, whose then-recent, environment-themed blockbuster, *Avatar*, Paulette and others liken to what bitumen extraction is doing to Fort Chipewyan. Radford explains the filmmakers' motivation:

> We made *Tipping Point* because we felt that if we can't have a dialogue on the oil sands, where can you start? It's not even dialogue in Alberta, where everyone drives big vehicles and is unconnected to what's happening to the planet. In Alberta, global warming is viewed as a positive, giving us a few extra days on the golf course each year.

In choosing imagery, Radford and Thompson focused on "images of scale"—a documentarian practice dating back to *Pay Dirt*[184]—because "most people don't understand how big the sacrifice zone, to use Schindler's term, is," states Radford. He views the boreal forest as "the lungs of the planet" and sought to "find a language for that." So *Tipping Point* provides helicopter shots of huge flocks of snow geese, ecological systems and the mines for which they are sacrificed. On a more intimate scale, the filmmakers sought to show the human costs of extraction, memorably exemplified in a living-room scene in Fort Chipewyan, in which a family gathers around a wall of photos and tearfully points out local cancer victims.

Tipping Point premiered to 580,000 viewers on the CBC, and more than one million Canadians have seen it on rebroadcasts, reports Thompson; the film is also freely available on the CBC's website and for sale on DVD as *Tipping Point: The End of Oil*.[185] "We have to make our

peace with Canadian Tire ads," he says, observing that television is still the best way to draw a big audience in a world of media fragmentation. "It's imperfect, but we do reach people."

Radford notes an apparent divide between those who wanted a discourse on the bit-sands and those who saw the film as an attack on who Albertans are.

The film was reviewed favourably in entertainment and scientific journals, and also by a scholar.[186] It is seen as the leading film on point by some of the independent filmmakers interviewed for this study,[187] one of whom, David Lavallee, notes:

[I]t is the best film on the tar sands because it got the big picture and captured key moments really well...The filmmakers had an intuitive sense that something was about to happen and managed to be there to capture it, as was the case with James Cameron's visit to Alberta...one Aboriginal man in the film tells him, "That movie you made [*Avatar*], that's about my life"...[and] catching Alberta's environment minister, Rob Renner, in a lie when journalists confronted him with Schindler's report refuting Renner's denials of any studies documenting toxins in the Athabasca River.

Thompson notes many positive letters published in the *Toronto Star*, *Montreal Gazette* and *Edmonton Journal*. The CBC's online comment space recorded eighty-four posts from January 14, 2011, to April 8, 2012, expressing divergent perspectives, with recurring themes being environmental concern and anti-development bias; a large majority of responses to these posts (indicated by counts of "agree" and "disagree" clicks) noticeably favour the environmental priority, which may (not) reflect the preferences of the CBC's audience generally.

However, the oil industry[188] and the business press[189] contested the *science* in the film. A national newspaper review opined that the film was insufficient to cover a very complex issue.[190] The *Calgary Sun* disparaged "the Toronto filmmakers who made *Tipping Point* and don't understand Alberta."[191] Two other singular attacks on the film occurred. First came a letter-writing campaign from what appeared to be the province's grassroots, as Thompson recalls:

Very soon after the broadcast, the predictable complaints born of Alberta's persecution complex started, and we faced a huge job defending the film's credibility. I suspect that the Public Affairs Bureau, CAPP and the PR departments of the oil companies marshalled the campaign of aggrieved Albertans against the CBC for broadcasting "two hours of fabricated lies." I say this because the letter-writing was so prolific and the arguments unchanging, consistent and the same as those made by the large PR companies, the PAB and CAPP.

Second came a formal complaint to the CBC alleging that *Tipping Point* was biased in its treatment of the bit-sands. In dismissing the complaint, the CBC's ombudsman wrote:

> While there are bound to be hard feelings...in the struggle over the destiny of the Albertan oil sands, a documentary that raises awareness of the need for stronger programs to monitor environmental effects is not an act of hostility or an attempt to denigrate those who favour the project. Done well, it is an act for the common good.[192]

"We got a glowing review, but it consumed vast amounts of time," reports Thompson. "I'm sure that was a victory for our critics. Then came three-year funding cuts to the CBC. I can't imagine that a film like *Tipping Point* didn't play a role in that."[193] Regarding the complainant to the CBC, he states, "Neither of us have any evidence on the matter, but the nature of her correspondence [her language and its recurrence in other "grassroots" complaints] convinced us and our co-producers at CBC that she was a mouthpiece for a coordinated, corporate program to dismantle the documentary after the fact." This view is bolstered the complainant's ties to at least two groups denying the harmful effects of human-caused greenhouse-gas emissions.[194]

Tipping Point played the environmental film festival circuit, community screenings and through the Natural Resources Defense Council; Al Jazeera re-versioned it for its *Witness* strand, and 133 nations saw it broadcast as *Until the Last Drop*; and it also played in Norway, Japan, and

other nations. However, the film did not meet its creators' hopes of selection in leading documentary festivals such as the International Documentary Film Festival Amsterdam, for which the CBC's preference for narrated stories is what Thompson calls "the kiss of death" in an era of auteur documentaries exemplified by Michael Moore. As Radford explains:

> We can't do this with the oil sands because it's part of larger issues from First-Nation rights, to the poisoning of rivers and the responsibility of science in our society, to peak oil. The interests there are bigger issues, so *Tipping Point* had to be a larger narration, a Griersonian film,[195] but by definition kind of old-fashioned now.

Nor was even distribution in Alberta a given.

> It's frightening because there is no *Tipping Point* at Albertan film festivals; silence seems to be the preferred option. It's fine for movies about oil in Burma and Ecuador, but the oil sands are a little too close to home. Where do film festivals get their money? Oil companies or those who work for them. It's a closed loop. In the last fifteen years, there is no way to get a film [like this] originated in Alberta. There is no *Tipping Point* without *The Nature of Things*.

Read alongside Matt Palmer's observation about the difficulty of exhibiting films that portray the sands *positively*, these remarks point to frustrations with distribution apparently shared among filmmakers, even at the professional level.

The film's sweeping, unflinching depiction of Alberta and the bit-sands uses the gamut of moralistic and transformational frames: *sellout*, *rogue*, *greed*, *eco-justice*, *health*, *present-minded* and *ecocide*. Its online and international dissemination may make it the most widely seen, and the most comprehensive, production on the bit-sands to date, even if its critical, even frightening, portrayal of the province is largely unwelcome at home.

White Water, Black Gold (2011)

Popularly perceived as more environmentally friendly than Alberta, neighbouring British Columbia boasts several filmmakers who released documentaries related to the bit-sands in 2011. The first of three examined here, premiering that March, is *White Water, Black Gold: A Nation's Water in Peril*,[196] a sixty-four-minute investigative, point-of-view film by David Lavallee, a Rocky Mountain hiking guide and environmental activist with an MA in psychology. Born in Alberta, then-recently fled to BC and inspired to make films by *An Inconvenient Truth*[197] and *Tar Sands*,[198] Lavallee shares his sense of the discourse on Alberta and the bit-sands:

> The tar sands have earned us an international reputation, and these documentary films are probably part of earning Alberta that reputation....In the petrodollar province of Alberta...the government is more beholden to oil companies, which is where its money comes from. The government is not taxing its people. This is why it's exceptionally hard in Alberta: it's not just the caribou but democracy that's in peril....Stifling dissent is like dictatorship. We're not there yet, but we are on the slippery slope.[199]

He adds that *White Water, Black Gold* aims to "kick-start a national conversation on the tar sands [that] pipelines are forcing us to start" because they affect an element essential to life. The film follows the filmmaker's three-year journey to investigate the bit-sands' profound threat to half of Canada's water. The quest begins with Lavallee's climb to the high point from which water flows into the Atlantic, Pacific and Arctic Oceans, and proceeds by canoe along the Athabasca River to the bit-sands, up to Fort Chipewyan, then through ecologically sensitive areas of the British Columbia coast and ending at the port of Kitimat, BC, terminus of Calgary-based Enbridge's proposed Northern Gateway Pipeline.

One glaciologist shows how glaciers are "almost being decapitated" while another observes the irony in extraction companies contributing to depleting the glaciers on which they depend for their operations. Drs. Timoney and Schindler explain the science of toxic tailings lakes, and

members of the Mikisew Cree First Nation share how they are being poisoned by the water on which their traditional livelihood has depended for millennia. In an emotional scene at a community meeting in Fort Chipewyan, local residents pillory three Suncor representatives for the company's polluting the Athabasca River and not telling anyone. Alberta's attitude to indigenous people and others downstream or offside of development is aptly captured when one Suncor rep apologizes for the company's not meeting earlier, noting that the locals actually came out ahead because this time take-out fried chicken was served. At the National Energy Board's hearing on the proposed pipeline in Kitimat, one Aboriginal resident states, "Two hundred days of the year, we're going to wake up in the morning, wondering if this is the day our community dies. Does any company have the right to make us live this way?"

The harshness of extraction's effects and the callousness of extraction companies is juxtaposed with views of nature during Lavallee's journey, accompanied by acoustic guitar music and sweet voices. His silently gliding canoe is met by the ominous, belching smokestacks of an extraction plant. Contrasting images of purity and destruction are reinforced by counterpoint editing. The film ends with a montage of kayakers, backpackers, spewing toxins, bitumen plants, glacial recession, pipelines and gutted adjoining land, refinery row, contaminated and deformed fish, an eagle, a bear, a whale, healthy fish, flowing water, beautiful vistas and mountain panoramas, smokestacks and toxic sludge spewing into tailings lakes. In reasserting his theme, Lavallee's narration quotes American naturalist John Muir: "When we try to pick out anything by itself, we find it hitched to everything else in the Universe."[200]

White Water, Black Gold has screened at dozens of public events across Canada and in the United States. A CBC podcast and a Canadian TV premiere on TVO occurred in 2012. It uses the now-familiar moralist (*rogue, sellout, greed, eco-justice* and *health*) and transformational (*present-minded*) frames. However, it extends the discourse by tracking the bit-sands' effects beyond Alberta to emphasize the interconnectedness of all life, an ecocentric theme that flows through Lavallee's story like the water in its title. While other films emphasize Alberta's ties to global economic forces (notably the US) as an opportunity and/or a problem,

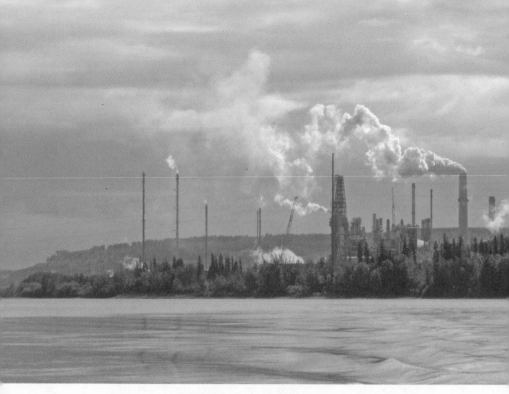

A bit-sands plant on the Athabasca River, from White Water, Black Gold *(Lavallee, 2011). [Photo by David Lavallee]*

this one links the province to ecosystems and communities through neighbouring BC to the Pacific Ocean, emphasizing Alberta's responsibility to the world and its perilous failure to meet it.

Peace Out (2011)

The second in BC's filmic trilogy addressing the bit-sands in 2011 premiered that October: *Peace Out*[201] by Charles Wilkinson, who left his native Calgary decades ago to escape its "honkytonk, temporary-worker mentality."[202] His credits include more than two dozen feature films, documentaries, TV movies and episodic TV programs in Canada and the United States, and a book, *The Working Film Director*.[203] He understands popular portrayals of Calgary as "Texas without capital punishment—yet," but observes that "as a mass medium, film is the second most expensive art form after architecture," which "tends to cause film to

make sweeping generalizations and go to drama whenever possible."
Here he points to Fort McMurray, where "You'll find far more happiness
in the suburbs than crack downtown, yet the media report 'Fort Crack.'"
Similarly, he finds bitumen-industry workers more worldly, informed
and conflicted than the "bullish cowboys" that stand in for them in the
media. As for Albertans:

> I sincerely sense that the vast majority of Albertans care deeply about
> their legacy. But they are bombarded cleverly by 24/7 messaging by corpor-
> ations that we are doing our best on the tar sands. People must feed their
> families and have no time to study the veracity of claims. Politicians are
> beholden to the resource companies....It's like you're in a relationship
> with someone who cheats on you, but they're nice to the kids and they
> pay some of the bills, so you turn a blind eye to it. Albertans are not stupid
> enough to believe that these resource companies have their best interests
> at heart, but they figure, "Ah, maybe the next generation will fix it."

He feels that Canadians see Alberta as "a brasher younger brother"
with "a chip on its shoulder," and that "the redneck-cowpokes view,
underwritten by corporate interests, creates a tremendous wedge,"
which he aims to help overcome with his film.

When Wilkinson heard of the construction of another dam in Fort
St. John on the Peace River, he went there, "looked at Mordor" and felt,
"I cause that every time I turn on the lights, turn up the thermostat or
gas up the car." Thus, he came to *Peace Out* "not as an activist or environ-
mentalist, but as someone sincerely wanting to know why that despoiled
situation came about. Most of us don't realize *we're* the guys with the
chainsaws and the oilrigs. Those people are acting for *us*." So his target
audience is people who are unconvinced of climate change or human
effects on Earth, plus "those who are struggling with what they can do."
He self-financed the film using his teaching earnings, providing him with
a level of independence that he credits with getting him access to CAPP,
for example, which he says might be less inclined to talk with the CBC or
the National Film Board.

With an opening shot of a clock-radio starting his day, Wilkinson shows or explains the ubiquity of energy and electronic gadgetry in our lives; how industry "has a free lunch on water" (the bit-sands are said to use enough each day to supply two million people); and (over a shot of an open-pit mine) how "we've destroyed the world," sacrificing and transferring huge amounts of land, water and natural gas-fired power to northern Alberta "for dirty oil bound for Texas." Sped-up point-of-view shots from inside a car barrelling down the highway illustrate the break-neck pace of life and the energy that it uses. Aerial shots of refineries and operations in Fort McMurray accompany interviews with now-familiar faces—Dr. Schindler, CAPP's VP of marketing and oil sands, and Alberta's Greenpeace rep—and other scholarly, financial, political, corporate and activist commentators. Wilkinson breaks with custom by having inter-viewees look straight at the camera, emphasizing their speaking directly to us rather than merely being observed by us. Over a final shot of a pris-tine river, Wilkinson concludes, "Are our grandchildren going to hate us for what we've done? Absolutely, yeah. They'll wonder why we couldn't just turn things off."

The film has screened in film festivals in Canada, the United States and New Zealand. Wilkinson signed a distribution deal in Canada and the US, and he has an international distributor. *Peace Out* has also played in theatres across Canada and enjoyed a TV premiere on Super Channel. It has distribution on iTunes, a DVD release and three film-festival honours. A companion book, also titled *Peace Out*, was published in 2015.[204]

Peace Out deals with the bit-sands not so much as a window into posi-tioning Alberta but as part of an energy bonanza around Peace River that raises larger questions about our use of energy. Still, in depicting the province as an apogee of endemic energy gluttony, it uses the *bridging, compromise, sellout, health* and *present-minded* frames in calling for rational dialogue toward stopping "further destruction" through extracting bitumen.

On the Line (2011)

The third BC-based work studied, *On the Line*,[205] premiered two days
after *Peace Out* at the Vancouver International Film Festival. The sixty-
eight-minute film examines a second controversial pipeline proposed to
carry bitumen, after Keystone xl: Enbridge's proposed 1,170-kilometre
Northern Gateway Pipeline from refineries in Bruderheim, Alberta,
through ecologically fragile areas in BC (including 773 waterways) to
Kitimat on the west coast, to facilitate shipping to Asian markets. The film
chronicles filmmaker Frank Wolf's self-propelled, 2,400-kilometre trek
along the pipeline's gps track to determine the true impacts of the
$5.5-billion megaproject. Wolf has canoed across Alberta on the North
Saskatchewan River, walked from Edmonton to Jasper and shot a short
film about the town of Vulcan. His take on the province:

> There's definitely more to Alberta then Fort McMurray and rural Alberta
> north of Edmonton to Grande Prairie....However, oil and gas *is* Alberta, you
> can't really get around that. Once Alberta was cowboy country, but now its
> self-identification is with oil and gas. Oil and gas rules. Some people didn't
> want to talk on camera [so] as not to offend their neighbours. They have to
> deal with the pumpjack on their land. Lots of people are resigned to it and
> feel small next to it, though some make $170,000 a year working in the tar
> sands. There's definitely a feeling of powerlessness.[206]

Wolf saw *Petropolis*[207] and found it "nicely shot," but its "engendering
a bludgeoning helplessness" inspired his intention to "do something
motivational and positive." Having read *Tar Sands* by Andrew Nikiforuk[208]
and been asked by the co-founder of the conservation group, Pacific
Wild, to make a film that walked the pipeline route, Wolf saw an oppor-
tunity to connect the pipeline, the bit-sands and "the encroachment on
lost wilderness by industry and humanity without a sustainable balance,"
all through "on-the-ground education, not just talking points on either
side." Believing it pointless to show such a film to "professional activ-
ists," he aimed for a broad audience by bringing a rough-and-tumble
humour to the ardour of walking, hiking, biking, rafting and kayaking

Pipeline crossing, from On the Line *(Wolf, 2011).* [Photo by Frank Wolf]

along the proposed pipeline's path, trying "not to be exhausting or bludgeoning like *Petropolis*."

So *On the Line* avoids experts to let Albertans who live and work along the pipeline tell their own story of the oil patch. We hear from farmers, a cab driver, an environmental cleanup worker and others, but there is no narration, which Wolf feels keeps it "more genuine." Macro shots "create intimacy," exemplified by close-ups of a bee on a highway shoulder that is blown off its path by a transport truck speeding past. "It's important to give the viewer a real feeling," he states. "I find aerial shots detached."

On the Line played film festivals and aired as an edited, fifty-two-minute version on the Documentary Channel and on CBC. It screened across BC, and DVDs are distributed at Mountain Equipment Co-op.

Wolf tried to get the film into Albertan film festivals but "couldn't get much traction."

From its ground-level, DIY perspective, *On the Line* positions Albertans as caught in the crossfire of economic benefits and ecological calamity, ordinary people who by geological chance find themselves overrun by something much larger: "Good people, and if anyone else was in their shoes, they would probably do the same thing." Thus, the film may initially seem more moderate than other, critical works studied here: its tone is certainly the jauntiest and least formal. But once Wolf leaves Alberta, his interviews with fishermen, a tour guide, landowners, a wildlife photographer, indigenous locals and other British Columbians encountered on his odyssey through proposed pipeline territory suggest the *greed, eco-justice, health, present-minded* frames regarding Alberta, personified by the pipeline purveyor, Enbridge, as the antagonist in the film. These frames are bolstered by the memorable image of that wind-swept bee along the highway, reproduced in logo form in the film's publicity material.

In the film, the opposition MP for Skeena–Bulkley Valley (the federal riding comprising most of the northwestern quarter of British Columbia, including Haida Gwaii), Nathan Cullen, cites the potential sacrifice of culture and traditional ways of life for Enbridge's corporate profit—and, as amply shown, dubious pipeline-safety record—and declares, "People don't make the land. The land makes the people. So why would we give up who we are?" So by inference, not only has Alberta sold its soul for bitumen, but, as is also shown in *White Water, Black Gold,*[209] it aims to drag "Super, Natural" British Columbia down with it.

Pipe Dreams (2011)

Hollywood's Leslie Iwerks returned to the discourse with *Pipe Dreams,*[210] which premiered in Los Angeles in November 2011. Unlike her earlier films, *Downstream*[211] and *Dirty Oil,*[212] Iwerks's thirty-nine-minute film is set not in Alberta, but in rural Nebraska, site of the Ogallala Aquifer, a vital water source facing destruction by the construction of TransCanada

Corporation's controversial Keystone XL Pipeline, aimed at moving bitumen south to refineries on the Gulf Coast of Texas.

Recast in his role of dodgy villain (as in *Tipping Point*),[213] Alberta's then-energy minister, Rob Renner, emphasizes Alberta's global leadership in reducing greenhouse-gas emissions and America's need to choose between importing oil from enemy nations or from its friendly northern neighbour—a choice that advocates of renewable energy and reduced consumption would call falsely framed. A Canada goose (staggering under the weight of oil that had burst from a pipeline operated by another Alberta-based giant, Enbridge, in the Kalamazoo River in Michigan) becomes a visual metaphor for Iwerks's representation of Alberta's/Canada's disregard for, and failure to prevent and clean up, the toxic, sludgy consequences of delivering its product. Renner's calling that cleanup successful is belied by local media reports of a catastrophe and aerial images of a sea of oil snaking through a forest. An elderly couple in their kitchen and others describe how TransCanada officials intimidate people into signing easements (rights of access) across their property without proper background, sometimes even without first disclosing the easement's path.

Iwerks observes rising environmental and human-rights concerns over the period of making her three films involving the bit-sands, and she comments, "In the US, it's hard to get people to care about something unless it affects them, but when the Keystone Pipeline came to the US, they cared."[214] *Pipe Dreams* was shortlisted for an Academy Award in the short-documentary category for 2011, raising the film's profile. Iwerks gave copies to members of Congress and screened it in Washington, DC, and at film festivals. She continues to seek a distribution agreement for all three of her films involving the bit-sands, noting that pipelines are "still an issue."

In positioning Alberta/Canada as a puppet for Big Oil, laying waste to everything in its path in pursuit of profit, and as the arch-villain in what the DVD package calls "the greatest environmental battle in the US today, the Keystone XL Pipeline," *Pipe Dreams* develops the theme of corporate power in Alberta, seeded in productions examined above. However, Iwerks's film brings fresh framing into the discourse: instead

of indigenous communities in distant northern Alberta (as in *Downstream* and *Dirty Oil*) or British Columbia and its citizens (as in *White Water, Black Gold*,[215] *Peace Out*[216] and *On the Line*[217]), it presents the victims of the bit-sands juggernaut as small farmers and landowners across what the film calls "the heartland of America." Thus, positioning Alberta in the context of environmental issues involved in the bit-sands, the film hybridizes and consolidates the *rogue, greed, health* and *present-minded* frames into a new frame of Alberta/Canada as a *globalist bully*. For a province in a region with an identity long reflected by a defensive frame as a colony of Central Canada,[218] this is irony, indeed.

CONTEXT IV: Kyoto and Pipelines (2011–2012)

Two high-profile events involving the bit-sands and likely affecting Alberta's reputation occurred in winter 2011–2012. Canada became the first nation to withdraw from the Kyoto Protocol, citing financial penalties that would accrue for failing to meet its obligations to cut its greenhouse-gas emissions 5 per cent below 1990 levels between 2008 and 2012.[219] *Time* magazine[220] and others linked this to Alberta and the bit-sands. Later, President Obama rejected the proposed Keystone XL Pipeline to move bitumen down to refineries in Texas, defying opposing Republicans' sixty-day deadline for its approval by the Department of State.[221] That battle is positioned as one of environmental concerns about "dirty" oil from the bit-sands versus massive job creation and "energy security" for Americans. Yet an environmental-impact report by the US Department of State indicates that the equivalent of 42,100 direct, indirect and induced *one-year*, full-time jobs would be created during the two-year construction of the Keystone XL Pipeline, with only thirty-five permanent full-time jobs and fifteen contract positions to follow.[222] Moreover, the US's demand for Alberta's bitumen may be reduced by its significantly increased production of oil through fracking.

Vote BP for Greenwash Gold (2012)

As the bit-sands create lucrative investment opportunities for foreign enterprises like British Petroleum (BP), France's Total and the China

National Petroleum Corporation, so do they inspire strong resistance abroad. An example is the UK Tar Sands Network (UKTSN), dedicated to "stopping the world's most destructive project."[223] Its "No Tar Sands" campaign—absorbing the aforementioned "Rethink Alberta" campaign begun by Corporate Ethics International—has drawn headlines for staging creative protest performances such as the "oil orgy" sprung on the Canada–EU Energy Summit[224] and a tarry adaptation of the ballet, *Swan Lake*, disrupting a BP-sponsored opera event at Trafalgar Square.[225] UKTSN's partners include the Indigenous Environmental Network, Greenpeace, the Council of Canadians, the Athabasca Chipewyan First Nation and others.[226] Its actions on the bit-sands began when it invited indigenous delegates to a UK climate conference in 2009 at which *H₂Oil*[227] was screened. UKTSN's founder, Jess Worth, was astounded at the bit-sands.[228]

In April 2012, UKTSN released *Vote BP for Greenwash Gold*,[229] an eighty-four-second online video, as part of its campaign challenging BP's status as a "sustainability" sponsor of the 2012 London Olympic Summer Games. This stems from BP's major investment in the bit-sands—which UKTSN views as killing the environment and Alberta's indigenous population—and its engaging in other enumerated, environmentally controversial practices. For UKTSN's Emily Coats, whose MSC work in nature, society and environmental policy examined resistance to the bit-sands, the global perception of Alberta is that government and the oil industry run the show, "rampaging people's lives":

> But everyone else is implicated, too. It's taboo not to like the tar sands in Alberta....There is an Oil Sands Discovery Centre in which they ask, "How dare you not be impressed by the struggle to get this resource out of the ground?"...Everyone is caught up in oil. It's so integrated into our economy, it's hard to oppose it. So we're caught between blaming everyone and blaming no one.

UKTSN's goal for the video was to convince the European Union to adopt legislation labelling bitumen as 23 per cent more emissions-intensive then regular oil in the face of the requirement under the EU's Fuel

Swath of destruction, from Vote BP for Greenwash Gold *(Dick, 2012).*

[Screen capture from online video by Angus Dick, produced for the UK Tar Sands Network]

Quality Directive to reduce greenhouse-gas emissions from transport fuel sold in Europe by 6 per cent. The direction of the video was left up to an independent filmmaker, Angus Dick, "though we shared ideas on framing the issue," notes Coats.

Vote BP *for Greenwash Gold* is a gory, guerrilla-style animation in the tradition of *South Park*, a TV series for adults known for its crudity and dark humour. An Olympic cyclist sporting BP's signature green and yellow pedals through Alberta's wilderness, leaking a trail of oil drops that instantly poisons wildlife, suffocates a protesting Aboriginal man, levels forests and lays waste to the landscape. This gives way to polluting refineries that pop up across the globe and turn oceans to toxic black. Accompanied by an industrial, thumping-bass soundtrack, the cyclist is revealed as an oily skeleton, the Canadian flag drips tar (and blood) and the last screen calls on viewers to vote for BP to win the gold medal in

greenwashing as "the worst Olympic sponsor." Coats sums up the visual approach:

> We often try to use subverted versions of popular images, as in the cyclist video, showing the Canadian flag with oil dripping from it, as we did with BP. We're not only saying this is bad, but we are distorting powerful branding and subverting the logo. We use imagery focusing on...the most powerful images we can find. I am becoming desensitized, but people still find it powerful.

The video garnered almost 21,400 viewings, 94 likes and 8 dislikes on YouTube as of mid-2016. Although initially, the UK government lobbied against singling out bitumen, the nation later abstained from the vote.[230] The EU executive later upheld its proposal to label bitumen as highly polluting,[231] but ardent Canadian lobbying is said to have led to the eventual dilution of Europe's fuel quality directive to remove that barrier to importing bit-sands oil.[232] After UKTSN's "medal" presentation (BP finished second in the public vote), seven arrests were made—for spilling and cleaning up the green custard crowning the three finalists.[233] Coats appreciates that the group can't stop the mining in Alberta from London, but it can raise awareness of it—as in giving Joe Oliver, Canada's then-minister of natural resources, a greenwashing award, which "received a lot of coverage in Canada, though not in the UK." She says it's hard to measure how much of a difference UKTSN makes, but its being "very small" and "nimble" lets it combine structured and reactive storytelling, and it is "always reframing to remain relevant."

In positioning Alberta/Canada as criminally indifferent to ecological issues and Aboriginal people, and as giving BP free rein to rape the landscape and kill all life in its path, *Greenwash Gold* adopts the *rogue, sellout, eco-justice, health* and *ecocide* frames. Unlike *Pipe Dreams*,[234] this video frames Alberta not as a globalist bully, but as a globalist stooge.

Opportunity
ives here.

Alberta is a vibrant, diverse western Canadian province that offers limitless economic, educational and personal opportunities. We're a multicultural province that embraces the unique talents of all Albertans and welcomes new ideas and experience.

Panels from the jacket for Alberta Opportunity *(Alberta, n.d.), a video promoting the province beyond its borders.* [Alberta Public Affairs Bureau]

A Day in Alberta (2012)

In 2012 the province produced an untitled three-minute marketing video, unofficially called *A Day in Alberta*.[235] With found government footage, voice-over narration and upbeat music, it is described by one of its creators as "a kind of inspirational piece" to show "what Albertans are like."[236] That year it accompanied then-Premier Alison Redford to the

London Olympic Games and, in Chinese translation, on an Asian trade mission. Unreleased publicly, it suggests the government's more recent positioning around the bit-sands.

Beyond a brief introduction from then-Premier Redford, the video cobbles together familiar stock footage: I recognized a few shots used in the introduction of my own short film, *Dual Alberta*.[237] There are time-honoured images—Rocky Mountains, vast blue skies, canola fields, cowboys and northern lights—plus workers in lab coats, skiers, children, seniors, bustling cities (notably Calgary), much machinery, happy visible minorities, an orchestra, and so on. The premier introduces "a place of incredible opportunity and immense beauty," and the narration calls Albertans "entrepreneurs, innovators and leaders" who "work smart, play hard and live large." Stepping beyond the generic and ultimately failed provincial rebranding in *An Open Door*,[238] this video presents a more varied portrait ("Yeah, we're complex," the narrator half-laughs over images of the Calgary Stampede and a skateboard park) and does mention "natural resources" and include a quick shot of an iconic yellow truck in a bitumen mine.

Of course, it is hardly for a video intended to market trade, tourism and investment abroad to address complex issues about the bit-sands. But at least this production does not ignore the project entirely, as in *An Open Door*. Unconnected to either of those government productions, Albertan videographer/video editor Mark Sereda, wrestling with the dualities of a province marketing economic opportunity and environmental beauty simultaneously, muses, "Maybe that's what Travel Alberta is trying to do, not let people see the real deal, that we're a tar pit. But Alberta is also the most beautiful place in the world."[239] In terms of the bit-sands, then, the government's video may be read as adopting at least the *status quo* frame, if not the *green* frame of *An Open Door*.

Oil Sands Karaoke (2013)

The director of *Peace Out*,[240] Charles Wilkinson, premiered *Oil Sands Karaoke*[241] at the Hot Docs film festival in Toronto in April 2013. This eighty-two-minute effort is his second of a planned trilogy of films

about human relationships with energy and the environment. Rather than focus on the bit-sands directly, this film explores the lives of residents of Fort McMurray, a city dually perceived in the public sphere as "the economic engine of the country" and "the poster child for all that's wrong with our world."[242] Seeking to mitigate that polarization, Wilkinson defines the film's aim as offering "an impartial look at a complex subject...to hit people not rabidly pro- or anti-industry...people who are interested in the subject, but not interested in being preached to and want to make up their own minds."[243] For him, the film asks, "Given the deep trouble we are in as a species on the environment, why are so many of us incapable of dealing with that problem as a society?" and resolves to "...go to one of the most perfect places on the planet to see if there are any keys to what can be done."

Wilkinson's inspiration, arising during a break while touring with *Peace Out*, was the unexpected camaraderie that he found among "hard-hats and hippies" in a blue-collar, oil-patch karaoke bar in Fort McMurray.[244] Rooted in the director's identification with the working class, the film follows five locals employed in extracting bitumen as they engage in a karaoke competition in such a bar. These genuinely talented contestants, mixed in gender and race, include a shy haul-truck driver who sings metal, a scaffolder and a haul-trucker who ooze soul, a country-lovin' haul-trucker, and a safety consultant with a second identity as a drag queen.

In terms of imagery, Wilkinson was sure that people would anticipate the usual "compelling, dark, disturbed, Hiroshima-like landscapes" of the bit-sands, and *Oil Sands Karaoke* delivers a smattering of that. But he finds that the most important images in the film are "four shots of unspoiled places near Fort McMurray—skies tinged with rosy hues, clouds lit from the side, indescribably beautiful," such that he could "feel the crowd's reverence for just how extraordinarily beautiful Alberta is." Recalling historical depictions of the province, he notes, "It's one thing to look at a picture of Lake Louise or Castle Mountain. They're in a national park; they've been that way for millions of years and they'll still be that way millions of years from now. It's quite another to look at a landscape

which is as beautiful in a different way and know that in a month from now, it will be gone. That's pretty striking."

He acknowledges the practice of news crews and environmental film-makers going up to Fort McMurray and shooting its "hellish" popular perception: "the hookers, the drug addicts, the homeless and all that really ugly-looking stuff"—a practice he finds dishonest in terms of depicting life in the community as a whole. In addition to now-familiar aerial shots of open-pit mining, we see karaoke singers, poured cocktails, a gargantuan warehouse interior, massive haul-trucks, rowdy pub dancers, a quiet residential street, bumper-to-bumper traffic to and from a site, a majestically tattooed arm, a man walking his dogs, spewing smokestacks, a drive-through fast-food window, muscle trucks, denuded landscapes, a stripper bar, a pickup football game, a school playground, sunset over a tailings lake, road hockey, downtown vehicle and pedestrian traffic, and a karaoke contestant (self-described as Fort McMurray's first openly gay male) applying drag-queen stage makeup. The film opens with a lingering long shot of one of world's largest trucks traversing the horizon at dawn, inching across the screen from left to right, and it ends with the truck reversing its journey.

For Wilkinson, however, most evocative of the place are the film's night shots of a child pausing after leaving a store and of a car emerging from a carwash, even if viewers may find them pedestrian. He states that it's easy to shoot horrible fly-over images of the bit-sands by directing your pilot and aiming your camera to frame out any forested areas in the background. Adopting a postmodernist perspective, he reminds us:

> It's impossible to film *without* a point of view because you always point your camera, and by definition you're not pointing it at something else. So we tried to point our camera in at least some other directions that you don't normally see up there....I think the story's bad enough without colouring it and trying to make it look horrible. People don't just line up and go to work with scowls on their faces, like "orcs" in *Lord of the Rings*. They enter karaoke contests, you know?

As for images of Alberta and its population, Wilkinson—a native Albertan, though transplanted to BC—notices "typically Albertan" representations embodying "the louder-faster-harder-bigger-better thing—big, fat steaks, muscular pickup trucks, gigantic haul trucks, vast landscapes, everything is big, like Texas—something we all do, but Albertans don't have the decency to be embarrassed about it." He believes most Canadians have serious reservations about Albertans glorifying material excesses when access to clean water, food and shelter is becoming increasingly difficult for millions of people around the world: "the days for that kind of bullshit are over." Consequently, he finds "a chip on Albertans' shoulders" such that "it's impossible even to begin to discuss climate change or our relationship to the environment without getting a pretty belligerent response."

He contrasts this with his needling Canadians from other provinces about their stereotypes and getting genial, respectful discussion in response. He finds Albertans' attitude typified in the film by a haul-truck driver who jokes about the bit-sands, "There was a massive oil spill a couple of million years ago and we're just now getting around to cleaning it all up." Wilkinson notes that this joke "...always gets a laugh from audiences because it hurts. It's such an ignorant thing to say [equating the formation of the bituminous sands to an oil spill and its unbridled extraction to a cleanup] that all you can do is laugh." He adds:

> Raising issues like the science of climate change in Alberta is walking on eggshells all the time. It feels like you've walked onto the set of Fox News. As an Albertan myself, I'm really troubled by that. We should be able to talk about this stuff. We shouldn't get angry at each other and label each other. When poor Neil Young made his comments comparing Alberta to Hiroshima, if you said something like that about anywhere else in Canada, people would have just laughed at it. But in Alberta, the most popular hashtag was NeilYoungLies.[245] I wish my fellow Albertans would lighten up on this a bit and just discuss it. We're not going to take their toys away.

In pitching the project to the Knowledge Network and Super Channel, Wilkinson was advised, adamantly, not to depict bit-sands workers as

"dupes entering a karaoke contest and fiddling while Rome burns" for two reasons: first, because that was felt to be "dishonest and done to death," and, second, because the broadcasters, which already had "a hundred" proposals that were negative about the bit-sands, wanted a deeper look at the human condition relative to the project. In addition, Wilkinson felt an "implicit, moral contract" with the karaoke participants in the film not to make them look foolish, having earned their trust and consequently their candour onscreen.

Oil Sands Karaoke has been received warmly by critics, earning praise as uplifting, intriguing, refreshing, thought-provoking and meaningful.[246] It was aired on British Columbia's Knowledge Network (a public broadcaster), screened at more than twenty film festivals and in every major centre across Canada, and honoured with two awards at the Yorkton Film Festival. Wilkinson theorizes that its receiving less audience-choice awards at festivals than his prior film, *Peace Out*, is due to those audiences seeking didactic messages. *Peace Out* provides those in examining our use of energy, but *Oil Sands Karaoke* is more ambiguous in its portrayal of bit-sands workers conflicted over the project's economic benefits and its environmental devastation. When asked on reflection how he would approach making a future film on Alberta and bitumen extraction, Wilkinson takes his cue from government and industry being "joined at the hip in Alberta." He envisions a more didactic project that objectively deconstructs and measures their joint position that the resource is being developed "safely and responsibly"—an assertion that he views as misleading.

Beyond adding a touch of "reality" television (the term must be contested in light of the argument by Wilkinson and others that all points of view are constructed), *Oil Sands Karaoke* contributes some singular framing to the discourse on Alberta and the bit-sands. We see several frames at work. For example, a karaoke contestant tells the aforementioned joke about the bit-sands as oil spill and cleanup (the *pride* and *green* frames). A bar server ties the supply of oil from Alberta's bitumen to the demand for it (*status quo*). Self-teasing as "a glorified pizza delivery person," a driver of the world's largest truck soberly admits, "It's a very

Karaoke contestants from Fort McMurray, from Oil Sands Karaoke *(Wilkinson, 2013).*

[Photo composite by Charles Wilkinson]

scary thing that our world is going to shit to make oil" (*ecocide*). The eventual karaoke champion acknowledges popular hatred of Fort McMurray for the bit-sands' impact on climate change (*rogue, present-minded*), then adds, "But we have families" (*money*).

However, in bringing us into the lives of the karaoke contestants and the bar manager, the film goes further than the other films studied here. Certainly, it shares the intimacy that we get from glimpsing, for example, the lives of Dr. O'Connor and his patients in *Downstream*,[247] the water-business operators in H_2Oil[248] and the cancer-plagued family in *Tipping Point*,[249] all of which employ more ecocentric frames like *health* and *eco-justice*. We also witness some of the pride of being on the front line of Alberta's (literally) groundbreaking exercise in extraction that we get from advocacy efforts like *Canada's Oil Sands*[250] and *About the Oil Sands*,[251] which use more anthropocentric frames.

But *Karaoke* takes the additional step of situating the tensions between economy and environment as cognitive dissonance, in showing the inner conflict faced by common people who work directly in bitumen operations. The unvarnished humanity and occasional, unabashed eccentricity

of the film's stars are accented by their vocal prowess, lent to proudly cheesy musical backing tracks, onstage in a brick-walled, dimly lit bar. Thus, in depicting divergent attitudes toward extracting bitumen within, rather than merely among, discernible, multidimensional individuals, the film adds a new frame to the discourse: Albertans—and by extension, other populations implicated in our societal reliance on fossil fuels— as *conflicted*.

Above All Else (2014)

Above All Else,[252] by the second American filmmaker considered here, premiered at the South by Southwest Film Festival in Austin, Texas, in March 2014. The ninety-five-minute feature was directed and filmed by John Fiege, a Texan cinematographer with an MSC in cultural geography and environmental history, plus an MFA in film production. Generally bored by environmental documentaries, which he sees as "dumbed-down versions of print media," he takes his inspiration from war documentaries, which give him the kind of immersive, visual, emotional, character-driven stories that he finds lacking in ecocinema.[253] He finds that his film "is a bit of a war story, though not in the traditional sense; it has warlike events, language and tactics on both sides. When you look at environmental issues, it *is* a war, with economic and ideological issues happening."

Above All Else is literally a David-versus-Goliath story, following David Daniel, a soft-spoken, high-wire artist and circus performer who retired to live modestly with his wife and young daughter in their self-built house adjoining a forest in eastern Texas. When he discovers survey stakes for TransCanada's controversial Keystone XL Pipeline on his land (located on the US-presidentially approved, southern leg of the route) and that the company was traversing people's land through intimidation and misrepresentation, he risks all to rally his neighbours and a band of young activists in a treetop blockade against the company's oncoming litigation, trucks and bulldozers. Daniel is the quintessential reluctant protagonist, afraid for his family, stating, "Like most people, I'm just trying to plough through life. I was always concerned about the pipeline, but I never did anything until they came knocking at my door."

In approaching the film, Fiege tried to shed his prior biases, to look for the strongest story and make it first and foremost a compelling human drama independent of its subject matter, privileging actual, observed experience over ideology, and hoping that the resulting film would align with his predispositions. He understands the perspectives on the ideologies involved, but seeks to show Daniel's lived experience of it. He admits to being "largely ignorant on the intricacies of Alberta," knowing only "what educated Americans tend to know," perceiving that "Alberta is basically Texas North, driven by the oil and cattle industries...reactionary...business people run the province and the oil business runs the government."

Fiege's first exposure to the bit-sands—introduced in the film by Daniel as "the Alberta tar sands, the dirtiest, most expensive unconventional fossil fuel in the world" and by the eminent environmentalist, Bill McKibben, as "the single greatest environmental issue right now"—was the massive protest in Washington, DC, against the proposed Keystone XL Pipeline. Fiege notes:

> With Keystone, people acted peremptorily. That caught my attention. Not since the 1970s did people come out in the thousands over an environmental issue. This is becoming personally and physically engaged to do something preventative, not just reactionary. That's a sea change in the American environmental movement.

He contrasts this with attitudes in Louisiana, site of BP's devastating spill of oil from an offshore rig. There, he finds that "oil is so engrained in the culture that people don't care about the environmental consequences," following "the same old story of the enormous wealth you can get from pulling oil from the ground."

His initial goal was to tell a sprawling story of how oil shapes our economy and our lives, and what ordinary people can do to stop it and to improve things. His earlier diagnosis of cancer was attributed to environmental exposure (despite a non-smoking, vegetarian lifestyle), which he traces to the ubiquity of petroleum. He was interested in Canadian First Nations being at the forefront of resistance to the bit-sands, but he backed

off on learning that Canadians were already producing documentaries on the project and could access public funds to help make them. Faced with financial and logistical constraints—and a relapse of cancer that delayed him for nine months—he abandoned his plan to go up to Alberta. Rather, he turned to the American side of the story and the question of how people can fight petroleum when it is everywhere: "I started hunting for people who stand up to it." An initial search in Louisiana led him, ironically, to discover struggles about Keystone back in his home state of Texas.

Funding was a rough road, typical in independent filmmaking. He was a finalist in funding applications to five national foundations, but he came up short each time. Some jurors at PBS raved over his proposal, but others advised that films like his had been done before. He was broke after his initial funding ran out, so he hired students to help with the film; he trained the sound recordist on the job. Left to his own resources, he finished his film on a threadbare budget, which, while arduous, provided creative freedom. Fiege set up an advisory board, as Palmer did with his seminal film on the bit-sands, *Pay Dirt*.[254] Fiege's board included a dozen distinguished professors, filmmakers and journalists.

Fulfilling Fiege's quest for "cinematically visual drama," *Above All Else* plays out like *Avatar*[255] without the grand special effects. There is gripping intensity and aching intimacy as we witness Daniel's quiet but determined fight to save "our homestead...all that we have to leave our daughter." We meet his neighbours, three principled, strong-willed women, and a band of galvanized young activists from a then-fledgling group, Tar Sands Blockade,[256] teaming up to oppose the oncoming Goliath from Alberta. "We're nothing but a bug under their shoes," one landowner intones, "little people who can't defend themselves." Daniel's resistance to the oncoming pipeline unfolds as a vivid forest war. We witness activists staking out positions high up in century-old trees, quoting the *Star Wars* oeuvre ("May the Force be with you") and posting banners prohibiting the pipeline, one echoing Gandalf's battle cry adapted from J.R.R. Tolkien's *Lord of the Rings*: "You shall not pass!"[257]

The unvarnished humanity of these brave, rural Texans and their young allies, and our immersion in their struggle, is underscored by their

knowledge (and ours) that they are vastly overmatched by the Canadian pipeline giant. The bit-sands are shown in purchased aerial and other footage, and TransCanada is visible mostly through its legal correspondence, helicopters, surveyors, bulldozer operators and crew of private "sheriffs," whose actions are apparently legal. The viewer's impression of the invader's power and greed, the humble righteousness of the reluctant defenders and the high, apparently irreversible stakes—virgin land—suggest a sort of holy war.

For Fiege, "This is a religious issue, and people have very strong perceptions that color their perception of things." He adds, "By focusing on everyday realities behind much larger social issues, I aim to unearth the universal human struggles and joys that we don't often see in the mainstream media coverage of these issues."[258]

This treatment echoes, for example, the human drama and intimacy of Dr. O'Connor and his patients in *Downstream*,[259] the protests of the Mikisew Cree in *Tipping Point*[260] and particularly the struggles of the Nebraskan landowners combatting the Keystone xl Pipeline in *Pipe Dreams*.[261] However, *Above All Else* adds an even stronger sense of intimacy and urgency. We witness Daniel's agony, as under the watch of corporate security forces brandishing legal documents, he must order the protesters to leave his land or eventually have it seized from him. Fiege reports the discomforting price of on-camera intimacy for participant and filmmaker alike: the invasion of Daniel's privacy and the disruption of his home life.

There is neither voice-over narration nor onscreen text (and thus no writing credit), and Fiege does not appear in the film. His cinéma-vérité style brings us right to the battlefront, under the forest canopy, twenty-five metres high on platforms and in tree-tents with the activists as they stare down the oncoming corporate earthmovers. Fiege views this as highly symbolic.

I saw the amazing forest behind where David built his house—and people were going to build a tree village there! I wanted to create a very tangible sense of place, a visceral connection to the trees, the stream, the animals, the birds, the wind. David's backyard becomes the environment, and he

aims to protect it for the future that his daughter is going to live in. David's daughter represents the future. I realized that the forest was taking on very strong symbolic significance and that it became the environment that *we* want to protect: if we don't take a stand, it will all disappear. This is cinematic because the pictures have meaning, and that's the difference between real films and films as journalism.

Fiege also sees the trees in Daniel's backyard as the boreal forest in Alberta: "David can't defend that [against the bit-sands], but he can defend his own property. So what are his options in the face of the formidably powerful corporations?" As the film reveals, those options are limited— Daniel stands to lose his land, his savings and his family—for resistance has enormous human as well as financial costs. And not even the feistiest eighty-year-old woman is a match for a land-clearing bulldozer. The yellow behemoths level old-growth trees with gut-wrenching ferocity. One elderly, protesting landowner tells us, "I can hear the trees screaming. It's the sound of death."

As for the film's reception, its many reviews range from effusive praise for the film's moving portrayal of Daniel's struggle and its cinematic prowess to dismissals of it as, in Fiege's phrasing, "crap." Key trade reviews were also mixed: for example, *Hollywood Reporter* called *Above All Else* "inspiring, dramatic and very timely,"[262] while *Variety* acknowledged that the film would be well-received by environmentalists but found it romanticized and one-sided.[263] Fiege notes that some reviewers play to the "dull, journalistic practice" of reducing everything to two sides and then simply airing both views.

Fiege is pleased with the film's portrayal of an intergenerational struggle in one of America's most conservative strongholds, and he finds "enormous interest" in the project but difficulty in getting distributors to pick it up for sale. Distribution has been through film festivals and on DVD, and Fiege is hoping for community and university screenings, to bring people together in a robust conversation about what we are giving up in our pursuit of fossil fuels. "The bar is so high for environmental documentaries," he says. He observes that his work is seen as an

environmental film and thus repellent to potential distributors, whom, if they do take an eco-documentary, "want the *An Inconvenient Truth* of the tar sands, with statistics and arguments." He adds, "That's never what I intended to make, although *Above All Else* is trying to be a film, too." He notes that filmmakers can complain about the industry, but they must accept that distributors know their markets.

The work had its international premiere at Toronto's Hot Docs festival, where it played four times; five hundred local high-school students saw it through that festival's singular school program. It also opened the 2014 Global Visions film festival in Edmonton, where it won the award for the best North American documentary. There, Fiege conducted a Q&A session by online videoconference and was surprised to learn that his work generated more enthusiasm in Alberta's capital city than at some American festivals.

"I should have realized how much interest I was getting from Canada," he observes. "The first *South Park* movie joked about blaming Canada. I hope this film doesn't come across like 'Blame Canada!' and that people don't get their only impression of Canadians from Russ Girling." The latter is TransCanada's CEO, who is shown in *Above All Else* in news clips that *Variety* called "glib sound bites intended to have viewers rolling their eyes in disbelief."[264] Fiege muses about expanding the scope of his next film, to something "more universal, to connect with more people," perhaps focusing on Canadian First Nations people, to give "the northern half of the story."

While focusing on the grassroots defence of the Texan landowners against the assault by what they call "Alberta tar sands"—run by "foreign-owned corporations taking Americans' land"—*Above All Else* unequivocally frames TransCanada, and by extension, Alberta and Canada, as *globalist bully*. This follows the approach to the struggle of Nebraskan landowners against TransCanada in *Pipe Dreams*.[265] The adoption of the *globalist bully* frame in work by both of the American documentary filmmakers studied here reflects the context of their films' production: during the rising controversy around the bit-sands in general and the furor over the Keystone XL Pipeline in particular. This treatment of Alberta's bituminous bonanza

stands in marked contrast to the *money* frame advanced rhapsodically to American (and global) audiences in the episode of *60 Minutes* aired back in 2006.[266]

Summary of Films and Frames

The 2005–2014 period marks a watershed in visual environmental communication about the bit-sands, which I situate as a bellwether in the ongoing debates around extracting fossil-fuel-burning resources, manifested in Alberta's place branding in a globalized and highly visual society. During this period, documentary filmmakers and professional communicators took up this discourse in film and video, as is recapped here.

This study begins with David Suzuki and the CBC invoking the *present-minded* frame in asking "When is enough, enough?" *Pay Dirt* investigates the bit-sands with financing from the oil industry, which its director admits could not happen today, and presents the more anthropocentric *progress* and *bridging* frames. After *60 Minutes*[267] trumpets the *money* frame and the Alberta government advances the *ethical oil* frame at two high-profile events in Washington, DC, the CBC returns to the topic, culminating in the critique of *Tar Sands*, using the *greed*, *sellout*, *health*, *eco-justice* and *present-minded* frames. Adding a critical perspective, a prominent Hollywood filmmaker employs the *eco-justice* frame to tar Alberta's reputation in its largest energy market. Alberta's provincial rebranding tries the *green* frame to ignore the bit-sands altogether, while a prominent film blending documentary and art, *Petropolis*, paints the project as toxically sublime, apparently through a *present-minded* frame. That another oft-cited film, H_2Oil, still looks to cast light and educate on the bit-sands and its effects suggests that the project is still emerging in the public sphere in 2009. *Land of Oil and Water* shares Aboriginal perspectives via the *eco-justice* frame, while COP15 boosts the *rogue* frame globally for Alberta's care of the resource.

Faced with this increasingly negative positioning of Alberta, the Canadian Association of Petroleum Producers launches a video campaign, highlighting people, not the oft-shown machines of

extraction, through the *green, ethical oil, progress* and *money* frames, as does the Alberta government's new suite of videos. *Rethink Alberta* gives the province another international black eye by evoking the notorious dead-duck incident, and the C B C's blockbuster, *Tipping Point*, brings the full battery of critical frames to bear, even if the film is shunned or attacked inside the province. A tarry trilogy from BC around water, energy use and the proposed Northern Gateway Pipeline echoes those critical frames. *Pipe Dreams* consolidates a new, moralist frame of Alberta as *globalist bully*, which reappears in another American documentary, *Above All Else*. As Canada's abandoning Kyoto and controversies over the proposed Keystone X L and Northern Gateway pipelines enhance Alberta's *rogue* framing, *Vote BP for Greenwash Gold* voices rising resistance to the bitsands abroad. *Oil Sands Karaoke* captures the tensions of these various colliding frames by presenting Albertans as *conflicted*, which we can logically place somewhere near the centre of the continuum of frames ranging from utilitarian to ecocentric. Thus, our earlier set of frames (Figure 3.1), aligned to Corbett's spectrum of environmental ideologies,[268] reads as follows:

FIGURE 4.1: Alignment of Frames (Revised)

Instrumentalist	Conservationist/ Preservationist	Middle Ground	Moralist	Transformational
Pride	Compromise	Conflicted	Rogue	Present-Minded
Green	Sellout		Greed	Ecocide
Ethical Oil			Globalist Bully	
Money			Eco-Justice	
Progress			Health	
Status Quo				
Bridging				

More Resistance to the Bit-Sands (2013–2015)

Controversy around the bit-sands continues, as is shown by the following samples of events occurring since the making of the aforementioned films.

Mocking the *green* frame, renowned water scientist David Schindler showed an Ontario audience an aerial photo of open-pit mining and declared that the Alberta and federal governments "seem to think that Americans believe in magic fairies—just shut your eyes and say the oil sands are clean four times and it happens."[269]

Online activism beyond Alberta in the tradition of the UK Tar Sands Network continues with videos like *Tar Sands Timmy*,[270] a scathing animation by a Pulitzer-winning American political cartoonist. The video satirically purports to sell Americans on importing more bitumen from Alberta despite its ecologically devastating side effects and economic benefits, which the video presents as vastly less than advertised by proponents of the proposed Keystone XL Pipeline.

A second *New York Times* editorial opposing the bit-sands[271]—the first came in 2011—was followed immediately by the Alberta government's buying another major, costly ad promoting the sands and the proposed Keystone XL Pipeline in the *New York Times*[272] and in the *Washington Post* and on news websites.[273] The government's spending another $107,000 lobbying for the oil industry during deficit budgeting while bitumen companies earn billions in profits (bolstered by public subsidies and concessions) speaks barrels about Albertans' perceived priorities late in the Age of Oil.[274]

At the National Renewable Energy Forum in Toronto in 2013, the province announced a forthcoming strategy to direct the production of solar, wind and geothermal electricity as of 2014. A professor and clean-technology advocate who chaired a panel on the new plan at that forum suggested that in the wake of all the opposition to Keystone, the plan could improve Alberta's international reputation and "offset the incredible public-relations issue they are facing with the oilsands."[275] As one columnist opined, "On a global scale, nobody has a reputation quite so bad as Alberta's oilsands."[276] Indeed, the province opened new trade offices in Brazil, California, Chicago, China, India and Singapore, adding

to its previous ten offices as part of a broader trade strategy, admittedly partly to combat "some international audiences'...equating Alberta with irresponsible energy development, specifically in the oilsands."[277]

Speaking at a First Nations conference in Fort McMurray, Nobel laureate and retired South African Archbishop Desmond Tutu singled out the bit-sands as the world's dirtiest oil and described it as "filth" and the product of "negligence and greed" in linking its extraction, carbon emissions and global warming.[278]

A video by Coastal First Nations advocating against oil-tanker traffic on Canada's west coast pursuant to Enbridge's proposed Northern Gateway Pipeline for oil from the bit-sands earned the support of Paul Simon. The venerable musician approved the use of his iconic song, "The Sound of Silence," as the soundtrack over images starting with the disastrous *Exxon Valdez* oil spill of 1989.[279]

Resistance to the bit-sands from the epicentre of global popular culture, Hollywood, continued after the visit by James Cameron in 2010, documented in *Tipping Point*,[280] discussed above. In 2013 actor Julia Louis-Dreyfus and renowned actor, director and founder of the Sundance Film Festival Robert Redford each appeared in videos calling for a boycott of the bit-sands, "the dirtiest oil on the planet," and the Keystone XL Pipeline, in favour of renewable energy sources.[281] As part of his environmental efforts, which include a video depicting the bit-sands as among the causes of climate change,[282] another well-known thespian, Leonardo DiCaprio, travelled to the bit-sands and to Fort Chipewyan to make an environmental documentary in 2014. When he tweeted a report of his visit that was published in the *Edmonton Journal*, the story attracted about as many online hits as the paper's top ten stories of 2014 combined.[283]

Responding in defence of the sands, one *Globe and Mail* columnist called the PR battle between Hollywood and the bit-sands unfair because of the former's star power. He quoted no less than Alberta's energy minister in suggesting that the attacks "by the entertainment crowd" were motivated by a desire for personal publicity, and he called on Alberta to "get its act together" with its own PR campaign "if the oil sands are no longer the greenhouse-gas-emitting monster they're being

made out to be."[284] However, even supporters of the bit-sands might agree that the project deserves more than a personal attack and an unsupported assumption.

In 2013 two American comedians entered the fray. Aiming to crowd-source funds to produce a documentary-film exposé on the bit-sands, Andy Cobb and Mike Damanskis broadcast a satirical trailer on YouTube mocking the province's "Remember to Breathe" tourism campaign in light of the substantial emissions generated by the resource. The trailer comically heralds the Los Angeles–based pair's intention to "head from one filthy cesspool to another" to take up the oil industry's invitation to come see the bit-sands for themselves.[285] Over jaunty narration and the symphonic strains of "O Canada," it intercuts quintessential tourist imagery from Alberta with increasingly familiar shots of desiccated landscapes, open-pit mining, sludgy effluent spewing into tailings lakes and endless streams of vehicle traffic, along with clips of apologists from the federal government and the "Ethical Oil" lobby. "Borrowed" footage from the "Remember to Breathe" campaign blend with the host doing a face-plant into an oily swamp, being doused with brownish sludge and, to close the trailer, spreading his arms in oil-stained exultation, recalling Julie Andrews's alpine opening in *The Sound of Music*. When Travel Alberta, the government-funded body charged with promoting tourism in the province, demanded the trailer's removal and threatened to sue for copyright infringement, YouTube dutifully complied. An environmental organization, DeSmog Canada, later revealed that the Alberta government's law firm has ties to Big Oil.[286] Ironically, the ensuing publicity allowed the pair to meet and exceed their $20,000 budget to travel to the bit-sands and make their film, titled *Welcome to Fort McMoney—Remember to Breathe!*, which is also sponsored by the non-profit, Los Angeles–based International Documentary Association and was apparently still in the editing stage at this writing.[287] Meanwhile, the trailer lives online on another popular video-sharing site, Vimeo.

Perhaps the largest public uproar around the bit-sands from 2004 to 2014 was triggered by iconic Canadian-born musician Neil Young. After driving to northern Alberta in his 1959 Lincoln convertible (converted into an ethanol-powered hybrid), he told a gathering of the National

Farmers Union in Washington, DC, in 2013 that mining the bit-sands is killing Native people and has turned the area into a toxic wasteland reminiscent of Hiroshima.[288] His latter claim was later supported by close, photographic comparisons in the *Huffington Post*.[289] The Canadian Association of Petroleum Producers called Young's rhetoric misinformed and divisive[290] and sources linked to the "Ethical Oil" lobby launched a hashtag and a website inviting donations in "the fight back against foreign celebrities and their slander."[291] One local radio station banned Young's music for a day, then polled listeners on whether or not to extend the ban indefinitely; the majority voted no, but when the station discovered that most of the majority voters' e-mail addresses were from out of town, it banned his music anyway.[292] An eerie parallel arises between the station's attitude and actions and those of the Alberta government regarding accelerating the production of the bit-sands, namely, to proceed despite the views and concerns of citizens who happen not to live in the province, and whose livelihoods presumably are not tied to extracting oil.

In 2014 Young's four-city Honour the Treaties Tour, supported by jazz musician Diana Krall, raised more than its targeted $75,000 to fund the legal fight by the Athabasca Chipewyan First Nation against the further expansion of the bit-sands, in defence of its members' constitutionally protected Aboriginal rights. Young said the tour aimed to get justice for Aboriginal people and to raise public awareness of their rights, not to be "an anti–tar sands crusade."[293] Apparently, polls conducted by both the *Huffington Post* and the *Edmonton Journal* suggested that a clear majority of Albertans supported Young's stance on the bit-sands, although there were fierce opposing views.[294]

One Albertan, whom Young's production company hired to shoot aerial footage of the sands, was particularly rankled by what he saw as selective filming by Young's film-production team in Fort McMurray[295] and by celebrities' forays into Alberta and the bit-sands. Coincidentally, since installed as leader of the Libertarian Party of Canada, Tim Moen announced his intent to raise funds to make a satirical film called *Tar Sands Messiah*, advocating environmentalism and sustainable energy to Los Angeles and its film industry.[296]

Following her latest internationally bestselling book, *This Changes Everything*,[297] Naomi Klein released its identically titled, feature-length documentary-film adaptation.[298] The film considers climate change as the catalyst for essential, fundamental change in an economic system that has failed us. It presents reducing greenhouse-gas emissions as our greatest opportunity to renew dysfunctional democracies, reduce widening social inequalities and rebuild failing economies. Filmed on five continents, the film opens on a sequence addressing the environmental damage and injustice caused by extracting the bit-sands, through the eyes of Crystal Lameman of the Beaver Lake Cree Nation, which is suing the Canadian government for thousands of treaty violations. The bit-sands are positioned as an exemplar of the evils of unrestrained capitalism and the need to cure them.

This argument finds resonance in a particularly significant development in the rising, global environmental consciousness. An encyclical released by Pope Francis in mid-2015 called for a courageous and sweeping cultural revolution "redefining our notion of progress."[299] The pontiff cited the "structurally perverse,"[300] exploitative and unfair economic system and industrial model that is poisoning "our common home"[301] and inflicting the greatest harm on the innocent poor. In framing environmental issues in general and the climate crisis in particular as a *moral* rather than a purely scientific, political or economic issue, Pope Francis echoes the pastoral letter by Bishop Luc Bouchard of St. Paul, Alberta,[302] which specifically addressed the bit-sands.

Meanwhile, evidence and claims of the perils of accelerating extraction of the bit-sands keep mounting.

Viewing the atmosphere, oceans and other natural resources as globally shared, the US-based Center for Global Development ranked Canada dead last among twenty-seven wealthy nations in environmental performance as it affects developing countries;[303] Canada is singled out for its "fossil-fuel production, high greenhouse gas emissions, and low gas taxes,"[304] its failure to adhere to the Kyoto Protocol—called "the most serious international effort yet to deal with climate change"—and its "poor compliance with reporting of biodiversity treaties."[305] Canada

enjoys further distinction as the only nation with a declining environmental score since the center's initial study in 2003.[306]

Contentious, high-profile advocacy and policy-making decisions involving the bit-sands continue. Enbridge's Northern Gateway Pipeline was approved by the Canadian government, subject to the National Energy Board's recommended 209 conditions and further talks with Aboriginal communities.[307] However, continued Aboriginal protests and the fall of the federal Conservative government,[308] compounded by sagging oil prices, suggest that the pipeline is unlikely to proceed. After an initial move to label oil from the bit-sands "dirty," as it is 22 per cent more carbon-intensive than conventional oil, the European Union diluted its fuel quality directive, a result credited to a two-year, $30-million lobbying campaign by the Canadian government.[309] And TransCanada's controversial Keystone xl Pipeline was approved by the Republican-controlled US Congress, circumventing a six-year-old administrative review, but vetoed by President Obama based on oil production from the bit-sands emitting more pollution than conventional oil.[310] In confirming the eventual, long-delayed rejection of Keystone by the Department of State, President Obama noted the pipeline's overinflated role in American political discourse and cited its failure to make a meaningful contribution to the American economy, lower gas prices or increase the nation's energy security. While praising the United States' relationship with Canada, he noted that approving the importing of "dirtier crude oil"[311] would undercut America's "global leadership" in "taking action to fight climate change."[312] However, as oil from the bit-sands continues to flow from Alberta to the US via other pipelines and rail, and, since 2014, also to Europe by tanker in light of the defeat of the EU's proposed penalties on imports of "dirty" bit-sands oil,[313] the Keystone victory may be mostly symbolic. Yet for the environmentally conscious, this remains a heady victory at a moment when the world needs decisive and immediate action toward weaning ourselves off fossil fuels, a need that Obama identified in rejecting Keystone.

By 2014 the province remained at an anticipated less than 10 per cent of its greenhouse-gas emission targets set in its 2008 climate-change

strategy (which hinged on faltering carbon capture and storage projects), and the provincial auditor general found no evidence of any planning or regular monitoring by the government of its performance;[314] moreover, Alberta remained the only province without programs addressing energy efficiency and renewable energy.[315] These joined a lengthy list of deficiencies, debacles and outrages that led Albertan voters to decisively decapitate the national-record, forty-four-year Conservative dynasty in the provincial election of May 5, 2015. In only the fourth change of government in 110 years of provincehood, voters elevated the progressive New Democratic Party (NDP) from third-party status at 4 seats to 54 of 87 seats, leaving the humbled Tories with 10 and third-party status.[316] The NDP's platform included strengthening environmental standards and leading on climate change. While optimists might be moved to celebrate a progressive or environmental turn in the province, one might note that the electoral turnout was a characteristically low 54 per cent.

Still, with a view to repairing Alberta's tarnished environmental reputation—and consequently, business prospects[317]—abroad, the new provincial government released a discussion paper, conducted public information sessions, consultations and an online survey, and produced a long-awaited, new climate-change strategy just in time for the twenty-first Conference of the Parties on climate change (COP21), held in Paris in late 2015. Aimed explicitly at repairing Alberta's blackened reputation owing to the bit-sands,[318] the strategy includes a carbon tax, a legislated cap in greenhouse-gas emissions from the bit-sands of 100 megatonnes per year (with another 10 megatonnes for upgrading and cogeneration pro-jects), in the face of an estimated output of 70 megatonnes at the time, and other measures.[319] While trumpeted as historic by its proponents, the strategy drew both praise and caution from 350.org, which observed that the plan did not go far enough to keep Canada in line with scientific imperatives to maintain global temperatures from rising by 2°C, and would certainly not stop the movement to protect the environment and the rights of Aboriginal people from the bit-sands.[320] Belying prior, alarmist, mainstream-media reports that a carbon tax would cripple economic activity, a report from an independent policy organization, Canada's Ecofiscal Commission, concluded that overall, carbon

pricing would only create significant competitiveness pressures on a few sectors, representing a small share of economic activity in Alberta.[321] Meanwhile, as noted above, the notoriously bitumen-friendly federal Conservative government fell to the Liberals, who campaigned on a more humane approach to public affairs, including a more aggressive environmental agenda.

On the scientific front, a study published in renowned journal *Nature* identifying which of the world's oil reserves must remain unburned to prevent disastrous climate change included between 85 and 99 per cent of the authors' estimate of 640 billion barrels of reserves of the bit-sands.[322] This followed reports by the Intergovernmental Panel on Climate Change (IPCC)[323] reaffirming, for example, that "[i]t is extremely likely [later defined as 95–100 per cent certainty, an increase of 5 per cent over the IPCC's initial 2007 report] that human influence has been the dominant cause of the observed warming since the mid-20th century" and that the effects will persist for centuries.[324] A reading of the IPCC's 2013 report suggests that at current rates of consumption, only about a third of the three trillion tonnes of carbon remaining in the ground can be burned and discharged into the atmosphere, so as not to reach the internationally agreed maximum rise in temperature (2°C above pre-industrial levels) at which Earth will experience the most dangerous effects of warming; if current rates of consumption persist, then that maximum will be reached by 2040.[325]

At this writing, at least three filmmakers whose work is studied here are developing further, related projects dealing with the bit-sands or our use of energy generally. Building on his earlier film, *Pay Dirt*,[326] Matt Palmer plans to release an ambitious "multi-format" documentary film, *Unintended Consequences*, offering a broad look at global energy's future. This project's apparent aim is to address the divisive and unconstructive polarization concerning the bit-sands. Charles Wilkinson, who gave us *Peace Out*[327] and *Oil Sands Karaoke*,[328] is working on the last of his filmic trilogy on energy. This one will examine Haida Gwaii (formerly the Queen Charlotte Islands), an archipelago about halfway up the coast of British Columbia, in seeking creative solutions to the problem of the human consumption of energy.[329] And David Lavallee plans to follow his

White Water, Black Gold[330] with *To the Ends of the Earth*, a film that links the world's appetite for energy to extreme energy projects like the bit-sands, in looking ahead to an ecologically sustainable, "post-growth economy."[331]

The positioning and contestation of Alberta around the bit-sands rolls on, and not least on the visual front.

5
Visually
Redefining
Alberta

Alberta's Binary Problem

WE HAVE GLIMPSED the formative role of images of Alberta in its development, focusing first on attracting settlers, then on tourism and finally on the extraction of oil. Historically, popular images deployed to promote Alberta tended to feature golden wheat fields, cowboys under open skies and soaring Rocky Mountain peaks framing impossibly azure lakes. Those images were consolidated in the provincial government's ill-fated rebranding effort, *An Open Door*.[1]

As shown in preceding chapters, the dominance of those images has been challenged by a volley of documentary films and videos produced in light of environmental concerns with extracting the bitsands. Collectively, this work has been released in theatres, on television and online between 2004 and 2014. These films offer a barrage of images such as spewing smokestacks, toxic sludge spewing from pipes, and hideously deformed fish;[2] the world's largest trucks savagely stripping virgin boreal forest;[3] and aerial views of breathtakingly immense, scarred

expanses of land denuded into a grey, deathly wasteland by open-pit mining.[4] Sweeping, panoramic aerial images of the gargantuan scope and brutality of the devastation to Earth in these and other films studied here provide a post-apocalyptic binary to the serene nirvana portrayed in the place-branding tradition followed in *An Open Door*. (This is not to suggest that as individuals or groups, participants in this study had one-dimensional views. In fact, many of them expressed a keen understanding of multiple perspectives on Alberta and the bit-sands.[5]) We have seen a seismic shift in the visual discourse around Alberta's identity, to the point that eminent public-relations practitioner Frank Calder suggests that bit-sands operations may have eclipsed the Rockies in the global public's visual imagination.[6]

The discrepancy between the preferred public persona of a place and its hidden shadow (to employ Jungian terms) creates a vulnerable "legit-imacy gap" that "threatens the dominant corporate and governmental institutions of our society."[7] If we define democracy as the capacity of the public to make a difference for itself,[8] and the public sphere as both a communicative space for discourse on public matters[9] and the primary place to advance that process, then Alberta has a serious problem. This is because the traditional discourse of identity in the province, typified by that filmic binary, seems to leave little room for dialogue, let alone compromise.

This problem is exacerbated in a place where the dominant, turbo-capitalist paradigm and its attendant utilitarian, anthropocentric view of the environment reign supreme (critics would say rampant) in a culture of twin evils: first, a "populism in reverse" that actively muzzles the expression of political dissent,[10] changing governments just four times since 1905, and second, an "electile dysfunction" manifested in declining turnouts in several provincial elections,[11] culminating in a national record-low 41 per cent in 2008.[12] Certainly, Albertan voters' turn to a progressive political party in the May 2015 provincial election and discussions between environmentalists and oil-industry representatives leading to a long-awaited climate-change strategy[13] are positive signs for proponents of actually addressing concerns such as climate change and democracy. But the customarily small electoral turnout returning the

customarily huge (albeit reduced) majority of Conservative MPs from Alberta in the October 2015 federal vote, together with the framing of that strategy in mostly economic terms and its scheduling *increased* greenhouse-gas emissions (at least in the short term) reminds us of the province's continuing dependence on oil and the enormous political inertia favouring business as usual.

Although the documentary film provides a useful and increasingly popular vehicle for members of a counterpublic (with the requisite resources) to express their dissent—and thereby enrich the democratic public sphere—it does not solve one fundamental problem of representing Alberta. That problem is that the discussion is apparently being led by elites. Certainly the heftiest elites are the hegemonic forces vested in furthering and even accelerating the status quo, namely the oil industry, its sycophants in the business of administering public revenue (the Albertan and Canadian governments, at least until both the federal and provincial Conservative governments fell in 2015) and the "mainstream" media, which has been sponsored by the oil industry.

Meanwhile, the leading exponents of opposition in this visual discourse (the counterpublic), by dint of their level of skill and access to traditional, more widely seen and publicly trusted avenues of distribution (theatre and television) are *professional* filmmakers. It is easy (and accurate) to view their efforts to take on a massive, powerful industry as David vs. Goliath, but their professionalism gives them an advantage over amateur filmmakers. In staking out such sharply competing visions of Alberta and Albertans' actions and attitudes about environment and economy, these independent, professional filmmakers and the PR professionals representing industry and government are furthering a binary that could omit a kaleidoscope of other interests and viewpoints in the province.

A modernist, essentialist view would hold that a place can adopt a single, monolithic identity that embraces the diversity of its geography, demography, history and culture. But a more open, pluralist view would question the long-standing hegemony of capitalism, patriarchy, heterosexism, individualism, consumerism, and white privilege, among other deeply entrenched framings of power in our society.[14] More likely,

different people and cultures affect each other, resulting in the ongoing contestation and renegotiation of identities, a process accepting of, and based on, *multiple* identities and interdependence rather than polarizing binaries.[15]

For some social scientists, identity is no longer defined as an unchanging set of traits specific to a group but mainly as a social construction, as a means of relating to other people and other groups.[16] Indeed, place-identities are (re-)formed, "through practices of visual inscription, transgression and contestation," creating "potential communities and alternative place-identities...continually being imagined and inscribed across its land and mediascapes."[17] So identity is situational, and the imagining of a community is never truly complete but always a work in progress.[18]

On this view, representations of identity in Alberta could involve and reflect a process that's contingent, iterative, participatory and socially constructed. This process may be influenced strongly by the natural environment, but we should avoid the modernist trap of environmental determinism that characterized earlier representations of place and identity[19]—the notion that one's identity is dictated solely by geography. As well, if we accept that relations of power are socially constituted, "then the main question for democratic politics is not how to eliminate power but how to constitute forms of power more compatible with democratic values."[20]

Thus, any redefinitions of Alberta must be more representative, not only in the content but also in the process of representation. People may be more likely to engage in that redefining process if the instigating content—in this case, imagery—is more open, reflecting diverse publics and counterpublics. The visual practices of both the provincial government and industry on one hand, and the dissenting, documentary filmmakers on the other run counter to this, but understandably so, given their respective missions. With the exception of the Alberta government's rebranding effort in *An Open Door*[21] and its marketing video, *A Day in Alberta*,[22] none of the productions studied here aimed to represent Alberta's *identity* to the world, even if they might have that effect.

The government's prior approach echoes a well-established practice of presenting nature in isolation, a fundamental flaw that will be discussed below. For their part, the dissenting filmmakers often depict environmental risk that is not only removed from people's everyday life but also shown on a massive, industrial scale. As such, their images may cause audiences to appreciate the existence and importance of ecological threats, but this does not necessarily boost people's engagement and their initiative to effect change.[23]

So how might independent filmmakers and public- and private-sector communicators help to redefine Alberta in a way that represents, and perhaps even engages, a broader audience than the polarizing practices characterizing the visual battle to represent Alberta in the public sphere today? Three possible avenues to that end are using images that could be more *realistic, balanced* and *forward-looking* in representing Alberta's identity and the values for which Albertans stand than some of the visual binaries that we have seen. This chapter will suggest factors that could inspire such new imagery.

Realistic Imagery

In advocating the use of images of Alberta that are more realistic than the polar opposites advanced by publics and counterpublics today—pristine and despoiled landscapes, respectively—we must be careful not to construe realism as simply reproduction. In a pre-Enlightenment project, Descartes led the recognition that our basis of making meaning shifted from similarity (resemblance) to difference (representation).[24] Representation dominates much writing on the visual, the main point being that the thing seen—the representation—exists in its own right, not merely as a substitute for the thing unseen and represented.[25] A visual representation has further features: (a) its form follows a set of conventions or codes, rather than what it represents; (b) it articulates and contributes to social processes; and (c) it implies an intended recipient.[26] Moreover, it is laden with political meaning.[27]

Given these features, one way to address realism is to treat it as an issue of threshold resonance and credibility. Essentialism—the notion

of a single, determinative answer to a problem—won't work here because an image has not only three *sites* where meaning can be created (production, image and audience) but also three *modalities* that can influence meaning by virtue of its context (technological, compositional and social).[28] The infinite panoply of subjectivities involved makes it difficult to generalize as to how viewers might respond to any specific imagery. However, we will assume here that the heart of any good story, whether told in images or otherwise, is "an emotional tide—the ebb and flow of human connection," the notion that people are somehow together in the world.[29] In this light, a fundamental factor that might negate engagement or "realism" for many viewers of imagery depicting nature as either pristine or despoiled is the absence of *people* from the image.

Another factor affecting potential resonance and credibility for viewing audiences is that there is no single "nature," but a diversity of "natures," each constituted (and contested) through diverse socio-cultural processes—reflecting or opposing dominant ideas of society—with which those natures are inextricably intertwined.[30] For environmental historian William Cronon, "Wilderness hides its unnaturalness behind a mask that is all the more beguiling because it seems so natural. As we gaze into the mirror it holds up for us, we too easily imagine that what we behold is Nature when in fact we see the reflection of our own unexamined longings and desires."[31]

This is why a documentary film like Ken Burns's *The National Parks: America's Best Idea*,[32] which reverently regards nature in isolation in the finest tradition of Romantic landscape painting and photography, is criticized for sapping nature's essential relevance and political power.[33] It does so by portraying nature as a sublime well of self-discovery and a national icon rather than as a physical place with its own history.[34] This may also help to explain why Al Gore's film, *An Inconvenient Truth*,[35] enjoyed widespread popular and critical acclaim, as it incorporated an affective, personal narrative in addition to notions of nature as sublime, stylized apocalyptic rhetoric, and the time-honoured rationalism of science.[36]

This variety of approaches may echo the difficulty in adopting any single perspective on nature today: our cultural readings of nature "may

well be as contradictory and as incongruous as the symbolic action that animates this [Gore's] film."[37] All of this suggests that reflecting or at least recognizing human presence in, and human impact on, nature in a documentary film might make it more "realistic"—that is, relevant and engaging—for audiences.

Related to the audience detachment that may accompany an unpopulated landscape is the notion of the tourist's "gaze," for which pristine images of Alberta are both figuratively and literally a poster. The implications of this idea become apparent in looking at traditional images of Albertan landscapes—from a federal-government pamphlet promoting (Caucasian) settlement of the prairies[38] to the province's shilling for business and tourism through its scenic "Alberta Train" trip linking Vancouver and Whistler a century later at the 2010 Winter Olympics.[39] Not only do we fail to get closer to what we are looking at, but we may actually detach ourselves affectively from having looked.[40]

On this theory, as communications scholar Anne Marie Todd tells us, "[v]isual rhetoric creates distance that allows us to pretend we are not seen and to ignore the implications of tourist practices: that in our pursuit of the visual, we change the world."[41] This is because "[i]mages of nature do not provide us with a vision of nature itself, but a version of nature rendered aesthetically pleasing, for human consumption."[42] Todd's study of a photo-essay of Africa in *National Geographic* magazine found an environmental aesthetic based on the *consumption* of place, encouraging readers to ignore the environmental impact of tourism and thus effectively making Africa invisible. This begs Todd to suggest that viewers "broaden the frame of tourist discourse to reveal what is not shown in the photos" and seek context and perspective in perusing tourist texts.[43]

Todd's investigation parallels developments in human geography, where landscape came to be understood as a synthesis of physical and human elements comprising a specific region. Subsequently, humanistic and cultural scholars[44] have argued that a landscape incorporates aspects of the cultures of the people coming into contact with it.[45] For the purposes of broadening the frame of the discourse of identity in Alberta through documentary film, for example, this suggests a need to

help viewers by providing contextual clues to the landscapes beyond the images of those landscapes. These clues may be in other images or via sound—that is, narration, dialogue, music or other effects—either diegetic (occurring during the shot, whether in the frame or not) or non-diegetic (added later). The clues could also reflect aspects of the culture of the people who live in, or otherwise affect or interact with, that land, relating to the land itself.

Literature also suggests that visually depicting a landscape implies not only detachment but also power over both the scene and its representation, furthering the dominant anthropocentric ideal in Western society. This is advanced in the case of still photography by Susan Sontag, who argues that privileging and extracting our visual sense detaches us from nature and thus invites our desire to commodify and acquire it, rather than engage with it emotionally.[46] Similarly, critical theorists suggest that landscape cinematography encourages a possessive and commodifying attitude toward the land that serves the interest of property-owning classes, reinforcing the dominant cultural ideologies responsible for environmental harm.[47]

However, one can argue that a shot of a vacant landscape does not innately signify the separation of human beings from nature, nor the desire to master and exploit nature: "[r]ather, an interpretation of this kind depends on the spectator's prior knowledge of radical environmentalism, which provides the viewing context within which the image can be interpreted in that way."[48] Another possible interpretation of the sublime, "possessory" or "magisterial" gaze might be that it engenders humility before the splendour of nature and a consequent wish to preserve that landscape.[49] A deeper analysis would examine not just representations in a film but also its discursive and narrative structures, intertextuality and capacity to extend or alter views of the larger world, along with the production's physical effects on the environment.[50]

All of this suggests that a more "realistic" visual redefinition of Alberta could build stronger connections between its natural majesty and the humanity with which nature is inevitably interconnected, physically, biologically, emotionally and spiritually. But this means more

than merely populating scenes of prairie harvests, hoodoo havens or Rocky Mountain hiking trails. Certainly pristine "wilderness" and heavy industry are both part of quotidian reality for many Albertans, but any attempt at portraying the essence or (from a more suitably postmodern perspective) even *an* essence of the province really ought to include what sociologist Henri Lefébvre called "spaces of representation"[51]— depictions of how the place is actually lived in by Albertans.

This could include Albertans addressing questions illustrating, for example, (a) who we are, (b) where we live, (c) how much we learn, (d) where we work, (e) what we have achieved, (f) what we believe, (g) how we inspire ourselves and (h) how we see our place in Canada. Beyond the familiar imagery cited above, precious little in the volley of film and video through which Alberta's identity is being contested today gives an inkling of a response to any of these elementary avenues of inquiry. Of course, only two of those productions—Alberta's ill-fated rebranding video[52] and subsequent marketing video[53]—aim to do so explicitly. Each of these eight, non-exhaustive sample questions will be touched on here, along with related factors that could help to visually redefine Alberta.

Who Are We?

If you use median age, Albertans boast the youngest population among the provinces (although Nunavut and the NWT are younger),[54] with by far both the fastest-rising population under fifteen years of age[55] and the lowest proportion of seniors among the provinces.[56] It is the only province in which males outnumber females, at a hair over half of the total head count,[57] and it has been the nation's largest producer of both "traditional" two-parent families[58] and babies.[59] It is also expected to lead the nation in population growth over the next quarter-century.[60]

Alberta is a major destination for migration within Canada,[61] though in the 2006 census, its international immigrant population of 527,030 (16 per cent of the total) was 4 per cent under the national average,[62] and its visible-minority population of 454,200 (14 per cent) was 2 per cent under the national average in 2009.[63] Alberta hosts a leading 23 per cent of Canada's Métis population.[64] With just over a tenth of Canada's

population, the province accounted for 20 per cent of national population growth between 2001 and 2011[65] and claims to have led North America in population growth from 2004 to 2014, at 27 per cent.[66]

A film purporting to portray Albertans might depict some of these trends. Alberta's large lead in youth, in-migration and population growth seem particularly notable, and could be represented through images of actual people, beyond any narration or scientistic graphics.

Where Do We Live?

Rooted in popular visions of the West and the prairie, Alberta boasts a defiantly rural identity. Noting that "[w]e have been obsessed with the land and its meaning for us for over a century," writer-scholar George Melnyk observes that western city-dwellers are "caught in a vise of an urban-denying identity rooted in a glorification of agrarian settlement" and that "[t]he land distinguishes us, while the city does not...Cities are not open, free or natural as the agricultural landscape."[67]

Urbanization is not unique to Alberta, but "in no other province has the domination of the city over the countryside been accomplished so abruptly":[68] between 1911 and 1941, the urban population crept from 37 to 39 per cent then leaped to 73 per cent by 1971 and jumped further to 82 per cent by 2006,[69] ranking it among the most urbanized provinces in Canada. Yet the face of Alberta remains resolutely rural. In the provincial election in 2012, for example, the approximately one-third of Albertans who lived outside of Calgary and Edmonton got to elect more than half of the province's MLAS. Even after the election of a progressive government in 2015, most Albertan MLAS remain older, Caucasian males. And in popular culture, words and images continue to glorify a mythical, rural West, largely devoid of people and dominated by vacant landscapes.[70]

A visual redefinition of Alberta should acknowledge the dichotomy (if not celebrate the absurdity) of a province characterized by "a rural soul with a developer's appetite."[71]

How Much Do We Learn?

Confounding condescending images of rusticity brandished by some pundits in the national media, Alberta's history reveals a persistent

commitment to education and training. Its first premier, A.C. Rutherford, called universal education "the greatest glory of our province" and bragged about importing Ontario's best teachers and paying the highest teacher's salaries in the country.[72] By 1916, with a primarily rural population of just under half a million people,[73] the province had fourteen post-secondary institutions: a university, the first publicly funded technical institute in Canada, two "normal" schools for teaching teachers, three agricultural schools and seven privately supported colleges.[74]

More recently, Alberta boasted twenty-seven universities, colleges, and technical and specialized arts and culture institutions, yet university participation was only 17 per cent, while other provincial totals ranged from 21 to 28 per cent.[75] This may relate to plentiful and lucrative job opportunities in the oil industry, at least when the commodity price is high.

The province cites OECD statistics of examinations held in seventy-five jurisdictions (including all of the Canadian provinces) in 2012, indicating that Albertan students posted the eighth-highest average score in science, the eighth-highest score in reading and the seventeenth-highest score in mathematics.[76] These rankings fell from second, fourth and seventh, respectively, in a like study conducted in 2006.[77] The province has since dropped its claims to rank "among the most skilled and educated populations in North America" and "among the world's best in terms of the quality of education."[78] Alberta did rank first in each of the five years of a study of formal and informal lifelong-learning opportunities across the country by the Canadian Council on Learning.[79]

Such a recognized affinity for self-improvement warrants representation in any discussion of Alberta's identity, and so visuals in a reimagining of the province could include Albertans of diverse ages, backgrounds and circumstances engaged in the diverse array of (in)formal, lifelong learning opportunities offered in Wild Rose Country.

Where Do We Work?

Despite the prominence of energy in the province's economic history and visual imagination, only 5 per cent of Albertans worked in mining and oil and gas extraction in 2014.[80] Other sectors include trade (presumably wholesale and retail, employing 13 per cent of the provincial work

force); health care and social assistance (11 per cent); construction (11 per cent), professional, scientific and technical services (8 per cent); accommodation and food services (7 per cent); manufacturing (6 per cent); transportation and warehousing (6 per cent); education (5 per cent); finance, insurance, real estate and leasing (4 per cent); with the remaining 25 per cent of the workforce otherwise occupied in smaller segments.[81]

Yet despite its small share of the workforce, the energy industry produces almost one-quarter of Alberta's GDP, followed by finance and real estate (14 per cent), construction (11 per cent), business and commercial services (11 per cent), and retail and wholesale (9 per cent); agriculture accounts for just 2 per cent.[82] Fuelled by soaring energy prices and bituminous investment, Alberta's economy led the nation in average annual economic growth over a period of twenty years,[83] although its singular dependency on energy for employment and GDP— and thus the vagaries of commodity markets and other forces beyond its control—makes its economy the most volatile in Canada.[84]

While boosting Albertans' overall standard of living, such growth also taxes everything from the province's health system, social fabric, and highway safety, to high-school dropout rates and limousine rental services. Perhaps most insidiously, if the First Law of Petropolitics[85] applies as Nikiforuk[86] and others[87] suggest, then Alberta's growing reliance on revenue from the bit-sands also diminishes the quality of democracy and the Alberta government's responsiveness to both the needs of its citizens and the environmental expectations of the global community.

Alberta has recorded the widest gap between rich and poor,[88] and both the largest rise in lower-income population and the lowest welfare income in Canada during the economic downturn of 2007–2009.[89] Working women have earned only two-thirds of their male counterparts' earnings, tied for the lowest rate in Canada, and the gulf between rich and poor continues to widen.[90] Albertans have recorded the most working hours and the least leisure time in Canada.[91] Coincidentally, Statistics Canada has found that residents of Albertan cities report less satisfaction with life than the Canadian average.[92]

A visual reimagination of the province could account for Alberta's singular economic situation and its effects on how Albertans live and what they value. This would include images of Albertans toiling in sectors as diverse as aeronautics, folk art, and emu ranching, in addition to the usual suspects, and visual indications of the striking contrasts among working and living environments in the province.

What Do We Achieve?

Beyond the geological gift of its immense resource wealth, Alberta has punched above its weight in terms of its contributions to fields as varied as constitutional development,[93] the arts,[94] and health, education and athletics, among others.[95] In this, the province exemplifies its self-declared "can-do" spirit[96] as well as the deeply entrenched notion of the West as "a tabula rasa where people could write their own destinies free of the limitations of privilege and tradition that hampered advancement in the East and in the Old World."[97] As historians observe, "[e]ven today the rhetoric of the West as Promised Land is used by the Alberta politicians to present the province as a free enterprise conduit and ideological Mecca."[98]

One would do well here—and throughout such a visual project—to adopt a primary goal of New Western History and tell stories beyond the dominant white, patriarchal, colonialist narratives[99] that have animated identity projects in the region to date. Imagery reflecting a more "realistic" Alberta could include representations of Albertan innovators and achievers—individually and particularly collectively, well-known and lesser-known—and physical manifestations of their achievements, be it treatment for Type 2 diabetes, women as legal persons, high rates of volunteerism or the world's largest pyrohy.

What Do We Believe?

As I have argued elsewhere,[100] Albertans transcend what one scholar aptly capsulized as "the ghoulish image of Alberta that haunts the imagination of many progressive Canadians: that of a highly aggressive and politicized province full of self-satisfied rednecks, militant

bible-thumpers, and mouth-breathing rural bigots."[101] For example, Alberta's enduring and notorious discontent and alienation obscure its strong tradition of productive social criticism;[102] its arch-conservative reputation masks a history of radicalism and labour reform;[103] and its bible-belt image is bedeviled by evidence that, per capita, the provincial population is actually the second-*least* religious in Canada in terms of reported religious attendance and self-identification as having no religious affiliation.[104]

Yet the province has its dark sides, being particularly harsh on its vulnerable and underprivileged citizens. For example, Albertans have racked up Canada's highest rates of family violence, homicide-suicides, and stalking, and have a low minimum wage, social-assistance rates far below the poverty line, severe income disparities for Aboriginal people, and the lowest sense of belonging to their communities in the nation.[105] The province showed shameful hesitation both in signing on to the United Nations Convention on the Rights of the Child (only after encouragement from Archbishop Desmond Tutu)[106] and in amending its human-rights legislation to prohibit discrimination based on sexual orientation (only after fighting it up to the Supreme Court of Canada and then waiting another dozen years to make it explicit).[107]

As for economic development and environmental protection, Alberta's laissez-faire approach to doubling down on the bit-sands despite calls to slow down from environmentalists, civic leaders in the Wood Buffalo region, Aboriginal leaders and, for non-ecological reasons, even some oil companies[108] trumpets how much anthropocentric values have dominated provincial public policy. On the other hand, at a grassroots level, the Green Party garnered more votes per capita in Alberta in the 2006 federal election than anywhere else, although the province slipped behind Yukon and BC in both the 2008 and 2011 national campaigns,[109] and then slid down to ninth out of thirteen provinces and territories, and below the national average, in the 2015 federal election.[110]

A visual redefinition of Alberta would add imagery belying stereotypical caricatures of Albertans' values and could depict counterpublics such as hard-core cyclists, dedicated labour advocates and new-age atheists of indeterminate sexual orientation.

How Do We Inspire Ourselves?

Beyond Alberta's perceived mantras of industrial progress and cowboy monoculture bubbles unabashed support for the arts. For example, in each of eight consecutive years, between 86 and 91 per cent of Albertans attended or participated in arts events.[111] Also, a survey of 15,000 households by Statistics Canada revealed that Albertans led the nation in consumers' cultural spending in 2001, 2003 and 2005, and were almost twice as likely to spend money on concerts and theatre as on hockey and football.[112] As one of Alberta's most lauded writers, Aritha van Herk, asserts, "[w]ithout a vibrant culture, we may be the richest of all provinces, but we will lack a soul,"[113] and without the inspiration of politicians, writers, musicians, journalists and others "fiercely believing that Alberta is a place worth fighting with, fighting for and fighting to change...Alberta would be just another destination on the roster of escapes for the rich and the restless."[114] Toward that latter point, Albertans lead the nation in per-capita retail spending,[115] in keeping with what filmmaker Charles Wilkinson notes is popularly perceived as a culture of consumer excesses in the province.[116]

Imagery capturing this aspect of Albertan life, not widely known outside of the province, could include some of its more unexpected aspects, such as a Beethoven in the Badlands concert, Canada's (apparently) only gay rodeo and music festival, or an unusual preponderance of "world's largest" roadside oddities. It could also include accomplished contrarians like painter Jane Ash Poitras, political blogger Dave ("daveberta") Cournoyer, and the province's senior documentary filmmaker, Tom Radford. Their work echoes the call of scholars of New Western History against furthering hegemonies through compliance or silence, "even to the point of presuming now and then to beat a self-appointed moral conscience of...society."[117]

Where Do We See Our Place in Canada?

Typically lost in the historical barrage of protest against Ottawa,[118] and notably absent from the discourse of Albertan identity, is reference to the province's status as an active contributor to Confederation on a variety of fronts. These impacts transcend paying into the federal equalization program to mitigate fiscal gaps among the provinces.[119]

Provincial control over natural resources found in the province, won after decades of constitutional quarreling, and Alberta's overwhelming economic dependence on the United States—particularly as the primary market for oil from the bit-sands—seem to relegate Canada to the sidelines in the discourse of identity in the province.

For example, as noted earlier, Alberta's singular appearance at the 2006 Smithsonian Folklife Festival in Washington, DC, (organized by the provincial government) notably downplayed the province's Canadian-ness in pitching its "secure" and "friendly" oil supply directly to its American hosts and their audience.[120] However, grassroots voices tell a larger story. Bucking tired stereotypes of alienated westerners, polls have shown that 71 per cent of Albertans feel very attached to Canada,[121] and 68 per cent of them are more likely to see themselves as Canadians before any other nationality;[122] both results lie roughly at the national average. In a study of more than 2,000 Canadians aged 12 to 30 by the Carleton University Survey Centre and the Department of Canadian Heritage in 2004, more than 87 per cent of young Albertans felt close to Canada, which was 2 per cent above the national average, but the second-lowest after Québec.[123]

A visual reimagining of Alberta's identity would show its citizens' connections to Canada, not merely through numbers on a transfer-payment ledger but through physical expressions of the diverse origins, imported traditions, perceptions and nuanced feelings of the hefty contingent of Albertans hailing from, or otherwise connected to, other parts of the country. One sociologist sees that volume of in-migration as transformative of Canadian society.[124]

Of course, no single film or other work can do justice to all of the foregoing or many other aspects of Albertan identity. But beginning to add them to the visual discourse would mark an important inroad into the dialogically and democratically vital—but perhaps less resonant, less engaging and therefore less "realistic"—polar binaries focusing (in)directly on the bit-sands and fuelling that discourse today.

Balanced Imagery

A second possible way to depolarize the visual discourse of identity in Alberta seems obvious: to deploy more balanced imagery. The foregoing discussion on realism as a means of engaging viewers in dialogue also applies to introducing a more even-handed approach to Alberta's battle of images. Yet the idea of balance itself raises practical difficulties along the lines associated with the essentialism marking the modernist project. As noted earlier, images are hardly neutral.[125] On the contrary, as scholars note, "the special qualities of visuals—their iconicity, their indexicality, and especially the syntactic explicitness—make them very effective tools for framing and articulating ideological messages."[126]

In visual studies, "framing" is choosing one view, scene or angle when making, cropping, editing or even selecting an image.[127] Visual framing is a continuous process of culling that "begins with the choice of subject, followed by the selection of what pictures to take, how to take them (angle, perspective, assumptions and biases, cropping and so on), and which ones to submit...and continues...with decisions about which images to publish, what size to make them and where to position them."[128]

So how can a visual balance be struck in a resource-based jurisdiction like Alberta?

One way might be to work toward a synthesis of the two opposing polarities. Such a comingling could begin with the views of non-elites, vested with neither political and economic interests in resource extraction, nor connections to organized environmental opposition to reaping bituminous bonanzas. Missing from the discourse of identity in Alberta are representations from Albertans on the street, the people beyond either the pastoral or pulverized landscapes. We should see, and hear from, Albertans expressing their hopes and concerns for their province, exploring both the advantages and disadvantages of current, proposed and new policy directions related to the continued, accelerated exploitation of what may well be the world's largest energy project in their own backyard. In conducting random, street interviews for my documentary film,[129] I was struck by the volume of thoughtful responses that did not slide neatly toward either polar extreme on the issue.

On the governmental side (undeniably anthropocentric, given the status quo), a far more balanced provincial branding video could include citizens interacting actively with nature and urbanity alike, as well as narration and sloganeering emphasizing human connectedness and fulfillment—still "safely" within the dominant capitalist paradigm. This is in contrast to depicting the pursuit of individual gain, which accurately (but disadvantageously) captured Alberta's turbo-capitalist zeitgeist in its branding video, *An Open Door*.[130] An example of a more humanistic ethos is a rival branding video, *Now Is the Time to Be in New Brunswick*,[131] which embraces visual opposites like skyscrapers and forests, car traffic and lighthouses, industry and art, business and recreation, individuals and families—exemplifying the notion of place as something that is lived in.[132] As for the physical landscape, Alberta's provincial curator of botany, Roxanne Hastings, ranks Alberta as having among the greatest biological and geological diversity on Earth,[133] meaning that a visually redefined Alberta should depict far more than cows, canola and Cascade Mountain.

On the more ecocentric side embraced by the dissenting documentary filmmakers, a redefinition of Alberta must reconsider the currently preferred usage of apocalyptic imagery in rhetorical appeals to fear. Scholars suggest that such appeals are of limited utility in environmental communications for three reasons.[134] First, there is significant temporal and physical distance between the destructive actions and the environmental effects on the audience. Second, the scale of those effects is so grand that individual citizens may perceive neither personal responsibility nor agency. Third, it seems difficult to motivate people to change their behaviour through threats. A contrary view suggests that apocalyptic rhetoric instills a greater sense of the importance of an issue than reassuring messages and that individuals respond to appeals based on threats with a stronger focus on taking collective action.[135]

In any case, caution is required when using fear in environmental communication.[136] Research indicating that care for the next generation has been an effective motivator in health communication suggests that such a long-term view could be deployed to direct people to an environmentally sustainable lifestyle, although this remains to be proven.[137]

Albertans may well be receptive to such preventive rhetoric: in the early 1990s, Premier Ralph Klein successfully justified and gained support for his agenda to slash government spending by 20 per cent by likening the province to a household and appealing to the promise of a debt-free future for our children. This may have struck a chord deep in the provincial psyche, as Alberta suffered the humiliation—unique in Canada—of defaulting on its bonds during the Great Depression, after overextending on infrastructure spending during its early years of provincehood.

So images of young people reacting to Alberta's environmental devastation wrought by the bit-sands—maybe a latter-day answer to the memorable "Crying Indian" anti-pollution TV ad[138]—may put a more human face on the threat sought to be mitigated. But at the same time, the economic benefits of the project should also be depicted—the youngsters' parents working (in)directly in resource extraction, supporting the family home—thereby expressing the need for public dialogue and compromise in clear, visual terms, and moving toward greater balance in the visual redefinition of the province.

Forward-Looking Imagery

The temporality of imagery is particularly important when its focus is on articulating the identity of a place, because excessive focus on either the past, the present or even the future can be counterproductive. Identity in our society today is fluid rather than fixed, contested rather than constant, and multidimensional rather than monocultural.[139] Consequently, framing place-identity as frozen in any point in time risks disengagement, if not alienation, from intended audiences for a project like a film. A documentary film, by its very nature, can only present a static snapshot of what it purports to represent, and serious productions tend to take protracted periods to plan, fund, execute and distribute. However, a significant part of the discourse of identity in Alberta today is unfolding in cyberspace, which trades on content that can be produced and shared far more quickly and affordably than allowed by the cumbersome structures of creation, production and distribution hallmarking technologies of older media like film and television.

This is why presenting history as the present is particularly problematic when it comes to place-identity. As noted earlier, visual representations of Alberta and the prairies in particular have been overwhelmingly rural and disconnected to our ever-increasing urbanity.[140] This practice today continues with the province's official imagery, for at least two reasons. First, as a political process, that imagery encodes and reinforces the dominant ideology of tourism culture, part of a global system that expressly involves constructing places and "the progressive perpetuation of Western ideology embedded in the power structures of global production and consumption."[141] Second, the cinematic treatment of Canada has always been characterized by colonialist images of unspoiled, unpopulated wilderness, in contrast to Europe's historical urbanity and America's bustling cityscapes.[142]

Yet marginalizing prairie dwellers in the rose-tinged nostalgia of the rural past is perilous and jejune, as it excludes Aboriginal people, urbanites and all manner of immigrants who continue to play an increasing part of prairie life.[143] As one scholar declares, "It is not just that general Canadian culture constructs the prairies as a region in decline, but that in a search for identity, those of us from the prairies are invited to cling to an artificial, land-based nostalgia that locates us and our place firmly in the past."[144]

Indeed, the popularity of books like *Prairie Dreams*,[145] *If You're Not from the Prairie...*[146] and *The Perfection of Morning: An Apprenticeship in Nature*[147]— contrasted with the more diverse, accurate and contemporary *A Prairie Alphabet*[148]—may be due to their "easy appropriation by the dominant culture through its reinforcement of prevailing stereotypes."[149] And the parade continues with picture books like *A is Alberta: A Centennial Alphabet*,[150] which allows only two cityscapes and nine images of people (three cowboys, two painters, a canoeist and some tourists) onto its twenty-six pages.

Certainly, Alberta's provincial centennial in 2005 unleashed its share of visual boosterism,[151] typically celebrating the past and pointing to a bright future. This is a common strategy of remembrance, dutifully consistent with anthropocentric narratives of economic progress and perpetuating the marginalization, if not erasure, of Aboriginal, feminist

and postcolonial legacies.[152] Rather than advance the discourse of identity in Alberta, much of this sort of imagery seems to retard it.

Thus, the past, while infinitely rich in gifting us with benefits like wisdom, understanding and emotional comfort, can be a trap when it comes to advancing the discourse of identity in Alberta. As historian Brian Dippie reminds us, a primary paradox of western Canadian mythology is that "the West was eager to sell itself to the nation as a dynamic, progressive region, even as the nation was looking to it to freeze the past and remain a bastion of unchanging pioneer values."[153] So there is substantial inertia working to perpetuate the familiar images that have served to put a pretty face on Alberta (and other places). More diverse and contemporary imagery that transcends our agrarian past and the scenic Rocky Mountains (as discussed above) would present a more forward-looking, as well as more balanced and more realistic, view of Alberta's place-identity.

But just as the traditional, pristine images of the province's natural majesty and rural beauty fall victim to the past, so might the new wave of ecologically catastrophic images become mired in the present. If purveyors of these latter views wish to move beyond trying to shock or scare viewers into taking action against the status quo on the bit-sands—as valid and necessary as that might be—they could augment their visual palette. For example, they could depict Albertans engaging in activities that create or rely on more sustainable energy solutions, such as solar, wind and geothermal power. These sources are in ample supply in Alberta, ready for further innovation and development from a significant research base comprising its scholarly and technical institutions and Canada's oldest provincial research council. Through images depicting scientists, researchers, (professional and amateur) inventors, cyclists and especially citizens demonstrating ecologically responsible practices in daily life, Alberta could present itself as working toward a solution to the world's spiralling addiction to oil rather than as a prominent feeder of it.

Pluralism, Anyone?

Since European contact, Alberta has been represented anthropocentric-ally as a place to be exploited for personal gain, typically in florid terms and, ironically, through seemingly ecocentric images trading on its vast and pristine natural majesty. Within the last decade, a growing counter-public opposed to the relentless and accelerating exploitation of the bit-sands has occupied the opposite visual polarity, presenting images of devastation of Alberta's boreal forest and water, and its ever-increasing harm to ecosystems, wildlife and people. Although all of these images serve the interests of their purveyors and have their place, Albertans and their filmmakers seeking to produce work exploring and expressing their identity and values can transcend these (un)conscious perpetuations of ideology through oversimplified, clichéd (if dramatically either gorgeous or horrifying), essentialist imagery. We have the power to share a more pluralistic, inclusive and engaging representation of the complex, ever-shifting sands of identity swirling around Alberta today.

In seeking to provide more realistic, balanced and forward-looking imagery to frame and advance a reimagination of the province, we would do well to consider a more critical, pluralist and global turn. This involves "challenging or deconstructing conventional meta-narratives, focusing on minorities or what postmodernists call 'Others,'...looking at Western Canadian society [for instant purposes, Alberta] from a global rather than a national or regional perspective."[154] It also involves widening our lenses to draw on cultural, feminist, postcolonial and environmental approaches, methods and theories[155] to present views beyond those of a dominant, white, testosterone-choked, consumers' utopia.

Ultimately, a less elite-led and more inclusive and widespread visual redefinition of Alberta stands to make a deeply needed contribution. It could invigorate the paralyzing political monoculture and the polarized public sphere characterizing the province today. And maybe, just maybe, a visually redefined Alberta can begin to tilt the balance toward an iden-tity (and a future) that we could leave with pride to those who will inherit the consequences of what we do, or don't do, today.

6
Implications

THIS STUDY EXAMINES a disparate body of film and video work by
independent filmmakers from Calgary, Edmonton, Lethbridge, the
lower mainland of British Columbia, Winnipeg, Toronto, Montréal,
Los Angeles, Austin and London, as well as senior Alberta-based public-
affairs professionals from the Government of Alberta, the oil industry
and a private PR firm. Situating their creations in a discourse from
2004—approximately when the United States recognized that extracting
the bit-sands was economically feasible[1]—to 2014 reveals significant
links among representations of Alberta and flows of power advancing or
contesting forces of neoliberalism, globalization and consumerism.
In the latter case, this particularly covers not only oil and its ubiquitous
by-products (which, as three participants pointed out, include film-
camera parts) but also tourist landscapes.

In considering the discourse of place-identity in Alberta as it unfolds
against the backdrop of resource extraction and the rising tide of related

environmental and other concerns, one is struck by the rising profile of the bit-sands during the last decade. The resource has become not merely a massive physical and economic enterprise but also an emerging symbol of the costs of human development in a world run—indeed, *overrun*—by neoliberal imperatives and fuelled largely and literally by their signature manifestation: extractive capitalism.

Positioned visually (and otherwise) as a frontier for economic advancement since European contact during the fur-trade epoch, Alberta has evolved through the economic—and in the public mind, visual—dominance of ranching, wheat farming and conventional oil extraction, always buttressed by tourism due to its spectacular landscapes. Today, unconventional oil from the bit-sands seems to have overtaken cowboys and the Rocky Mountains as the primary symbol of the province in the global public's imagination.[2] (Citing the energy industry's co-opting of the visual and verbal rhetorical power of Alberta's ranching heritage, Frank Wolf observes, "The cowboy, the Western 'heartland' glamorous image in language is applied to oil and gas. But you can't compare the cowboy on the range to the guy waist-deep in a tailings pond."[3]) This echoes conflations of Alberta and its principal economic sector by its elites, as in the provincial government's showcasing the industry and its technology at a supposedly cultural exhibition at the Smithsonian Folklife Festival in Washington, DC, in 2006;[4] in one of Canada's largest museums, celebrating the role of oil and gas in "creating the Alberta identity";[5] and in the Canadian Association of Petroleum Producers' campaign declaring that "Alberta Is Energy."[6]

However, from a critical perspective, this study supports the claim that construing a place as an apparently cohesive whole in accord with dominant images of that place opens that constructed totality to contestation and disruption by counterpublics.[7] These dissenters may have more legitimacy and may better reflect public discourse than traditional actors like the state and industry. That a singularly prominent, emerging forum for dissent against Alberta's (mis)management of the bit-sands is documentary films created by participants in this study speaks to two phenomena. First, visual representations have powerful allure in an

arguably ocularcentric world.[8] Second, documentary films can evoke strong emotions aimed at inspiring corrective social action,[9] or at least dialogue and debate. Greenpeace's advocacy/art film, *Petropolis*,[10] cited by several participants in this study, and the battery of online postings by viewers of the CBC's broadcasts of *Tar Sands*[11] and *Tipping Point*[12] evince the power of the eco-documentary to meet those ends—and express the critical researcher's ethic.

Conversely, the Alberta government's ignoring the province's economic foundation and initially co-opting a Scottish beach in its rebranding video, *An Open Door*,[13] testify to the far-flung public derision that can answer less successful efforts to depict place-identity in an age of unprecedented global competition for tourism, trade and investment cash, in which place branding plays a critical role.[14] *An Open Door* grounded a critical case study in place branding, centred on the bit-sands as an emerging flashpoint and bellwether among the mounting tensions of seeking to accommodate economic, ecological and other aims in a resource-based economy.

Several overarching points emerge from this study.

First, I found that a significant part of positioning and contesting place in Alberta's resource-based economy has been driven by events and representations of the province beyond its borders. Indeed, relatively high-profile, international replies to traditional, touristic images of Alberta—the Rocky Mountains, golden fields of grain and cowboys on horseback, all under open, azure skies—have come from video work such as a deliberate visual corruption of that imagery by an American-based organization;[15] a gruesome, satirical cartoon by a British activist group mocking Alberta's environmental stewardship and its ecological injustices to Aboriginal people;[16] and exposés by an established Hollywood documentarian of Alberta's indifference to the devastating effects of the bit-sands on downstream Aboriginal communities.[17] Leslie Iwerks's work is particularly notable because as a Hollywood insider positioning Alberta/Canada as a corporate bully state for a primarily American audience, particularly in *Pipe Dreams*,[18] she is indirectly urging the province's largest energy customer—and a formative contributor to

first developing the bit-sands, through Sun Oil—to help to save the province from its own greed and present-mindedness. The only other American film studied here, *Above All Else*,[19] also employs that frame.

Meanwhile, video work from those with the greatest vested interest in maintaining the status quo and even accelerating it—the Canadian (read Albertan) petroleum industry and, historically its greatest cheerleader, the Alberta government—has tended to be reactive and defensive. That work has taken its impetus from both the aforementioned body of independent documentary film work and from domestic and globally broadcast developments such as the demise of 1,606 ducks in an unguarded tailings lake. Thus, Alberta's stewardship of the bit-sands is unfolding largely as a discourse in place branding, a high-stakes, international PR battle to convince the world that the province is a worthy supplier of oil. This must be ironic for filmmakers like Tom Radford, who believe that "Albertans are paid very well to forget about the discourse" on who we are as a province and for what it stands. Radford adds, "There so much money, Alberta didn't have the chance to grow its own sense of place, its own identity. We are no longer building a culture as a place, and identity, but as an economic opportunity. The two don't work together, we must choose one."

Citing the great historian Harold Innis, Radford sees the bit-sands precipitating a recolonization of the province by foreign economic interests with little interest in Alberta's social, cultural or ecological well-being. Tellingly, Radford stands almost alone in creating documentary work questioning Alberta's stewardship of the resource *from inside the province*. Except for his two films[20] (one of them co-produced with Niobe Thompson) and the first film studied here, Matt Palmer's *Pay Dirt*,[21] all of the documentaries analyzed here come from filmmakers who live outside of the province.

Pay Dirt consciously attempts a balanced approach but is seen by Thompson as "positively depicting the engineering challenges of the tar sands." In my own, concurring reading, *Pay Dirt* is less critical of Alberta's handling of the resource than any other documentary film studied here. This seems to be a logical consequence of the film's significant funding

from the oil industry. This testifies to the view of Radford and other participants of the discourse of identity in Alberta being a casualty of indifference born of affluence[22]—or, as Frank Wolf suggests, a casualty of fear. In that light, *Tar Sands* and *Tipping Point* are particularly courageous in the face of the economic and political might of oil interests in Alberta. This study shows clearly that recent discourse on the bit-sands has been driven not by local sources but by external forces, be they documentary films or events unfolding internationally, such as American debates over TransCanada's proposed Keystone XL Pipeline and the European Union's Fuel Quality Directive, which has grappled with penalizing Alberta's "dirty" oil.

Another key finding from this research relates to participants' practices of framing Alberta as the host of the bit-sands. Producers of the films and videos studied here use a wide gamut of frames. I have identified seventeen, ranging from more anthropocentric to more ecocentric, or "instrumentalist" to "transformative" as situated on Corbett's spectrum of environmental ideologies.[23] My findings suggest that as the global profile of the bit-sands rises, the discourse has shifted from mainly more anthropocentric frames (e.g., *money, progress*) to begin to account for more ecocentric frames (e.g., *eco-justice, present-minded*). As my interviewees[24] and others point out, the public was much less aware of the bit-sands in the mid-2000s than today. This suggests that raising ecological, social and other concerns around Alberta's bituminous bonanza has affected the discourse, although any remedial effects on policy (with the notable exception of Alberta's 2015 climate-change strategy) and, more important in any event, on Earth's ecosystems, have been painfully slow in coming.

In positioning Alberta, the provincial government and the oil industry have relied on more instrumentalist frames, typically *money, progress* and especially *status quo*. This troika may be the most potent, appealing as these frames respectively do to the basic human need for security, the time-honoured rationality of science as a panacea for problems (like climate change), and the formidable weight of inertia (favouring the status quo) as well as its contemporary obverses, overscheduling,

apathy or both. More recently, pro-development interests have added the *ethical oil* and *green* frames to their arsenal of communication tools, perplexing ethicists as well as environmentalists.

Documentary filmmakers in this study have used more preservationist, moralist and transformational types of frames, most commonly adopting moralist frames (*rogue, greed, globalist bully, eco-justice, health*) and the *present-minded* frame. A recent addition, *Oil Sands Karaoke*[25] introduces the *conflicted* frame, likely reflecting attitudes held by Albertans who enjoy economic and consumer benefits from the bit-sands but also appreciate the immense and unsustainable environmental costs, and other perils of the endeavour. Although I have not studied it empirically, my sense in conducting this research is that the Canadian popular media's coverage of the discourse around the bit-sands gravitates toward instrumentalist and conservationist views through the *status quo* and *compromise* frames, perhaps reflecting "mainstream" environmental thinking in this country—or at least that of such media's corporate-owned, advertiser-sensitive masters.

The Alberta government's rebranding video, *An Open Door*, is particularly instructive. Beyond its laudable attempt to define Alberta to itself and the world—albeit falling back on a bevy of traditional touristic imagery while essentially ignoring the oil industry—the video teaches that visual omissions or denials can be as significant in environmental discourse as explicit representations. However, the failure of that video and the campaign of which it became the flagship seem to have less to do with the government's use of what I term the *green* frame (though critics might call it *greenwash*) and more to do with its producers' inability to remedy its unfortunate inclusion of a photo of a *Scottish* beach, which immediately went viral via social media. Inaccuracy and irrelevance may be twin killers in communication, but as this study shows, the framing of a message can be as important as its content: imagery that resonates with audiences in a tourism video can rankle them in another context. As one filmmaker-participant, Shannon Walsh, observes, "I think that the propaganda machine of the Government of Alberta is such an important part of the story. Often, we are using the same images that they are. It's

really about framing; that's an important part of the story and will
be ongoing."

A further finding from this research relates to participants' use of visual-communication strategies in their work. In representing the detrimental effects of extracting the bit-sands—and by inference at least, negative attributes of the citizens who ultimately own and are responsible for developing the resource—documentary filmmakers have tended to use moralist frames such as *rogue, greed* and *health*. They have focused on both *macro* and *micro* aspects of the bit-sands and its impacts.

On the macro side, in availing themselves of the latest, stabilized, high-definition camera equipment—which in one case required special permission from American authorities to remove from the United States[26]—they have shown us the massive scale of bit-sands operations by flying high above them in hired helicopters. *Petropolis*[27] epitomizes this approach, with its conspicuously lengthy shots of the landscape before, during and after open-pit mining, leaving us to witness the transformation—critics might say rape—of pristine boreal forest into denuded, scarred wasteland. The immensity of the extraction and processing apparatus, trumpeted earlier in the discourse in *Pay Dirt*[28] and the segment of *60 Minutes,*[29] becomes a point of attack in critical documentary films such as *Tar Sands.*[30]

In counterpoint to the macro approach, the documentary filmmakers also strive to bring home the impacts of bitumen extraction at ground-level, on citizens living in downstream communities, particularly Aboriginal people in Fort Chipewyan and Fort McKay. For example, scenes set in the home of Dr. O'Connor, the whistleblower on the federal and provincial government's inadequate water monitoring,[31] in a community hall in which furious citizens eviscerate representatives of Suncor for polluting their water,[32] and in the living room of a family grieving the deaths of several members due to rare cancers[33] offer indelible images of tragic casualties of Alberta's stewardship of the bit-sands. *Land of Oil and Water*[34] and *On the Line*[35] respectively extend the micro view with memorable, metaphorical images of a spider clinging to its web, and a bee being blown violently off the shoulder of a highway by a gargantuan truck.

In contrast, video productions by the Alberta government[36] and the Canadian Association of Petroleum Producers[37] have uniformly adopted a markedly micro focus in the latter stages of the decade under study. Beyond more obvious tactics like using tightly framed shots of bitumen operations and including trees in actual and simulated backgrounds—the *green* frame minimizing the ecological impact of the bit-sands—these productions have taken a softer approach. These videos are "less about place and more about the people working there,"[38] featuring industry employees talking about what they do with calm confidence, "a lot of highly educated, highly competent people working in the oil sands, not a faceless, big, black thing with machines all over it."[39] Appreciating that prior efforts to "fight emotion with fact" did not succeed, CAPP videos now depict "real people, focusing on increasing the base of understanding and instilling a sense of pride in developing our natural resources and a sense of values around the production of resources."[40] This reference to values echoes the Alberta government's stated aim to show the world "how our values drive our decisions."[41]

Collectively, this later video work by the Alberta government and the oil industry draws primarily on three frames: first, a scaled-down version of the *pride* frame, which, at its fullest, conflates Albertans with oil, as in CAPP's "Alberta Is Energy" campaign;[42] second, the *compromise* and *progress* frames, positioning Albertans as reasonably mitigating the environmental challenges of the bit-sands through wisdom and technology; and third, the *status quo* frame, suggesting that the resource is in good hands and, by inference, that concerns raised by dissenters are unwarranted.

This turn to a softer approach in both government and industry videos on the bit-sands contrasts with the more aggressive tone (perhaps rooted in defensiveness) underlying efforts like the Alberta government's $30,000 ad in the *New York Times*. That ad called on the Obama administration to approve TransCanada's proposed Keystone XL Pipeline as "the choice of reason" and declared Albertans' values to mirror those of Americans in terms of balancing "strong environmental policy, clean technology development, energy security and plentiful job opportunities for the middle class and returning war veterans."[43] This reference

to values and the appeal to emotion (most apparent in the conspicuous reference to military personnel) seem consistent with CAPP's stated strategies, whether by coincidence or coordination.

A final, overarching conclusion from this study questions the ultimate utility of using film and video as media in the discourse of Alberta and the bit-sands. The perceived need to appeal to audiences' emotions certainly makes moving images an attractive option to communicators in a society that shares meaning increasingly through visuals.[44] Each participant in this study expressly or impliedly acknowledges the persuasive force of film. Yet one wonders, as does Niobe Thompson, whether film and television—and by media extension, online videos—despite their power and pervasiveness, are the best formats for raising debates over not merely scientific issues but also questions of environmental ethics and positioning place-identity.

As Charles Wilkinson suggests, the significant costs of producing professional documentary films impel filmmakers to "make sweeping generalizations and go to drama whenever possible"[45] rather than dwell on nuanced details in tackling complex issues like environmental concerns about resource development. This is echoed in Warren Cariou's observation of the power of film to move people in addressing, in his case, the threat of the bit-sands to Aboriginal communities downstream: "It's important for people to respond emotionally, not just intellectually." It also resonates with the documentarian's directive to deliver a compelling human drama, as John Fiege reminds us.[46] Drama clearly helps to sell documentaries to film festivals and TV broadcasters, and of course to attract audiences. An advocacy video like *Rethink Alberta*,[47] with its dead-duck imagery, ominous music and biting satire of Alberta's tourism campaigns, draws significantly more viewers on YouTube than a less visceral rebranding campaign like *An Open Door*.[48]

While my participants' musings on the limitations of visual media are thoughtful and well-taken, one could probably find shortcomings in any medium deployed to debate public issues of profound complexity and consequence. For example, even if text does admit a depth and complexity of argument beyond the capacity of images as some may contend, can it be made widely accessible to people and hold their attention? Performance

art may be unforgettable, but can it attract an audience large enough to match the communicator's aims? Perhaps the answer lies in transmedia, the idea of telling a story across multiple platforms systematically to create a unified and coordinated experience for the audience.[49] The scope, graveness and urgency of ecological issues suggest that environmental communicators and others should avail themselves of every channel available to them, within the limits of reason, logistics and budget.

Ultimately, I am compelled by Wilkinson's Griersonian call for documentary films to "rally the troops" when "something is desperately wrong" and "the system is out of balance," the latter also echoing Innis's call for homeostasis between the competing priorities of space and time in civilizations.[50] Most compelling of all is Radford's assertion that in such circumstances, the most dangerous response is remaining silent. Although it seems too soon to assess the full impact of this formative decade of filmic, public discourse on Alberta and the bit-sands, even its relatively limited dissemination compared to, say, your average Hollywood summer blockbuster, stands to engage and move people, one audience member at a time. Most of us do not change the world in a fell swoop; rather, when we do make a difference, it happens more incrementally, as anthropologist Stephen Jay Gould puts it, "people taking care of each other in small ways of enduring significance."[51]

What this Book Does

This study stands to add small steps to the bigger literature in four over-lapping avenues of inquiry: environmental communication, critical research, place studies and media studies.

In the emerging field of visual environmental communication, this book responds to Hansen and Machin's call to look beyond icons and abstractions to link visualizations of the environment to "concrete processes like global capitalism and consumerism."[52] This study does so by situating visualizations of Alberta in a discourse that is tied contextually to, and responds to, events in the international arena. More broadly, this study provides insights into visual communicative processes related to the environment in a resource-based economy, and specifically into

how place is framed in film and video, in reflecting diverse perspectives relating to the rising tensions between the imperatives of economic development and its ecological costs, focusing on Alberta's bituminous sands. In doing so, this work also takes up analogous calls by visual-studies scholars for critical visual analyses to challenge naturalized master narratives[53]—in this case, the master visual narrative of a resource-based jurisdiction as pristine and environmentally responsible.

In the area of critical research, generally, this study takes up three challenges posed by leading scholars in their respective fields. First, on a methodological front, blending narrative research with visual framing analysis and discourse analysis reflects the bricolage called for in critical research.[54] This involves deploying complementary, but not necessarily traditionally juxtaposed, methods in service of engaging and activating people toward alleviating social, economic and other injustices. Second, this study helps to extend framing analysis from its traditional base in social-science research to a more humanities-focused approach, drawing on qualitative ways of knowing the world that can be called critical and rhetorical.[55] Such an approach explores not only what is being framed but how, why and in what discursive context it occurs.

As extended here, this also focuses on those doing the framing, which one longitudinal survey concludes has been significantly understudied.[56] Third, this work follows Laura Nader's call to "study up" in the social sense, i.e., to look at the more powerful in society, those with more dominant voices and visibility in public discourse, to determine how they affect our lives.[57] Her work addresses anthropology, but her concerns apply equally to communications studies as far as critical research is concerned.

As for critical communication theory, this work takes up Robert Babe's extensions of Innis's thought on political economy,[58] and Innis's anticipation of postcolonialism, into environmental communication. Innis's notions of space- and time-biased societies[59] are echoed and advanced in my identifying and situating seventeen frames used in the discourse of Alberta and the bit-sands on Julia Corbett's anthropocentric-to-ecocentric continuum of environmental ideologies.[60] Also,

Innis's "plea for time"[61] and his call for homeostasis, a healthy balance, are reflected in the documentary filmmakers' ecocentric-oriented framing to seek to redress excesses of anthropocentricism in the rampant acceleration of extraction of the bit-sands. As well, Innis's staples thesis of Canadian economic development[62]—extended in Jody Berland's situating Canada at the margins of globalized power both as a natural-resource producer and as a commoditized, visual and communicational landscape[63]—finds eerie resonance in postcolonial views of the bit-sands. As Tom Radford and David Lavallee tell us, the greatest beneficiaries of extraction live far away from the bit-sands, with little reason to care about its substantial impacts on Alberta and Albertans, or on the project's powerful symbolic value in terms of global environmental concerns.

In sum, this study builds on the aforementioned and other extensions of Innis, even if he was not a critical theorist per se, in connecting visual representations of place to international flows of power late in the Age of Oil. This work suggests that the discourse on Alberta and the bit-sands is influenced strongly by international economic and political forces, and could do with more reflection, dialogue, depolarization and especially remedial action on the resource here at home.

In the broadly categorized area of place studies, this work responds to scholars' citing a relative lack of studies of place-identity in industrially despoiled environments.[64] An interesting aspect of this case study is that Alberta, a province almost as large as Texas and remarkable for its biodiversity,[65] is positioned in terms of either or both of its *extreme* landscapes—pristine and toxic—depending on the source and the goal of the positioning; this reinforces Charles Wilkinson's point about losing nuances in going to drama in documentary film.[66] In including Alberta's provincial rebranding effort and other framings of the province in a visual PR clash aimed at influencing audiences at home and particularly abroad, this work also addresses a scholarly call to examine the impact of place branding on the broader social field.[67] The latter is part of wider calls for more critical work in marketing discourse. In responding to that appeal, this study steps beyond relatively uncritical case studies that

serve the need to promote economic development, tourism and investment in the global marketplace.

Finally, in media studies, this work offers insights into visual communication practices in the production of documentary films and online advocacy videos aimed at representing place in resource-based economies. As such, it departs from what I read as the natural tendency in ecocinema to focus mostly on the site of the image, i.e., the films themselves, and, to a lesser extent, on the films' relationship with the broader culture and even on their reception, but least of all on their creators. I find a particular paucity of primary scholarly work exploring creators' motivations, their experiences and their reflections on their own work and to films presented on related themes by others.[68]

This accords with scholars' observations that the site of production is the least studied in visual communication research as a whole,[69] and that in research on framing, the creators of the frames are significantly understudied.[70] Given the direct link between how we communicate about the natural world and how we relate to it, use it and solve environmental problems,[71] studies of those actually doing the communicating, particularly in powerful, pervasive media like film and video, stand to contribute to film studies generally and to ecocinema in particular. This seems especially important to the critical research investigating how filmmakers negotiate their positions relative to political, economic and other forces, be they dominant or subaltern.

What this Book Does *Not* Do

The mandate of any research to plumb the depths of an issue can necessarily circumscribe its application to other circumstances. This effort is limited by the specific circumstances of its case study, focusing on representations of a place, Alberta, in documentary films and advocacy videos produced in light of environmental concerns with extracting bitumen. That the site of extraction has been called the world's largest industrial project[72] and even the largest industrial project in history[73] suggests that the bit-sands have important symbolic value in the rising global tensions between human economic development and its

increasingly unsustainable costs. This is borne out by the bit-sands having ignited a maelstrom of protest and debate in the US over the Keystone xl Pipeline, awakening an environmental consciousness unseen there since the 1970s.[74] However, the extraction project's transcendent, symbolic value collides with several potential limits on abstracting its results to other cases.

First, the films and videos studied here were produced over a short period, primarily from 2005 to 2014, in the wake of the rising international profile of the bit-sands that preceded and accompanied those works. As such, their production schedules overlapped, reducing the potential for dialogue among their producers in terms of discursive responses that audiences can see onscreen, even if some of the directors conferred privately during the making of their work[75] and some commented on other works studied here.[76] A related limitation is the currency of these visual productions at this writing, which does not permit the longitudinal reflection that can benefit scholarship. Because the discursive struggle over Alberta's place-identity in light of the bit-sands in documentary film and advocacy video is compacted, current and still unfolding, this study, like a documentary film itself, can only present a snapshot that is frozen in time at its point of completion. The passage of time would permit a deeper, historical assessment of the film and video work and its effects.

A second key constraint on this study is that my visual sample involves the work of a relatively small body of professionally produced and/or exhibited work only. It excludes grassroots, do-it-yourself documentary films and advocacy videos that, while lacking the formers' status, are unhindered by fiscal, temporal, technical, cultural and other realities of professional production and distribution.

Third, this study focuses on film and video productions, even if they are contextualized within a broader discourse and sequence of events. It does not examine other forms such as literary, dramatic, musical, purely visual or other texts, or the relationships among them.

Another limit on this study is its grounding in a single and unique resource project that involves what is called "unconventional" oil, to distinguish its enormously elaborate, expensive and resource-intensive

extraction and separation processes from conventional oil plays. My findings may well differ from those in studies of projects producing other sources of energy, be they renewable or not.

Related to the latter limit is this study's centring on one place. As a case can be made for Alberta's exceptionality, at least in Canada, owing to its hefty reliance on resource revenues, ossified electoral tradition and other factors,[77] findings from a study of Wild Rose Country may not be readily portable to other places, although they can certainly serve as an informative basis for comparison—if not alarm.

A final limit noted here, and perhaps a hazard of scholarship generally, is the reductionist tendency to lose complexities and nuances of data in service of representing individual positions and broader themes in an orderly report.[78] I have also come to better understand limitations of film and video in environmental communication—particularly in their tendency to dramatize in the interests of storytelling and advocacy—despite their tremendous visual and affective power. For example, while immensely affective, dramatization can also elicit deeper polarizations among different sides of the economic–environmental divide. It can also obscure nuances that might help to bridge that divide. Ultimately, one is left with Leslie Iwerks's apt reflection: "The reality as a filmmaker is that you wish you could change the world and stop everything. But everyone takes small steps towards a bigger goal."

Where to Go from Here?

Research building on this study could take up at least four avenues of inquiry.

From a comparative perspective, there is ample room to consider whether or not results peculiar to Alberta and the bit-sands apply to case studies based on creative work addressing place-identity in light of environmental issues, that is, for example: (a) produced over a longer timespan than the decade observed here; (b) produced by *non*-professionals practising "dissident-vernacular cultural production"[79] to disrupt dominant discourses of place-identity; (c) focused on the extraction of *conventional* oil or other natural resources, be they renewable or not; and/or (d) located in other places in Canada or beyond.

From a film-studies perspective, this study could be extended by
exploring how films and videos considering the bit-sands fit within the
wider context of documentary and/or advocacy films generally, and the
Canadian documentary tradition in particular. Canadian contributions
to the form have been significant and influential, starting with the
founding of the National Film Board (NFB) under John Grierson, who
saw the documentary film as an active expression of humane, demo-
cratic values, or positive propaganda, and under whose leadership the
NFB became an instrument of building national identity.[80] Also, one
could extend this study by situating the films and videos in relation to
other works of ecocinema or "film vert" from Canada (including French-
language work from Québec) and other nations.

From a broader, media-studies perspective, one could further explore
several issues around creative work within environmental communica-
tion and place-identity. This study's focus on documentary films and
advocacy videos raises issues of intersections and differences rising out
of the production, use, distribution and impact of each form in contrast
to the other. For example, documentary films benefit from the credibility
of popular media forms (theatre and television) and cachet in the film
industry and the art world, while online advocacy videos benefit from
greater accessibility for creators, quicker production and release times,
lower costs and the potential to go viral. We need more studies to show
various impacts of using different media for different types of posi-
tioning (for example, place branding, risk management), as well as using
transmedia—content flowing across multiple media platforms[81]—in
negotiating place-identity. It would be interesting to learn more about,
for example, the extent to which the choice of media or distribution
channel for a creative work (television broadcast, film-festival screening
or online dissemination) affects the potential for audience engagement
in issues of social or environmental justice in response to positive or
negative portrayals of a place.

Further fruitful insights into the negotiation of place-identity might
be gleaned from conducting, for example, a study of environmental film-
makers and video producers and their culture of production as it influences

the content and dissemination of their oeuvre. Also, this study's focus on the producers of creative work rather than their audiences could be advanced by research addressing the reception of media work by viewers, be they from the general public or more specific segments such as policy makers or media pundits. In addition, one could investigate the role and effect of media coverage of environmental-themed films and other forms on the discourse of place-identity in places portrayed in that work.

Staying with the reception of environmental communication, from a place-branding perspective, further qualitative, quantitative, critical and arts-based research could study the effect of critical, environmentally themed imagery or other creative work on its target jurisdiction's trade, tourism or investment opportunities. Examples such as the *Rethink Alberta* video[82] offer potentially productive ground to address environmental communication as counter-hegemonic discourse. This is particularly important in an age in which projecting visually appealing representations through place branding is vital to the fortunes of jurisdictions competing in a globalized market.[83] In addition, dark tourism, occupied with sites of morbidity and the macabre,[84] and more particularly toxic tourism, concerned with sites of ecological devastation,[85] offer intriguing possibilities for further scholarly investigation. This is in counterpoint to traditionally sunny representations of place that, when juxtaposed with critical documentary films such as those studied here, may seem ironic, if not tragic.

A final suggestion for further research relates to research methods. The subfield of environmental communication would benefit from further engagement with arts-based research. This invokes Bill McKibben's call for artistic expressions of climate change, to boost understanding and feeling and thereby create the kind of political change that art helped to inspire in the case of AIDS over the last two decades.[86] The health of Earth affects human beings not only as individual hiccups in history but as a species, just as the planet's well-being influences the condition of every other known resident form of life that we have purported to master. I make the case for arts-based research in environmental scholarship (with my scripts for a documentary film for television, a 'musical

eco-comedy' stage play and an online video, all drawing on Alberta's oil-based economy and culture) in a book paralleling this one.[87]

Although green art is well-established,[88] scholarly work through more publicly accessible, artistic forms could help us in two ways. Certainly, it can advance the stock of knowledge around environmental concerns and potential actions to ameliorate them. But it can also engage people, boost their sense of agency and perhaps even inspire them to take a few steps in Stephen Jay Gould's "small ways of enduring significance."[89] On a planet that in the hands of its dominant species has apparently passed its ecological best-before date alarmingly ahead of prior forecasts, is this too much to ask?

Notes

1. Carson.

2. de Steiguer.

3. Oreskes and Conway.

4. W. Potter.

5. Centre for Bhutan Studies and GNH Research.

6. Parliament of Canada.

7. Hayden.

8. Geisel.

9. Intergovernmental Panel on Climate Change, *Climate Change 2014*.

10. Francis [Pope].

11. Leahy.

12. e.g., Cryderman; Wood.

13. Alberta, 2014a.

14. Alberta, 2015a.

15. Nikiforuk, 2010.

16. Davidson and Gismondi.

17. Avery; Fiege, 2014b.

18. Canadian Association of Petroleum Producers, 2012a; Dembicki.

19. D. Gibson, 2011.

20. *Calgary Herald*, 2011, A10.

21. Gunster and Saurette.

22. CBC Radio.

23. Clark and Blair.

24. Palmer and Palmer.

25. Lamb.

26. Chastko.

27. Gray and Luhning.

28. Energy Resources Conservation Board.

29. National Energy Board, 2013.

30. Alberta, 2015e.

31. Honarvar et al.

32. Canadian Energy Research Institute, 2014, ix.

33. Alberta, 2015b.

34. Alberta, 2015c.

35. Alberta, 2014b.

36. Timilsina et al.

37. Alberta, 2012a.

38. Alberta, 2015b.

39. Skuce.

40. Canadian Energy Research Institute, 2013, 1.

41. Raval.

42. Landon and Smith.

43. Alberta, 2015b.

44. Parkland Institute, 2013.

45. See McFarlane; Pratt; Sands and Brooymans.

46. Alberta, 2014c.

47. Alberta, 2014e and 2014c.

48. Schneider and Dyer.

49. Grant, Angen and Dyer.

50. Nikiforuk, 2010.

51. Bergerson and Keith.

52. Flanagan.

53. Pembina Institute, 2015.

54. Grant, Angen and Dyer.

55. Nikiforuk, 2010.

56. Ibid.

Notes

57. Grant, Angen and Dyer.

58. Pembina Institute, 2013.

59. Dyer, Grant and Angen.

60. Weber, 2014.

61. See Schneider and Dyer.

62. Carbon Brief.

63. McGlade and Ekins.

64. Radford and Thompson, 2011.

65. e.g., Beaver Lake Cree Nation; Canadian Press, 2014.

66. e.g., Radford and Thompson, 2011; Grant; Saher.

67. e.g., Marsden; *The Economist*; Kunzig; Nikiforuk, 2010; Homer-Dixon; Holden.

68. Lieber.

69. UK Tar Sands Network, 2013.

70. UK Tar Sands Network, 2011a.

71. e.g., Blanchfield; *The New York Times*, 2011, 2013; Kolbert; Leslie.

72. Feldman.

73. Alberta, 2014e.

74. Nikiforuk, 2012; Friedman.

75. Holden.

76. Gismondi and Davidson.

77. Nikiforuk, 2010.

78. Elections Alberta, 2015.

79. Stewart and Carty; CBC News, 2008a; Elections Alberta, 2015; Heard, 2011.

80. Mirzoeff, 2009; Banks.

81. Baudrillard.

82. e.g., Radford, 2008; S. Walsh, 2009a; Iwerks, 2009. See Chapter 4.

83. e.g., Alberta, 2009; Canadian Association of Petroleum Producers, 2009, 2010a. See Chapter 4.

84. Alberta, 2013a.

85. Warren.

86. Couldry.

87. Takach, 1992.

88. van Herk, 2001.

89. e.g., Takach, 2006; 2009a; 2009c; 2012a.

90. Takach, 2008a and 2008b.

91. Takach, 2009b.

92. Takach, 2010.

93. Takach, 2011.

94. Takach, 2012b.

95. Takach, 2013c. That dissertation won the Illinois Distinguished Qualitative Dissertation Award (Experimental Category) in 2014 from the International Center for Qualitative Inquiry based at the University of Illinois at Urbana-Champaign.

96. Takach, 2013a.

97. Takach, 2013b.

98. Takach, 2014.

99. van Herk, 2001, 1.

2 Four Foundational Principles

1. e.g., Intergovernmental Panel on Climate Change, 2007, 2014; Suzuki, 2010; McKibben, 2012a.

2. e.g., Gore, [1992] 2006a, 2006b.

3. Guggenheim.

4. Nobel Prize.

5. 350.org; Dutton.

6. Cantrill and Oravec; Dobrin and Morey.

7. Cox and Pezzullo, 2.

8. Cronon; Cantrill and Oravec; Corbett.

9. Brereton, 16–17.

10. L.M. Johnson, 1.

11. Ibid., 217.

12. Carbaugh and Cerulli.

13. Corbett.

14. Gergen.

15. Butler, v.

16. Campbell.

17. Hansen; Hendry.

18. Hansen.

19. Cronon, 69.

20. Macnaghten and Urry.

21. Ibid., 15.

22. Corbett.

23. Singer.

24. Mick Smith.

25. Boime.

26. Foucault, 1972.

27. Intergovernmental Panel on Climate Change, 2007.

28. e.g., Flannery; Suzuki, 2010; McKibben, 2012a.

29. Hamilton.

30. Beck, 22.

31. Brereton.

32. Hirt; Gailus, 2012.

33. Suzuki, 2012.

34. de Vries, Ruiter and Leegwater.

35. Brulle.

36. McLuhan.

37. Peters, 15.

38. Hansen.

39. Ibid.

40. Ibid., 182.

41. Gamson and Modigliani.

42. Hannigan.

43. Boycoff and Smith, 216.

44. Heath et al., 46.

45. E. Gilbert, 65.

46. Ibid.

47. Melnyk, 2007, 26.

48. Hansen.

49. Williams.

50. Corbett.

51. Hansen, 137.

52. Trachtenberg.

53. B. Goldstein.

54. Tagg, 1993; Jamieson; Kress and van Leeuwen.

55. G. Potter.

56. Dobrin and Morey.

57. Berger; Sturken and Cartwright; Tagg, 1993.

58. Dobrin and Morey.

59. Lester.

60. Julie Doyle.

61. Rose, 2012, 4, citing Mirzoeff, 1998.

62. Baudrillard.

63. Hansen and Machin, 2008, 779.

64. Blue, 81–82.

65. Hansen and Machin, 2013.

66. e.g., Bal; Dikovitskaya; Pink; Rose, 2012.

67. Mirzoeff, 2013, xxx.

68. Rusted, 5.

69. Killingsworth and Palmer.

70. Clark, Halloran and Woodford.

71. Hodgins and Thompson; Takach, 2013a.

72. Meister and Japp.

73. Rehling, 27.

74. Davidson and Gismondi, 61, 62.

75. Dispensa and Brulle.

76. Hansen.

77. Todd.

78. Gailus, 2012.

79. Ingram.

80. Opel.

81. Japp and Japp, 93.

82. Banks.

83. Price, 1995, 56.

84. van Ham, 2010b.

85. Campelo, Aitken and Gnoth, 3.

86. Finucan.

87. van Ham, 2010a.

88. Dittmer.

89. van Ham, 2010a.

90. van Ham, 2010b.

91. Dahlgren.

92. Vorkinn and Riese.

93. Corbett.

94. R.D. Francis, 2009.

95. König.

96. Innis, [1950] 2007, 2008, [1952] 2004.

97. Wayne.

98. Foucault, [1977] 1998.

99. Anholt, 2010.

100. van Ham, 2010a.

101. Chouliaraki and Morsing, 3.

102. van Ham, 2002, 252, 265.

103. Mayes.

104. Price, 2002.

105. Babe, 2011, 324.

106. Gailus, 2012.

3 Images and Frames of Alberta

1. R.D. Francis, 1989, 1992.

2. Berry and Brink.

3. R.D. Francis, 1989, 193.

4. Hart; D. Francis.

5. Campbell.

6. e.g., Wiebe, Savage and Radford; Hines; Kyi; Ainslie and Laviolette.

7. Dippie.

8. van Herk, 2001; Sharpe; Takach, 2010.

9. Davidson and Gismondi, 31.

10. Gismondi and Davidson.

11. Davidson and Gismondi, 32.

12. Ibid., 61.

13. Pearson.

14. Morris.

15. Pratley.

16. Bowie, 2004.

17. Innis, 2008.

18. Bowie, 2006.

19. Burgess.

20. Lilley.

21. Raj.

22. Canada (Government), 1991, ss. 3(1)(l), (m)(vi).

23. Spears, Seydegart and Zulinov.

24. C. Smith.

25. Plec and Pettenger, 21.

26. Goffman.

27. Entman, 1993, 53, 54.

28. Ibid., 55.

29. Ibid.; Entman, 2004.

30. Chong and Druckman.

31. Ibid., 107.

32. Canadian Association of Petroleum Producers, 2010b.

33. Davidson and Gismondi; Canadian Press, 2012b; Thomson, 2013b.

34. Radford, 2012; Takach, 2010.

35. Koring.

36. Thomson, 2010b.

37. Bell; Frontier Centre for Public Policy, 2013b.

38. Canadian Press, 2012a.

39. Canadian Press, 2012c.

40. Levant; Weismiller.

41. Levant.

42. MacDonald.

43. Simpson.

44. Canadian Association of Petroleum Producers, 2010a.

45. Wells; Redford.

46. Alberta, 2013b; Canadian Association of Petroleum Producers, 2010b.

47. Honarvar et al.; Canadian Energy Research Institute, 2014.

48. D. Gibson, 2012.

49. G. Potter.

50. Alberta, 2013c; Coglon, 2015.

51. Desrochers and Shimizu.

52. e.g., Van Praet.

53. Alberta, 2013d; Redford.

54. Taras; Takach, 2010. As to Alberta's earlier radicalism, see Bright.

55. Roberts.

56. National Energy Board, 2011.

57. Nikiforuk, 2010; Leach.

58. Nikiforuk, 2010.

59. Leach.

60. D'Aliesio and Markusoff.

61. Skuce.

62. Climate Action Network Canada.

63. Nikiforuk, 2010.

64. Innis, [1930] 1999, [1940] 1978.

65. Campanella.

66. Indigenous Environmental Network; B. Walsh.

67. B. Walsh.

68. Heinbecker.

69. McKibben, 2012c; Gillespie.

70. Mercredi; Forest Ethics.

71. United Nations.

72. W. Gibson.

73. Bowers.

74. Marsden; Weber.

75. e.g., Radford and Thompson, 2011; Grant.

76. Cardwell and Elliott.

77. Bouchard; Nikiforuk, 2010.

78. Innis, 2008.

79. Bouchard.

80. Cryderman.

81. Greenpeace Canada, 2013; Galloway.

82. Corbett.

4 Positioning and Contesting Alberta

1. Palmer, 2005a.

2. Palmer, 2012.

3. Roberts.

4. Roach.

5. Holden. Also see Gutstein.

6. Roberts.

7. Palmer, 2005b.

8. Couldry.

9. Dean.

10. Edelstein.

11. Schorn.

12. McKibben, 2012b.

13. Schorn.

14. Alberta, 2011a.

15. Smithsonian Folklife Festival.

16. Gauthier, 2008, 2009.

17. Gauthier, 2009, 656.

18. e.g., Alberta, 2006a, 2006b, 2006c, all p. 1.

19. Whitelaw.

20. Alberta, 2006d.

21. Whitelaw, 14.

22. Bowie, 2006.

23. Bowie, 2004.

24. Burgess.

25. Ibid.

26. Ibid.

27. Ibid.

28. Schorn.

29. Radford, 2008.

30. Radford and Savage; Wiebe, Savage and Radford.

31. Murray.

32. BC Hydro.

33. Radford, 2012.

34. Schorn.

35. Palmer, 2005a, 2005b.

36. CBC.

37. Lamphier, E1.

38. e.g., Anderson, 2008; Brenner, 2008; Vanderly, 2008.

39. N. Thompson, 2008.

40. Takach, 2010.

41. Nikiforuk, 2010.

42. R. v. Syncrude Canada Ltd.

43. Henton, 2010.

44. Sinnema, 2010.

45. Brooymans.

46. Thomson, 2010a.

47. Cotter.

48. Lavallee, 2011.

49. Benoit, 2012.

50. Iwerks, 2008.

51. Leslie Iwerks Productions.

52. Volmers.

53. J. Gilbert.

54. Iwerks, 2012.

55. J. Gilbert, 2.

56. Radford, 2012.

57. As *Downstream* chronicles, Alberta Health, Health Canada and Environment Canada filed charges against Dr. O'Connor with the Alberta College of Physicians and Surgeons, alleging sixty-eight counts of double-billing, unethical financial practices and "raising undue alarm." All charges were dropped or dismissed. Dr. O'Connor moved his practice back to Nova Scotia, although he continued to consult with patients in Fort Chipewyan via videoconference and telephone.

58. Carnevale, 3.

59. Iwerks, 2012.

60. Palmer, 2005a.

61. P. Goldstein.

62. J. Gilbert.

63. Palmer, 2012.

64. Alberta Environmental Network.

65. Natural Resources Defense Council, 2015.

66. Volmers.

67. CBC News, 2008b.

68. Christian.

69. P. Goldstein.

70. Volmers, C1.

71. Schorn.

72. Hinman.

73. Kiss.

74. Laghi.

75. Taft.

76. Benoit, 2012.

77. F. Calder.

78. Harris/Decima.

79. Benoit, 2008.

80. Benoit, 2012.

81. Markusoff.

82. Alberta, 2014e.

83. Markusoff.

84. Pratt.

85. O'Donnell.

86. Alberta, 2012b.

87. Audette and Henton, 2009.

88. Alberta, 2009.

89. Takach, 2013a.

90. Marquard Smith, 30.

91. Rancière, 2001.

92. Mirzoeff, 2013, xxx.

93. Leahy.

94. Alberta, 2015b.

95. Ibid.

96. Alberta, 2014c.

97. Alberta, 2013a.

98. Canadian Association of Petroleum Producers, 2010b.

99. Audette and Markusoff.

100. Harris/Decima.

101. Wainwright.

102. Canadian Press, 2009.

103. Braid.

104. However, it was available as of this writing on YouTube as *Alberta: An Open Door to Opportunities*, posted by "alberta taiwan" with perhaps Taiwanese subtitles and 240 viewings in mid-2016.

105. Benoit, 2012.

106. Markusoff, B8.

107. Pitschen and Schönholzer; White, 2006.

108. Mettler, 2012a.

109. Mettler, 2009.

110. Diehl.

111. Burtynsky et al.

112. Baichwal.

113. Peeples, 377.

114. Nikiforuk, 2010.

115. Palmer, 2005b.

116. White, n.d.

117. Guise.

118. Alberta, 2009.

119. Clarke.

120. Mettler, 2012b.

121. S. Walsh, 2009a.

122. S. Walsh, 2012.

123. Radford, 2012.

124. S. Walsh, 2009b.

125. Szeman.

126. Radford, 2008.

127. Iwerks, 2008.

128. Acland. Although Canada is estimated to rank third among all nations in per-capita spending on movies, English-Canadian films accounted for only 1 per cent of Canadian box-office receipts in 2011, with French-Canadian films accounting for another 1.7 per cent. See De Rosa.

129. This study does not include a review of those edited versions or the French-language version of H_2Oil, nor does it consider a comparison of the latter with the original, English-language version.

130. Lakoff, xii.

131. Alberta, 2009.

132. van Ham, 2010a, 2010b.

133. McArthur and Cariou, 2009a.

134. Cariou.

135. McArthur and Cariou, 2009b.

136. Radford, 2008.

137. Methot.

138. Iwerks, 2009.

139. Iwerks, 2008.

140. Schorn.

141. Timoney.

142. Palmer, 2005a.

143. Radford, 2008.

144. Bowie, 2004, 2006.

145. S. Walsh, 2009a.

146. Mettler, 2009.

147. McArthur and Cariou, 2009a.

148. Iwerks, 2009.

149. Foley.

150. Carnevale, 4.

151. CBC News, 2008b; Volmers.

152. United Nations Framework Convention on Climate Change.

153. SourceWatch.

154. Canada West Foundation.

155. Ibid., 1.

156. Lewis, Ljunggren and Jones.

157. Lukacs.

158. Canadian Association of Petroleum Producers, 2012b.

159. Davies, 2012.

160. Canadian Association of Petroleum Producers, 2009.

161. Benoit, 2012.

162. Corporate Ethics International, 2010.

163. Corporate Ethics International, n.d.a.

164. Corporate Ethics International, n.d.b.

165. Corporate Ethics International, n.d.c.

166. Jones.

167. O'Donnell.

168. Gerein.

169. Marx, n.d., 1. Marx had left CEI by 2012. My efforts to contact and interview him were protracted and unsuccessful. Eventually, I made contact with a member of the anti-bitumen campaign, responsibility for which had shifted from CEI to the UK Tar Sands Network.

170. D'Aliesio.

171. Alberta, 2009.

172. Alberta, 2010a.

173. Released in 2009, *Avatar* (Cameron) is Hollywood's all-time top-grossing film (IMDb.com, 2015), depicting the struggle of a peaceful society living in harmony with nature to save its world from environmental destruction by brutal, imperialist forces. Mordor is a term borrowed in popular usage from J.R.R. Tolkien's *Lord of the Rings* books to connote a shadowy place of death and destruction, since visualized for contemporary audiences in film (e.g., Jackson).

174. Anonymous.

175. e.g., Mettler, 2012a.

176. Anonymous.

177. Alberta, 2010b.

178. Radford and Thompson, 2011.

179. Radford, 2008.

180. N. Thompson, 2012.

181. Schorn.

182. Radford, 2012, citing Iwerks, 2009.

183. Paulette et al. v. The Queen.

184. Palmer, 2005a.

185. Radford and Thompson, 2012.

186. McMillan.

187. S. Walsh, 2012; Cariou, 2012; Lavallee, 2012.

188. Canadian Association of Petroleum Producers, 2011.

189. Foster.

190. John Doyle.

191. Radford, 2012.

192. LaPointe, 6.

193. The then-Conservative federal government provided $1.15 billion per year to the CBC, about 64 per cent of the public broadcaster's budget. The government's

funding cut of $115 million over three years starting in 2012 was 10 per cent of that budget (CBC News, 2012). In 2015 the Liberal Party's federal election campaign, ultimately successful, included a promise to reverse those cuts and add $35 million per year (Desjardins).

194. The complainant, Michelle Stirling-Anosh, was then listed as a research associate for a body devoted to advancing "policy choices that will help Canada's prairie region live up to its vast but unrealized economic potential" (Frontier Centre for Public Policy, 2012, 2013a). A media release from the group led with quotes that essentially deny that anthropogenic greenhouse-gas emissions are causing harmful global warming, and declare that carbon dioxide emissions *help* the environment by improving crop yields and forest growth (Frontier Centre for Public Policy, 2013b). In a later opinion column, Stirling-Anosh called Earth Day "cult indoctrination" to brainwash our children "that would make Stalin proud" (Gailus, 2014).

195. Radford's reference to "Griersonian" invokes John Grierson (1898–1972), the founding commissioner of the National Film Board, and his view of the documentary film as an active expression of humane, democratic values—propaganda for the public good—in counterpoint to the authoritarian propaganda practised by Nazi Germany at the time (Hardy; Babe, 2000; Druick).

196. Lavallee, 2011.

197. Guggenheim.

198. Radford, 2008.

199. Lavallee, 2012.

200. Muir, 110.

201. Wilkinson, 2011.

202. Wilkinson, 2012.

203. Wilkinson, 2013a.

204. Wilkinson, 2015a.

205. Wolf, 2011.

206. Wolf, 2012.

207. Mettler, 2009.

208. Nikiforuk, 2010.

209. Lavallee, 2011.

210. Iwerks, 2011.

211. Iwerks, 2008.

212. Iwerks, 2009.

213. Radford and Thompson, 2011.

214. Iwerks, 2012.

215. Lavallee, 2011.

216. Wilkinson, 2011.

217. Wolf, 2011.

218. Innis, [1923] 1971; Melnyk, 1992, 1993; Takach, 2010; Janigan.

219. Curry and McCarthy.

220. B. Walsh.

221. Goldenberg.

222. United States Department of State.

223. UK Tar Sands Network, 2015.

224. UK Tar Sands Network, 2011a.

225. UK Tar Sands Network, 2011b.

226. UK Tar Sands Network, 2013.

227. S. Walsh, 2009a.

228. Coats, 2012.

229. Dick.

230. Ibid.

231. Lewis and Jones.

232. Mep.

233. Laville.

234. Iwerks, 2011.

235. Alberta, 2012c.

236. Anonymous, 2012.

237. Takach, 2008a.

238. Alberta, 2009.

239. Sereda.

240. Wilkinson, 2011.

241. Wilkinson, 2013b.

242. Wilkinson, 2013c.

243. Wilkinson, 2014.

244. Wilkinson, 2013c.

245. #NeilYoungLies is linked to a lobby group called Ethical Oil, which promotes the bit-sands and was founded on the *ethical oil* frame discussed in Chapter 3.

246. Wilkinson, 2013c.

247. Iwerks, 2008.

248. S. Walsh, 2009.

249. Radford and Thompson, 2011.

250. Canadian Association of Petroleum Producers, 2010a.

251. Alberta, 2010a.

252. Fiege, 2014a.

253. Fiege, 2014b.

254. Palmer, 2005a.

255. Cameron.

256. Tar Sands Blockade describes itself as a peaceful, "all-volunteer horizontal, consensus-based organizing collective dedicated to working in solidarity with frontline communities most impacted by tar sands mining, transportation and refining" (Tar Sands Blockade).

257. Jackson.

258. Fiege, 2014c, 4.

259. Iwerks, 2008.

260. Radford and Thompson, 2011.

261. Iwerks, 2011. Before making the film, Fiege had not seen Iwerks's films, although his team did reach out to her during his project.

262. DeFore, 1.

263. Berkshire.

264. Ibid.

265. Iwerks, 2011.

266. Schorn.

267. Ibid.

268. Corbett.

269. Spears.

270. Fiore.

271. *The New York Times*, 2013. In 2014 the paper printed an op-ed titled, "Is Canada Tarring Itself?" (Leslie).

272. Bennett.

273. Weismiller.

274. Alberta's budget deficit is curable in the eyes of the Conference Board of Canada and others if it were to institute a provincial sales tax, as every other province has (Canadian Press, 2013a; Henton, 2013)—and/or by giving Albertans a rate of return on their natural resources closer to that collected by other oil-producing jurisdictions (Weir). A political watershed occurred in early 2015 when Jim Prentice, Alberta's then-new premier (elected by party vote in 2014 after the resignation of his scandal-ridden predecessor), stated that in the face of plummeting oil prices and provincial deficits, he was willing to discuss instituting a sales tax, even if he did not embrace the idea personally (Ibrahim). He subsequently recanted and was later resoundingly tossed from that office by voters for other reasons.

275. Kleiss.

276. Thomson, 2013a, A19.

277. Alberta, 2013e, 9.

278. Cryderman.

279. Coastal First Nations.

280. Radford and Thompson, 2011.

281. Natural Resources Defense Council, 2013a, 2013b.

282. Connors.

283. *Edmonton Journal.*

284. Mason.

285. Cobb and Damanskis, 2013.

286. Horn.

287. Indiegogo.

288. *Huffington Post Alberta,* 2013a.

289. *Huffington Post Canada,* 2014.

290. CBC News, 2014.

291. EthicalOil.org.

292. Canadian Press, 2013b.

293. Krugel.

294. *Huffington Post,* 2014.

295. *Huffington Post Alberta,* 2013b.

296. McDermott.

297. Klein.

298. Lewis.

299. Francis [Pope], 142.

300. Ibid., 38.

301. Ibid., 1.

302. Bouchard, 2009.

303. Krylová and Barder.

304. Ibid., 3–4.

305. Ibid., 7–8.

306. Waldie.

307. Payton and Mas.

308. Hoekstra.

309. Cheadle.

310. Calamur.

311. Obama, 2.

312. Ibid., 3.

313. Lieber.

314. Saher.

315. Sinnema, 2015.

316. Elections Alberta, 2015.

317. Sinnema, 2015.

318. Alberta, 2015f.

319. Alberta, 2015g.

320. Fenton.

321. Canada's Ecofiscal Commission.

322. McGlade and Ekins.

323. Intergovernmental Panel on Climate Change, 2013, 2014.

324. Ibid., 2014, 3.

325. Gillis.

326. Palmer, 2005a, 2005b.

327. Wilkinson, 2011.

328. Wilkinson, 2013b.

329. Wilkinson, 2015b.

330. Lavallee, 2011.

331. *The Tyee.*

5 Visually Redefining Alberta

1. Alberta, 2009.

2. Burgess, 2007.

3. Radford, 2008.

4. Radford and Thompson, 2011.

5. e.g., F. Calder; Gallant; Palmer, 2012; G. Potter; Sereda; Wilkinson, 2012, 2014.

6. F. Calder.

7. Nelson, 15.

8. Coleman and Ross.

9. Jönsson, 122.

10. Taras, 758.

11. Soron, 74–75.

12. CBC News, 2008a.

13. Weber, 2015.

14. Entman, 2007.

15. Rose, 1994.

16. van Dam.

17. Glynn, 19, 21.

18. Tann.

19. Buttimer and Seaman.

20. Mouffe, 14.

21. Alberta, 2009.

22. Alberta, 2012c.

23. Remillard.

24. Webb.

25. Banks.

26. Chaplin.

27. Berger, 1972; Rancière, 2007.

28. Rose.

29. C. Johnson, xxiii.

30. Macnaghten and Urry.

31. Cronon, 69–70.

32. Burns.

33. DeLuca.

34. Ott.

35. Guggenheim.

36. L. Johnson.

37. Rosteck and Frentz, 16.

38. Canada (Government), 1911.

39. CBC News, 2010.

40. Pezzullo.

41. Todd, 230.

42. Ibid., 231.

43. Ibid.

44. e.g., Relph, 1976; Tuan, 1977.

45. Macnaghten and Urry.

46. Sontag.

47. Clark, Halloran and Woodford.

48. Ingram, 33–34.

49. Ivakhiv.

50. Ibid.

51. Lefébvre.

52. Alberta, 2009.

53. Alberta, 2012.

54. Statistics Canada, 2009a, 2014c.

55. Alberta, 2010c.

56. Statistics Canada, 2014c.

57. Alberta, 2010c.

58. Zubjek and Audette.

59. Audette.

60. Statistics Canada, 2014c.

61. Hiller.

62. Statistics Canada, 2009b.

63. Statistics Canada, 2009c.

64. Statistics Canada, 2008.

65. Alberta, 2012a.

66. Alberta, 2015b.

67. Melnyk, 1999, 100, 101, 103, 105.

68. Richards and Pratt, 233–234.

69. Statistics Canada, 2009d.

70. Melnyk, 1999; A. Calder.

71. Takach, 2010, 351.

72. Rutherford, 56.

73. Library and Archives Canada.

74. Byrne.

75. Alberta College of Social Workers.

76. Alberta, 2015b.

77. Alberta, 2010d.

78. Alberta, 2011c.

79. Canadian Council on Learning.

80. Alberta, 2014d; Statistics Canada, 2015.

81. Statistics Canada, 2015.

82. Alberta, 2015d.

83. Alberta, 2012a.

84. Alberta, 2015b.

85. Friedman, 2006.

86. Nikiforuk, 2010.

87. Shrivastava and Stefanick.

88. Pembina Institute, 2005, 2013.

89. Conference Board of Canada.

90. D. Gibson, 2012.

91. Alberta College of Social Workers.

92. Lu, Schellenberg, Hou and Helliwell.

93. Connors and Law, 2005.

94. van Herk, 2005a.

95. Takach, 2010.

96. Sharpe.

97. Francis and Kitzan, xi.

98. Ibid., xxii.

99. Limerick, Milner and Rankin.

100. Takach, 2008a, 2009a, 2009b, 2009c, 2010.

101. Soron, 67.

102. Melnyk, 1993.

103. Melnyk, 1992.

104. Statistics Canada, 2005.

105. Alberta College of Social Workers.

106. Svidal.

107. Alberta Human Rights Commission.

108. D'Aliesio and Markusoff.

109. Heard, 2011.

110. Heard, 2015.

111. Alberta, 2011b.

112. Hill Strategies Research.

113. van Herk, 2007, 132.

114. van Herk, 2005b, D6.

115. Statistics Canada, 2014a, 2014b.

116. Wilkinson, 2014.

117. Worster, 22.

118. e.g., Melnyk, 1992, 1993; Janigan.

119. e.g., Takach, 2010.

120. Gauthier, 2008; Whitelaw.

121. E. Thompson.

122. Carlson.

123. Jedwab.

124. Hiller.

125. Tagg; Jamieson; Kress and van Leeuwen.

126. Messaris and Abraham, quoted in Coleman, 238.

127. Coleman.

128. Schwalbe, 269.

129. Takach, 2009b.

130. Alberta, 2009.

131. New Brunswick.

132. Lefébvre.

133. Takach, 2010.

134. de Vries, Ruiter and Leegwater.

135. Brulle.

136. Moser and Dilling.

137. de Vries, Ruiter and Leegwater.

138. Keep America Beautiful.

139. Hall.

140. Melnyk, 1999.

141. Ateljevic and Doorne, 649.

142. Melnyk, 2007.

143. A. Calder.

144. Ibid., 95.

145. Milne.

146. Bouchard and Ripplinger.

147. Butala.

148. Bannatyne-Cugnet and Moore.

149. A. Calder, 98; Melnyk, 1999.

150. Tingley and McInnis.

151. e.g., Van Horn and Wagner; Walters.

152. Rosenberg, Dean and Granzow.

153. Dippie, 47.

154. R.D. Francis, 2011, 549.

155. Finkel, Carter and Fortna.

6 Implications

1. Humphries suggests that this recognition came in 2004, while the United States
 Energy Information Administration claims that it occurred in 2003.

2. F. Calder; Coats.

3. Wolf, 2012.

4. Gauthier, 2008.

5. Glenbow Museum.

6. Alberta, 2010b.

7. Glynn, 2009.

8. Jay.

9. Rabiger; Aufderheide.

10. Mettler, 2009.

11. Radford, 2008.

12. Radford and Thompson, 2011.

13. Alberta, 2009.

14. Govers and Go.

15. Corporate Ethics International, 2010.

16. Dick.

17. Iwerks, 2008, 2010.

18. Iwerks, 2011.

19. Fiege, 2014a.

20. Radford, 2008; Radford and Thompson, 2011.

21. Palmer, 2005a, 2005b.

22. e.g., Cariou; Lavallee, 2012.

23. Corbett.

24. e.g., Radford, 2012; Iwerks, 2012; S. Walsh, 2012.

25. Wilkinson, 2013b.

26. N. Thompson.

27. Mettler, 2009.

28. Palmer, 2005a, 2005b.

29. Schorn.

30. Radford, 2008.

31. Iwerks, 2008, 2010.

32. Lavallee, 2011.

33. Radford and Thompson, 2011.

34. McArthur and Cariou.

35. Wolf, 2011.

36. Alberta, 2010a, 2010b, 2012.

37. Canadian Association of Petroleum Producers, 2010a.

38. Davies.

39. Anonymous.

40. Davies.

41. Benoit, 2012.

42. Canadian Association of Petroleum Producers, 2010b.

43. Bennett.

44. Mirzoeff, 2009; Banks.

45. Wilkinson, 2012.

46. Fiege, 2014b.

47. Corporate Ethics International, 2010.

48. Alberta, 2009.

49. Jenkins.

50. e.g., Innis [1950] 2007, 1981.

51. Gould, 246.

52. Hansen and Machin, 779.

53. e.g., Bal; Pink; Dikovitskaya; Rose, 2012.

54. Kincheloe, McLaren and Steinberg.

55. Kuypers.

56. Borah.

57. Nader, 1974.

58. Babe, 2008.

59. Innis, [1950] 2007, 2008, [1952] 2004.

60. Corbett.

61. Innis, 2008, 61.

62. Innis, [1930] 1999, [1940] 1978.

63. Berland.

64. Broto et al.

65. Takach, 2010.

66. Wilkinson, 2012a.

67. Mayes, 2008.

68. The tendency to focus more on films themselves rather than on their creators in ecocinema is apparent in a 2013 edited collection (Rust, Monani and Cubitt), as well as in landmarks of the subfield (e.g., Ingram; Brereton).

69. Hansen and Machin, 2013.

70. Borah.

71. Cox and Pezzullo.

72. Leahy.

73. Davidson and Gismondi.

74. Avery; Fiege, 2014b.

75. e.g., N. Thompson.

76. e.g., Lavallee, 2012; Wilkinson, 2012; Wolf, 2012.

77. Takach, 2012a.

78. This reductionism is among the perils sought to be mitigated by arts-based research, with its emphasis on voice, acceptance of ambiguity, acknowledgment of subjectivity, and creative opportunities to engage and challenge diverse positions through techniques such as documentary and dramatic personification. See, for example, Barone and Eisner, and Leavy.

79. Miles, 47.

80. Hardy; Babe, 2000; Druick.

81. Jenkins.

82. Corporate Ethics International, 2010.

83. van Ham, 2010a, 2010b.

84. Sharpley and Stone.

85. Pezzullo.

86. McKibben, 2005.

87. Takach, 2016.

88. Carruthers.

89. Gould, 246.

Notes

References

350.org. n.d. "Our Team's History." Web.

Acland, Charles R. 2002. "Screen Space, Screen Time and Canadian Film Exhibition." In *North of Everything: English-Canadian Cinema since 1980*. Edited by William Beard and Jerry White. Edmonton, AB: University of Alberta Press. 2–18.

Ainslie, Patricia, and Mary-Beth Laviolette. 2007. *Alberta Art and Artists*. Calgary, AB: Fifth House Publishers.

Alberta (Government). 2006a. "Alberta Community Development: Final Report: Minister Denis Ducharme's Mission to Washington, DC." Web.

———. 2006b. "Alberta International and Intergovernmental Relations: Final Report. Minister Gary Mar's Mission to Washington, DC." Web. No longer online.

———. 2006c. "Alberta Energy: Final Report. Minister Greg Melchin's Mission to New York and Washington, DC." Web.

———. 2006d. "Alberta's Integrated Energy Vision." Alberta Energy / Legislative Assembly. Web.

———. 2009. *An Open Door* [video]. Web. No longer online.

———. 2010a. *About the Oil Sands* [video]. oilsands.alberta.ca. Web.

———. 2010b. *Alberta Oil Sands: About* [video]. youtube.com. Web.

———. 2010c. "Distribution of Population by Age and Sex, Alberta, 2001 and 2006." Web.

———. 2010d. "Highlights of the Alberta Economy 2010." Web.

———. 2011a. "60 Minutes – Alberta Oilsands – 2006-151" [video link]. Web.

———. 2011b. "Attendance and/or Participation in the Arts by Sex, Alberta, 2003–2004 to 2010–2011." Web.

———. 2011c. "Highlights of the Alberta Economy 2011." Web.

———. 2012a. "Highlights of the Alberta Economy 2012." Web.

———. 2012b. "Alberta Washington DC Office." albertacanada.com. Web.

———. 2012c. *A Day in Alberta* [DVD]. Edmonton, AB: Government of Alberta.

———. 2013a. "Oil and Gas." albertacanada.com. Web.

———. 2013b. "Alberta's Oil Sands: Economic Benefits." Web.

———. 2013c. "Alberta's Oil Sands: Research and Technology." Web.

———. 2013d. "Alberta's Oil Sands: Alberta's Clean Energy Future." Web.

———. 2013e. "Alberta's International Trade Strategy 2013: Building Markets." Web.

———. 2014a. "Alberta Energy: Our Business: Oil Sands." Web.

———. 2014b. "Operational Plan: Fiscal Plan 2014–17." #buildingAlberta. Web.

———. 2014c. "Alberta's Oil Sands: The Facts." Web.

———. 2014d. "Alberta's Leased Oil Sands Area" [map]. Web.

———. 2014e. "US–Alberta Relations." Alberta International and Intergovernmental Relations. economic.alberta.ca. Web.

———. 2015a. "Alberta Energy: Our Business: Resource." Web.

———. 2015b. "Backgrounder on Alberta's Fiscal Situation." Alberta Finance. Web.

———. 2015c. "Alberta Resource Revenues: Historical (1970 to latest) and Budget ($ Millions)." Alberta Energy. Web.

———. 2015d. "Highlights of the Alberta Economy 2015." Web.

———. 2015e. "Alberta Official Statistics: Total Bitumen Production, Alberta." Alberta Energy / osi.alberta.ca. Web.

———. 2015f. "Climate Leadership Plan Speech [by Premier Rachel Notley]." November 22. Web.

———. 2015g. "Capping Oil Sands Emissions." November 22. Web.

———. n.d. *Alberta Opportunity* [video]. Edmonton, AB: Public Affairs Bureau.

Alberta College of Social Workers. 2010. ACSW *Social Policy Framework 2010: Visioning a More Equitable and Just Alberta*. Web.

Alberta Environmental Network. 2009. "Canadian Premiere of Oscar Shortlisted Film 'Downstream.'" Web.

Alberta Human Rights Commission. 2009. "Notice of Changes to Alberta Human Rights Legislation." Web.

Anderson, Jack. 2008 (March 14, 5:12 p.m.). Comment on "Tar Sands: The Selling of Alberta." CBC Documentaries Blog. March 11, 2008.

Anholt, Simon. 2010. "Definitions of Place Branding: Working Towards a Resolution." *Place Branding and Public Diplomacy* 6, no. 1: 1–10.

Ateljevic, Irena, and Stephen Doorne. 2002. "Representing New Zealand: Tourism Imagery and Ideology." *Annals of Tourism Research* 29, no. 3: 648–667.

Audette, Trish. 2007. "Mini-Baby Boom in Base Mirrors Rest of Alberta." *Edmonton Journal.* September 13. A2.

Audette, Trish, and Darcy Henton. 2009. "New Brand to Counteract Image of 'Dirty Oil.'" *Edmonton Journal.* March 16. A1.

Aufderheide, Patricia. 2007. *Documentary: A Very Short Introduction.* New York, NY: Oxford University Press.

Avery, Samuel. 2013. *The Pipeline and the Paradigm: Keystone XL, Tar Sands, and the Battle to Defuse the Carbon Bomb.* Washington, DC: Ruka.

Babe, Robert E. 2000. *Canadian Communication Thought: Ten Foundational Writers.* Toronto, ON: University of Toronto Press.

———. 2008. "Innis and the Emergence of Canadian Communication/Media Studies." *Global Media Journal – Canadian Edition* 1, no. 1: 9–23.

———. 2011. "Innis, Environment and New Media." In *Media, Structures and Power: The Robert Babe Collection.* Edited by Edward Comor. Toronto, ON: University of Toronto Press. 314–335.

Baichwal, Jennifer [dir.]. 2006. *Manufactured Landscapes* [DVD]. Montréal, QC / Toronto, ON: National Film Board of Canada / Mongrel Media.

Bal, Mieke. 2003. "Visual Essentialism and the Object of Visual Culture." *Journal of Visual Culture* 2, no. 1: 5–32.

Banks, Marcus. 2007. *Using Visual Data in Qualitative Research.* Thousand Oaks, CA: Sage.

Bannatyne-Cugnet, Jo, and Yvette Moore. 1992. *A Prairie Alphabet.* Toronto, ON: Tundra.

Barone, Tom, and Elliot W. Eisner. 2012. *Arts Based Research.* Thousand Oaks, CA: Sage.

Baudrillard, Jean. 1994. *Simulacra and Simulation.* Translated by Sheila Faira Glaser. Ann Arbor, MI: University of Michigan Press.

BC Hydro. 2013. "W.A.C. Bennett Dam Visitor Centre." Web.

Beaver Lake Cree Nation. 2014. "Beaver Lake Cree Nation vs. Alberta and Canada." Web.

Beck, Ulrich. 1995. *Ecological Enlightenment: Essays on the Politics of the Risk Society.* Atlantic Highlands, NJ: Humanities Press.

Bell, Bill. 2009. "The Scam of Our Lifetime" [advertisement-opinion]. *Calgary Herald.* December 8. B5.

Bennett, Dean. 2013. "Alberta Buys *New York Times* Ad to Make Its Case for Keystone
 XL Pipeline." *Calgary Herald*. March 18. Web.

Benoit, Roxanna. 2008. "Alberta's Brand Initiative Overview." Web.

Berger, John. 1972. *Ways of Seeing*. London: BBC and Harmondsworth.

Bergerson, Joule, and David Keith (2006). "Life Cycle Assessment of Oil Sands
 Technologies." Alberta Energy Futures Workshop, Calgary, AB. Web.

Berkshire, Geoff. 2014. "Film Review: *Above All Else*." *Variety*. March 28. Web.

Berland, Jody. 2009. *North of Empire: Essays on the Cultural Technologies of Space*.
 Durham, NC: Duke University Press.

Berry, Susan, and Jack Brink. 2004. *Aboriginal Cultures in Alberta: Five Hundred
 Generations*. Edmonton, AB: Provincial Museum of Alberta.

Blanchfield, Mike. 2011. "US Mayors Want 'Dirty' Oil Discussion in Canadian Election
 Campaign." Canadian Press. April 7. Web.

Blue, Gwendolyn. 2008. "If It Ain't Alberta, It Ain't Beef: Local Food, Regional
 Identity, (Inter)National Politics." *Food, Culture and Society* 11, no. 1: 69–85.

Boime, Eric. 2008. "Environmental History, the Environmental Movement, and the
 Politics of Power." *History Compass* 6, no. 1: 297–313.

Borah, Porismita. 2011. "Conceptual Issues in Framing Theory: A Systematic
 Examination of a Decade's Literature." *Journal of Communication* 61, no. 2:
 246–263.

Bouchard, David, and Henry Ripplinger. 1993. *If You're Not from the Prairie...*
 Vancouver, BC: Raincoast.

Bouchard, Luc. 2009. "The Integrity of Creation and the Athabasca Oil Sands." Web.

Bowers, C.A. 2001. "Toward an Eco-Justice Pedagogy." *Educational Studies* 32, no. 4:
 401–416.

Bowie, Geoff [writer-dir.]. 2004. "When Is Enough, Enough?" *The Nature of Things*
 [DVD]. Toronto: CBC Learning.

——— [writer-dir.]. 2006. "When Less Is More." *The Nature of Things* [DVD]. Toronto:
 CBC Learning.

Boykoff, Maxwell T., and Joe Smith. 2010. "Media Presentations of Climate Change."
 In *Routledge Handbook of Climate Change and Society*. Edited by Constance Lever-
 Tracy. London, UK: Routledge. 210–218.

Braid, Don. 2011. "'Spirit to Achieve' Headed for Exits." *Calgary Herald*. October 26. A1.

Brenner, Jim. 2008 (March 14, 1:47 p.m.). Comment on "Tar Sands: The Selling of
 Alberta." CBC Documentaries Blog. March 11, 2008.

Brereton, Pat. 2005. *Hollywood Utopia: Ecology in Contemporary American Cinema*.
 Bristol, UK: Intellect.

Bright, David. 2006. "1919: 'A Year of Extraordinary Difficulty.'" In *Alberta Formed—Alberta Transformed, Volume 2*. Edited by Donald G. Wetherell, Michael Payne and Catherine Anne Cavanaugh. Edmonton, AB / Calgary, AB: University of Alberta Press / University of Calgary Press. 412–441.

Brooymans, Hanneke. 2010. "Alberta Hunters Shoot About 125,000 Ducks Each Year." *Edmonton Journal*. October 28. A2.

Broto, Vanesa Castan, Kate Burningham, Claudia Carter and Lucia Elghali. 2010. "Stigma and Attachment: Performance of Identity in an Environmentally Degraded Place." *Society and Natural Resources* 23, no. 10: 952–968.

Brulle, Robert J. 2010. "From Environmental Campaigns to Advancing the Public Dialog: Environmental Communication for Civic Engagement." *Environmental Communication* 4, no. 1: 82–98.

Burgess, Lynn [prod.]. 2007. "Crude Awakening: The Oil Crash." CBC's *The National*. Toronto, ON: Canadian Broadcasting Corporation. Broadcast December 12.

Burns, Ken [dir.]. 2009. *The National Parks: America's Best Idea* [DVD]. Walpole, NH: Florentine Films.

Burtynsky, Edward et al. 2009. *Burtynsky Oil*. Göttingen, Germany: Steidl / Corcoran.

Butala, Sharon. 1994. *The Perfection of Morning: An Apprenticeship in Nature*. Toronto, ON: HarperCollins.

Butler, W.F. 1872. *The Great Lone Land: A Narrative of Travel and Adventure in the North-West of America*. London, UK: Sampson Low, Marston, Low and Searle.

Buttimer, Anne, and David Seaman. 1980. *The Human Experience of Space and Place*. London, UK: Palgrave Macmillan.

Byrne, T.C. 1991. *Alberta's Revolutionary Leaders*. Calgary, AB: Detselig.

Calamur, Krishnadev. 2015. "Obama Vetoes Keystone XL Pipeline Bill." *The Two-Way*. January 29. Web.

Calder, Alison. 2001. "Who's from the Prairie? Some Prairie Self-Representations in Popular Culture." In *Toward Defining the Prairies: Region, Culture, History*. Edited by Robert Wardhaugh. Winnipeg, MB: University of Manitoba Press. 91–100.

Calgary Herald. 2011. "The Divisiveness that Jack Built: Cheap Shots Against Oilsands Fuel Regional Animosity." *Calgary Herald*. April 4. A10.

Cameron, James [dir.]. 2010. *Avatar* [DVD]. Beverly Hills, CA: 20th Century Fox Home Entertainment.

Campanella, David. 2012. "Misplaced Generosity (Update 2012): Extraordinary Profits in Alberta's Oil and Gas Industry." Parkland Institute. March 15. Web.

Campbell, Claire Elizabeth, ed. 2011. *A Century of Parks Canada, 1911–2011*. Calgary, AB: University of Calgary Press.

Campelo, Adriana, Robert Aitken and Juergen Gnoth. 2011. "Visual Rhetoric and Ethics in Marketing of Destinations." *Journal of Travel Research* 50, no. 1: 3–14.

Canada (Government). 1911. *Canada West: The Last Best West*. Ottawa, ON: Government of Canada, Minister of the Interior.

———. 1991. Broadcasting Act, S.C. 1991, c. 11 as am.

Canada West Foundation. 2010. "Oil Sands Media Monitoring Report." January 20. Web.

Canada's Ecofiscal Commission. 2015. *Provincial Carbon Pricing and Competitiveness Pressures: Guidelines for Business and Policymakers*. Web.

Canadian Association of Petroleum Producers. 2009. *A Side of Fort McMurray You Haven't Seen* [video]. Web.

———. 2010a. *Canada's Oil Sands – Come See for Yourself* [video]. Web.

———. 2010b. "Alberta Is Energy." Web.

———. 2011. "CBC's *Tipping Point* Gives Science the Short End of the Stick." Web.

———. 2012a. "What are Oil Sands?" Web.

———. 2012b. "About Us: Our Mission." Web.

Canadian Council on Learning. 2010. "Composite Learning Index." Web.

Canadian Energy Research Institute. 2013. "Recent Foreign Investment in the Canadian Oil and Gas Industry." Web.

———. 2014. "Canadian Economic Impacts of New and Existing Oil Sands Development in Alberta (2014–2038)." Web.

Canadian Press. 2009. "Alberta Unveils New Logo: 'Freedom to Create, Spirit to Achieve.'" *Trail Times* [British Columbia]. March 26. 5.

———. 2012a. "Danielle Smith: Climate Change Science 'Not Settled.'" *Huffington Post*. April 16. Web.

———. 2012b. "Western Premiers to Talk Environment, Energy and Tom Mulcair." Web.

———. 2012c. "Ex-Alberta Premier Says Climate Change Denial Cost Wild Rose Election." *Metro News*. May 9. Web.

———. 2013a. "Conference Board of Canada Calls on Alberta to Introduce Provincial Sales Tax." *Maclean's*. February 26. Web.

———. 2013b. "Fort McMurray Tunes out Neil Young after Rocker Blasts Oilsands." CBC News. September 12. Web.

———. 2014. "Alberta Oilsands Facing Aboriginal Legal Onslaught in 2014." Web.

Cantrill, James G., and Christine L. Oravec, eds. 1996. *The Symbolic Earth: Discourse and Our Creation of the Environment*. Lexington, KY: University Press of Kentucky.

Carbaugh, Donal, and Tovar Cerulli. 2013. "Cultural Discourses of Dwelling: Investigating Environmental Communication as a Place-Based Practice." *Environmental Communication* 7, no. 1: 4–23.

Carbon Brief. 2014. "Two Degrees: The History of Climate Change's Speed Limit." Web.

Cardwell, Francesca S., and Susan J. Elliott. 2013. "Making the Links: Do We Connect Climate Change with Health? A Qualitative Case Study from Canada." *BMC Public Health* 13, no. 208: 1–12. Web.

Carlson, Kathryn Blaze. 2012. "Canada Day Poll: 15 Things You Should Know About Canadian Identity." *National Post*. June 30. Web.

Carnevale, Robert. 2009. "*Dirty Oil* – Leslie Iwerks Interview." *Indie London*. Web.

Carruthers, Beth. 2006. "Art, Sweet Art." *Alternatives Journal* 32, no. 4–5: 24–27.

Carson, Rachel. 1962. *Silent Spring*. Boston, MA: Houghton Mifflin.

CBC. 2008. "Tar Sands: The Selling of Alberta" [discussion forum]. Web.

CBC News. 2008a. "Low Voter Turnout in Alberta Election Being Questioned." Web.

———. 2008b. "Alberta Rethinks Film Funding Rules After Anti-Oilsands Doc Gets Cash." December 11. Web.

———. 2010. "Alberta Charters Luxury Train for Vancouver Olympics." Web.

———. 2012. "CBC Budget Cut by $115M over 3 Years." March 29. Web.

———. 2014. "Neil Young's Anti-Oilsands Comments Draw Fire from Industry." January 16. Web.

CBC Radio. 2009. *Calgary Eyeopener*. December 21. Web.

Centre for Bhutan Studies and GNH Research. 2015. "Bhutan GNH Index." Web.

Chaplin, Elizabeth. 1994. *Sociology and Visual Representation*. New York, NY: Routledge.

Chastko, Paul. 2004. *Developing Alberta's Oil Sands: From Karl Clark to Kyoto*. Calgary, AB: University of Calgary Press.

Cheadle, Bruce. 2014. "Canadian Oil Sands Exporters Narrowly Survive 'Dirty Oil' Vote." *The Globe and Mail*. December 17. Web.

Chong, Dennis, and James N. Druckman. 2007. "Framing Theory." *Annual Review of Political Science* 10: 103–126.

Chouliaraki, Lilie, and Mette Morsing. 2010. "Introduction: Towards an Understanding of the Interplay between Media and Organizations." In *Media, Organizations and Identity*. Edited by Lilie Chouliaraki and Mette Morsing. Houndmills, UK: Palgrave Macmillan. 1–24.

Christian, Carol. 2008. "Council of Canadians Blasts Alberta Gov't." *Fort McMurray Today*. December 15. Web.

Clark, Gregory, S. Michael Halloran and Allison Woodford. 1996. "Thomas Cole's Vision of 'Nature' and the Conquest Theme in American Culture." In *Green*

Culture: Environmental Rhetoric in Contemporary America. Edited by Carl George
Herndl and Stuart Cameron Brown. Madison, WI: University of Wisconsin
Press. 261–280.

Clark, K.A., and S.M. Blair. 1927. *The Bituminous Sands of Alberta*. Scientific and
Industrial Research Council of Alberta, Report No. 18. Edmonton, AB: King's
Printer.

Clarke, Cath. 2010. "Petropolis." *The Guardian*. May 13. Web.

Clear, James, ed. 2015. "Masters of Habit: The Wisdom and Writing of Maya Angelou."
Web.

Climate Action Network Canada. 2012. "Dirty Oil Diplomacy." Web.

Coastal First Nations. 2013. *Have You Heard the Radio Call from the Exxon Valdez?*
[video]. Web.

Cobb, Andy, and Mike Damanskis [dirs.]. 2013. *Remember to Breathe: Indiegogo Pitch
Video* [video]. Web.

Coglon, David. 2015. "Focus on Innovation." *Context Magazine*. Canadian Association
of Petroleum Producers. Web.

Coleman, Renita. 2010. "Framing the Pictures in Our Heads: Exploring the Framing
and Agenda-Setting Effects of Visual Images." In *Doing News Framing Analysis:
Empirical and Theoretical Perspectives*. Edited by Paul D'Angelo and Jim A.
Kuypers. New York, NY: Routledge. 232–261.

Coleman, Stephen, and Karen Ross. 2010. *The Media and the Public*. Chichester, UK:
Wiley-Blackwell.

Conference Board of Canada. 2011. "Hot Topic: Canadian Income Inequality." Web.

Connors, Leila [dir.]. 2014. *Carbon* [video]. Web.

Connors, Richard, and John M. Law. 2005. *Forging Alberta's Constitutional Framework*.
Edmonton, AB: University of Alberta Press.

Corbett, Julia B. 2006. *Communicating Nature: How We Create and Understand
Environmental Messages*. Washington, DC: Island Press.

Corporate Ethics International. 2010. *Rethink Alberta* [video]. Web.

———. n.d.a. "About CEI." Web.

———. n.d.b. "Our History." Web.

———. n.d.c. "Projects." Web.

Cotter, John. 2008. "Dead Ducks Tar Canada's Image, PM Says." *The Globe and Mail*.
May 2. A4.

Couldry, Nick. 2010. *Why Voice Matters: Culture and Politics after Neoliberalism*.
Thousand Oaks, CA: Sage.

Cox, Robert, and Phaedra C. Pezzullo. 2016. *Environmental Communication and the
Public Sphere*. 4th ed. Thousand Oaks, CA: Sage.

Cronon, William. 1995. "The Trouble with Wilderness; or, Getting Back to the Wrong Nature." In *Uncommon Ground: Toward Reinventing Nature*. Edited by William Cronon. New York, NY: W.W. Norton & Co. 69–90.

Cryderman, Kelly. 2014. "Desmond Tutu Takes on the Oil Sands." *The Globe and Mail*. May 31. B4.

Curry, Bill, and Shawn McCarthy. 2011. "Canada Formally Abandons Kyoto Protocol on Climate Change." *The Globe and Mail*. December 12. Web.

D'Aliesio, Renata. 2010. "Controversial Oilsands Ad Could Hurt Tourism; Survey Shows Video by Environmentalists Will Have Fallout." *Edmonton Journal*. August 9. A4.

D'Aliesio, Renata, and Jason Markusoff. 2008. "No Brakes on Oilsands: Stelmach Won't Suspend Land Leases for Now." *Edmonton Journal*. February 26. A1.

Dahlgren, Peter. 2009. *Media and Political Engagement: Citizens, Communication, and Democracy*. New York, NY: Cambridge University Press.

Davidson, Debra J., and Mike Gismondi. 2011. *Challenging Legitimacy at the Precipice of Energy Calamity*. New York, NY: Springer.

De Rosa, Maria. 2012. *The Canadian Feature Film Distribution Sector in Review: Trends, Policies and Market Developments*. Web.

de Steiguer, J.E. 2006. *The Origins of Modern Environmental Thought*. Tucson, AZ: University of Arizona Press.

de Vries, Nanne, Robert Ruiter and Yvonne Leegwater. 2002. "Fear Appeals in Persuasive Communication." In *Marketing for Sustainability: Towards Transactional Policy-Making*. Edited by Gerald Nelissen and Wil Bartels. Amsterdam, NL: IOS Press. 96–104.

Dean, Jodi. 2008. "Enjoying Neoliberalism." *Cultural Politics* 4, no. 1: 47–72.

DeFore, John. 2014. "*Above All Else*: SXSW Review." *Hollywood Reporter*. March 20. Web.

DeLuca, Kevin Michael. 2010. "Salvaging Wilderness from the Tomb of History: A Response to *The National Parks: America's Best Idea*." *Environmental Communication* 4, no. 4: 484–493.

Dembicki, Geoff. 2011. "'Tar Sands' vs. 'Oil Sands' Political Flap Misguided?" *The Tyee*. April 25. Web.

Desjardins, Lynn. 2015. "Liberals Promise to Restore CBC and Arts Funding." Radio Canada International. September 22. Web.

Desrochers, Pierre, and Hiroko Shimizu. 2012. *Innovation and the Greening of Alberta's Oil Sands*. Montréal, QC: Montreal Economic Institute.

Dick, Angus [dir.]. 2012. *Vote BP for Greenwash Gold* [video]. UK Tar Sands Network. Web.

Diehl, Carol. 2006. "The Toxic Sublime." *Art in America* 94, no. 2: 118–123.

Dikovitskaya, Margaret. 2005. "A Look at Visual Studies." *Afterimage* 29, no. 5: 4.

Dippie, Brian W. 1988. "Review of *The Mythic West in Twentieth-Century America*." *Great Plains Quarterly* 8, no. 1 (Winter): 47–48.

Dispensa, Jaclyn Marisa, and Robert J. Brulle. 2003. "Media's Social Construction of Environmental Issues: Focus on Global Warming – A Comparative Study." *International Journal of Sociology and Social Policy* 23, no. 10: 74–105.

Dittmer, Jason. 2010. *Popular Culture, Geopolitics and Identity*. Lanham, MD: Rowman and Littlefield.

Dobrin, Sidney I., and Sean Morey. 2009. "Ecosee: A First Glimpse." In *Ecosee: Image, Rhetoric, Nature*. Edited by Sidney I. Dobrin and Sean Morey. Albany, NY: State University of New York Press. 1–19.

Doyle, John. 2011. "CBC Oil-sands Doc Needs to Wade Deeper." *The Globe and Mail*. January 27. Web.

Doyle, Julie. 2009. "Seeing the Climate? The Problematic Status of Visual Evidence in Climate Change Campaigning." In *Ecosee: Image, Rhetoric, Nature*. Edited by Sidney I. Dobrin and Sean Morey. Albany, NY: SUNY Press. 279–298.

Druick, Zoë. 2007. *Projecting Canada: Government Policy and Documentary Film at the National Film Board*. Montréal, QC / Kingston, ON: McGill-Queen's University Press.

Dutton, Mohan J. 2012. *Voices of Resistance: Communication and Social Change*. West Lafayette, IN: Purdue University Press.

The Economist. 2008. "Please Buy Our Dirty Oil." *The Economist*. March 13. Web.

Edelstein, Robert. 2008. "60 Minutes." *Broadcasting & Cable* 138, no. 41: 46.

Edmonton Journal. 2014. "Top Stories on the Journal Website for 2014." *Edmonton Journal*. December 28. Web.

Elections Alberta. 2015. "Provincial General Election May 5, 2015: Winning Candidates, Provincial Results." Web.

Energy Resources Conservation Board (Alberta Government). "Alberta's Energy Reserves 2008 and Supply/Demand Outlook 2009–2018." Web.

Entman, Robert M. 1993. "Framing: Toward Clarification of a Fractured Paradigm." *Journal of Communication* 43, no. 4: 51–58.

———. 2004. *Projects of Power: Framing News, Public Opinion, and US Foreign Policy*. Chicago, IL: University of Chicago Press.

———. 2007. "Framing Bias: Media in the Distribution of Power." *Journal of Communication* 57, no. 1: 163–173.

EthicalOil.org. 2014. "Neil Young Lies." Web.

Feldman, Stacy. 2010. "US Politicians Oppose 2,000-Mile Oil Sands Pipeline." *The Guardian*. June 24. Web.

Fenton, Cameron. 2015. "Alberta's New Climate Plan is Historic, But It's Not Enough." *Huffington Post Alberta*, November 23. Web.

Fiege, John [dir.]. 2014a. *Above All Else* [video]. Austin, TX: Fiege Films.

———. 2014b. *Above All Else* [press notes]. Web.

Finkel, Alvin, Sarah Carter and Peter Fortna, eds. 2010. *The West and Beyond: New Perspectives on an Imagined Region*. Edmonton, AB: Athabasca University Press.

Finucan, Karen. 2002. "What Brand Are You?" *Planning* 68: 10–13.

Fiore, Mark [dir.]. 2013. *Tar Sands Timmy* [video]. Web.

Flanagan, Erin. 2014. "Oilsands Expansion, Emissions and the Energy East Pipeline." Web.

Flannery, Tim. 2010. *Here on Earth: A Natural History of the Planet*. Toronto, ON: HarperCollins.

Foley, Jack. 2010. "*Dirty Oil* – Review." *Indie London*. Web.

Forest Ethics. 2013. "Economic and Health Impacts of Tar Sands Expansion." Web.

Foster, Peter. 2011. "Tripping Point." *National Post*. January 28. FP13.

Foucault, Michel. 1972. *The Archeology of Knowledge*. Translated by A.M. Sheridan Smith. London, UK: Tavistock.

———. [1977] 1998. "What is an Author?" In *Aesthetics, Method, and Epistemology*. Edited by James D. Faubion. Translated by Robert Hurley et al. New York, NY: New Press. 205–222.

Francis [Pope]. 2015. *Encyclical Letter Laudato Si' of the Holy Father Francis on Care for Our Common Home*. Web.

Francis, Daniel. 1997. *National Dreams: Myth, Memory, and Canadian History*. Vancouver, BC: Arsenal Pulp Press.

Francis, R. Douglas. 1989. *Images of the West: Changing Perceptions of the Prairies, 1690–1960*. Saskatoon, SK: Western Producer Prairie Books.

———. 1992. "In Search of Prairie Myth: A Survey of the Intellectual and Cultural Historiography of Prairie Canada." *Journal of Canadian Studies* 24, no. 3: 44–69.

———. 2009. *The Technological Imperative in Canada: An Intellectual History*. Vancouver, BC: University of British Columbia Press.

———. 2011. "The West and Beyond: New Perspectives on an Imagined Region (review)." *Canadian Historical Review* 92, no. 3 (September): 549–551.

Francis, R. Douglas, and Chris Kitzan. 2007. *The Prairie West as Promised Land*. Calgary, AB: University of Calgary Press.

Friedman, Thomas L. 2006. "The First Law of Petropolitics." *Foreign Policy* 154: 28–36.

Frontier Centre for Public Policy. 2012. Web.

———. 2013a. "What Is the Frontier Centre for Public Policy?" Web.

————. 2013b. "Earth Day's Credibility Damaged by Dominance of Climate Activists." Web.

Gailus, Jeff. 2012. *Little Black Lies: Corporate and Political Spin in the Global War for Oil.* Calgary, AB: Rocky Mountain Books.

————. 2014. "Climate Denier Grabs Earth Day Headline in *Vancouver Sun.*" Desmog.ca. April 25. Web.

Galloway, Gloria. 2011. "Environmentalists, Natives and Unions Denounce 'Biocidal' Oil-sands Policy." *The Globe and Mail.* September 26. Web.

Gamson, William A., and Andre Modigliani. 1989. "Media Discourse and Public Opinion on Nuclear Power: A Constructionist Approach." *American Journal of Sociology* 95, no. 1: 1–37.

Gauthier, Jennifer L. 2008. "Whose Mission Accomplished? Alberta at the 2006 Smithsonian Folklife Festival." *American Review of Canadian Studies* 38, no. 4: 451–472.

————. 2009. "Selling Alberta at the Mall: The Representation of a Canadian Province at the 2006 Smithsonian Folklife Festival." *International Journal of Cultural Studies* 12, no. 6: 639–659.

Geisel, Theodor S. (Dr. Seuss). 1971. *The Lorax.* New York, NY: Random House.

Gerein, Keith. 2011. "Tourism Boycott Had No Impact." *Edmonton Journal.* January 12. B3.

Gergen, Kenneth J. 2009. *An Invitation to Social Construction.* 2nd ed. Thousand Oaks, CA: Sage.

Gibson, Diana. 2011. Conversation with the author. Edmonton, AB. June 24.

————. 2012. *A Social Policy Framework for Alberta: Fairness and Justice for All.* Web.

Gibson, William E. 2004. *Eco-Justice: The Unfinished Journey.* Albany, NY: State University of New York Press.

Gilbert, Emily. 2008. "Beyond Survival? Wilderness and Canadian National Identity into the Twenty-First Century." *British Journal of Canadian Studies* 21, no. 1: 63–88.

Gilbert, Jan. 2010. "Leslie Iwerks (Director) – Dirty Oil." *My Movie Mundo: A World of Film Features and Interviews.* Web.

Gillespie, Curtis. 2008. "Scar Sands." *Canadian Geographic* 128, no. 3: 64–78.

Gillis, Justin. 2013. "UN Climate Panel Endorses Ceiling on Global Emissions." *The New York Times.* March 27. Web.

Gismondi, Mike, and Debra J. Davidson. 2012. "Imagining the Tar Sands 1880–1967 and Beyond." *Imaginations* 3, no. 2: 68–103. Web.

Glenbow Museum. 2006. "*Mavericks:* Teacher Resources: Oil and Gas." Web.

Glynn, Kevin. 2009. "Contested Land and Mediascapes: The Visuality of the Postcolonial City." *New Zealand Geographer* 65, no. 1: 6–22.

Goffman. Erving. 1974. *Frame Analysis: An Essay on the Organization of Experience*. New York, NY: Harper & Row.

Goldenberg, Suzanne. 2012. "Keystone xL Pipeline: Obama Rejects Controversial Project." *The Guardian*. January 18. Web.

Goldstein, Barry M. 2007. "All Photos Lie: Images as Data." In *Visual Research Methods: Image, Society, and Representation*. Edited by Gregory C. Stanczak. Thousand Oaks, CA: Sage. 61–81.

Goldstein, Patrick. 2008. "A Non-Glam Oscar Field is Buzzing." *Los Angeles Times*. December 23. Web.

Gore, Al. [1992] 2006a. *Earth in the Balance: Ecology and the Human Spirit*. New York, NY: Rodale.

———. 2006b. *An Inconvenient Truth: The Planetary Emergence of Global Warming and What We Can Do About It*. New York, NY: Rodale.

Gould, Stephen Jay. [1989] 1994. *Eight Little Piggies: Reflections in Natural History*. New York, NY: Norton.

Govers, Robert, and Frank Go. 2009. *Place Branding: Glocal, Virtual and Physical Identities, Constructed, Imagined and Experienced*. New York, NY: Palgrave Macmillan.

Grant, Jennifer. 2013. "Let's Make Oilsands Development Responsible." *The Globe and Mail*. November 27. Web.

Grant, Jennifer, Eli Angen and Simon Dyer. 2013. "Forecasting the Impacts of Oil Sands Expansion." Web.

Gray, G.R., and R. Luhning. 2013. "Bitumen." *The Canadian Encyclopedia*. Web.

Greenpeace Canada. 2012. "People from across Canada Gather in Victoria to Oppose Tar Sands Pipelines and Tankers." October 22. Web.

Guggenheim, Davis [dir.]. 2006. *An Inconvenient Truth* [DVD]. Los Angeles, CA: Paramount.

Guise, Steve [dir.]. 2009. "Marie Adam, Fort McMurray Resident" [webisode]. Greenpeace Canada. Web.

Gunster, Shane, and Paul Saurette. 2014. "Storylines in the Sands: News, Narrative and Ideology in the *Calgary Herald*." *Canadian Journal of Communication* 39: 333–359.

Gutstein, Donald. 2012. "Canada West Foundation Rewrites History: Think-Tank Tracker." rabble.ca. February 1. Web.

Hall, Stuart. 1996. "The Question of Cultural Identity." In *Modernity: An Introduction to Modern Societies*. Edited by Stuart Hall, David Held, Don Hubert and Kenneth Thompson. 595–634. Malden, MA: Blackwell.

Hamilton, Sheryl. 2010. "Considering Critical Communication Studies." In *Mediascapes: New Patterns in Canadian Communication*. 3rd ed. Edited by Lesley Regan Shade. Toronto, ON: Nelson Education.

Hannigan, John A. 2006. *Environmental Sociology: A Social Constructionist Perspective*. 2nd ed. Oxon, UK: Taylor and Francis / Routledge.

Hansen, Anders. 2010. *Environment, Media and Communication*. Oxon, UK: Routledge.

Hansen, Anders, and David Machin. 2008. "Visually Branding the Environment: Climate Change as a Marketing Opportunity." *Discourse Studies* 10, no. 6: 777–794.

———. 2013. "Researching Visual Environmental Communication." *Environmental Communication* 7, no. 2: 151–168.

Hardy, Forsyth, ed. 1966. "Introduction." In *Grierson on Documentary*. Edited by Forsythe Hardy. London, UK: Faber and Faber. 13–39.

Harris/Decima. 2009. "Research Summary: Branding Alberta Initiative." Web.

Hart, Edward John. 1983. *The Selling of Canada: The CPR and the Beginnings of Canadian Tourism*. Banff, AB: Altitude Publishing.

Hayden, Anders. 2014. *When Green Growth is Not Enough: Climate Change, Ecological Modernization, and Sufficiency*. Montréal, QC / Kingston, ON: McGill-Queen's University Press.

Heard, Andrew. 2011. "Elections." Simon Fraser University, Department of Political Science. Web.

———. 2015. "Elections." Simon Fraser University, Department of Political Science. Web.

Heath, Robert L., et al. 2007. "Nature, Crisis, Risk, Science and Society: What Is Our Ethical Responsibility?" *Environmental Communication* 1, no. 1: 34–48.

Heinbecker, Paul. 2013. "2014 is Too Soon for Canada to Run for a Security Council Seat." *The Globe and Mail*. May 7. Web.

Hendry, Judith. 2010. *Communication and the Natural World*. State College, PA: Strata.

Henton, Darcy. 2010. "Syncrude Fine a Windfall for Conservation Groups." *Edmonton Journal*. October 23. A1.

———. 2013. "Economists Say Sales Tax Best Solution for Province." *Calgary Herald*. March 2. A4.

Hill Strategies Research. 2007. "Consumer Spending on Culture in Canada, the Provinces and 15 Metropolitan Areas in 2005." Canada Council. Web.

Hiller, Harry H. 2009. *Second Promised Land: Migration to Alberta and the Transformation of Canadian Society*. Montréal, QC / Kingston, ON: McGill-Queen's University Press.

Hines, Sherman. 1981. *Alberta*. Toronto, ON: McClelland and Stewart.

Hinman, Paul. 2010. *Alberta Hansard*. 27th Legislature, 3rd Session. February 10: 63.

Hirt, Paul W. 1999. "Creating Wealth by Consuming Place: Timber Management on the Gifford Pinchot National Forest." In *Power and Place in the North American West*. Edited by Richard White and John M. Finlay. Seattle, WA: University of Washington Press. 204–232.

Hodgins, Peter, and Peter Thompson. 2011. "Taking the Romance out of Extraction: Contemporary Canadian Artists and the Subversion of the Romantic/Extractive Gaze." *Environmental Communication* 5, no. 4: 393–410.

Hoekstra, Gordon. 2015. "Northern Gateway Pipeline Likely Dead after Liberal Election Win." *Victoria Times Colonist*. October 21. Web.

Holden, Michael. 2013. "From Dead Ducks to Dutch Disease: The Vilification of Canada's Oil Sands in the Media." Canada West Foundation. Web.

Homer-Dixon, Thomas. 2013. "The Tar Sands Disaster." *The New York Times*. March 31. Web.

Horn, Steve. 2013. "Law Firm Behind Removal of YouTube Tar Sands Satire Fundraiser Tied to Big Oil." Web.

Honarvar, Afshin, Jon Rozhon, Dinara Millington, Thorn Walden, Carlos A. Murillo and Zoey Walden. 2011. *Economic Impacts of New Oil Sands Projects in Alberta (2010–2035)*. Calgary, AB: Canadian Energy Research Institute.

Huffington Post. 2014. "Neil Young Oilsands Comments Gets Massive Support in Alberta, But Also Serious Tongue Lashings." *Huffington Post*. January 14. Web.

Huffington Post Alberta. 2013a. "Neil Young Talks Oilsands, Compares Fort McMurray to Hiroshima." *Huffington Post Alberta*. September 10. Web.

———. 2013b. "Neil Young Oilsands: Hiroshima Comments Ignore the Full Picture, says Alta. Filmmaker." *Huffington Post Alberta*. September 11. Web.

Huffington Post Canada. 2014. "The Oilsands Really Do Look like Hiroshima." *Huffington Post Alberta*. January 16. Web.

Humphries, Marc. 2008. "CRS [Congressional Research Service] Report for Congress: North American Oil Sands: History of Development, Prospects for the Future." January 17 (revised). Web.

Ibrahim, Mariam. 2015. "Prentice Willing to Talk Sales Tax as Oil Prices Slump." *Edmonton Journal*. January 14. A1.

IMDb.com. 2015. "Box Office Mojo: All Time Box Office." Web.

Indiegogo. 2013. "Welcome to Fort McMoney—Remember to Breathe!" Web.

Indigenous Environmental Network. 2013. "Don't Buy It, Canada Has No Credibility on Climate." Web.

Ingram, David. 2000. *Green Screen: Environmentalism and Hollywood Cinema*. Exeter, UK: University of Exeter Press.

Innis, Harold A. [1923] 1971. *History of the Canadian Pacific Railway*. Toronto, ON: University of Toronto Press.

———. [1930] 1999. *The Fur Trade in Canada: An Introduction to Canadian Economic History*. Toronto, ON: University of Toronto Press.

———. [1940] 1978. *The Cod Fisheries: The History of an International Economy*. Rev. ed. Toronto, ON: University of Toronto Press.

———. [1950] 2007. *Empire and Communications*. Toronto: Dundurn Press.

———. [1952] 2004. *Changing Concepts of Time*. Lanham, MD: Rowman and Littlefield.

———. 1981. *Innis on Russia: The Russian Diary and Other Writings*. Toronto, ON: Harold Innis Foundation.

———. 2008. *The Bias of Communication*. 2nd ed. Toronto, ON: University of Toronto Press.

Intergovernmental Panel on Climate Change. 2007. *Climate Change 2007: Synthesis Report*. Web.

———. 2013. *Climate Change 2013: The Physical Science Basics*. Web.

———. 2014. *Climate Change 2014: Impacts, Adaptation, and Vulnerability*. Web.

Ivakhiv, Adrian. 2008. "Green Film Criticism and Its Futures." *Interdisciplinary Studies in Literature and Environment* 15, no. 2: 1–28.

Iwerks, Leslie [dir.]. 2008. *Downstream* [DVD]. Santa Monica, CA: Leslie Iwerks Productions.

——— [dir.]. 2009. *Dirty Oil* [DVD]. Santa Monica, CA: Leslie Iwerks Productions.

——— [dir.]. 2011. *Pipe Dreams* [DVD]. Santa Monica, CA: Leslie Iwerks Productions.

Jackson, Peter [dir.]. 2001. *Lord of the Rings: The Fellowship of the Ring* [DVD]. Montréal, QC: Alliance Atlantis.

Jamieson, Harry. 2007. *Visual Communication: More than Meets the Eye*. Bristol, UK: Intellect Books.

Janigan, Mary. 2012. *Let the Eastern Bastards Freeze in the Dark: The West Versus the Rest Since Confederation*. Toronto, ON: Knopf Canada.

Japp, Phyllis M., and Debra K. Japp. 2002. "Purification Through Simplification: Nature, the Good Life, and Consumer Culture." In *Enviropop: Studies in Environmental Rhetoric and Popular Culture*. Edited by Mark Meister and Phyllis M. Japp. Westport, CT: Praeger. 81–94.

Jay, Martin. 1988. "The Rise of Hermeneutics and the Crisis of Ocularcentrism." *Poetics Today* 9, no. 2: 307–326.

Jedwab, Jack. 2005. "Alberta, Canada's History and Canadian Identity: Knowledge, Interest and Access." Web.

Jenkins, Henry. 2010. "Transmedia Storytelling and Entertainment: An Annotated Syllabus." *Continuum: Journal of Media and Cultural Studies* 24, no. 6: 943–958.

Johnson, Claudia Hunter. 2015. *Crafting Short Screenplays that Connect*. 4th ed. Burlington, MA: Focal Press.

Johnson, Laura. 2009. "(Environmental) Rhetorics of Tempered Apocalypticism in *An Inconvenient Truth*." *Rhetoric Review* 28, no. 1: 29–46.

Johnson, Leslie Main. 2009. *Trail of Story, Traveller's Path: Reflections on Ethnoecology and Landscape*. Edmonton, AB: Athabasca University Press.

Jones, Jeffrey. 2010. "US Green Groups Attack Alberta Tourism Industry." Reuters. July 15.

Jönsson, Anna Maria. 2011. "Framing Environmental Risks in the Baltic Sea: A News Media Analysis." *Ambio* 40, no. 2: 121–132.

Keep America Beautiful. 1971. "Iron Eyes Cody ['Crying Indian'] PSA." Web.

Killingsworth, M. Jimmie, and Jacqueline S. Palmer. 2009. "Afterword." In *Ecosee: Image, Rhetoric, Nature*. Edited by Sidney I. Dobrin and Sean Morey. Albany, NY: State University of New York Press. 199–209.

Kincheloe, Joe L., Peter McLaren and Shirley R. Steinberg. 2011. "Critical Pedagogy and Qualitative Research: Moving to the Bricolage." In *The Sage Handbook of Qualitative Research*. 4th ed. Edited by Norman K. Denzin and Yvonna S. Lincoln. Thousand Oaks, CA: Sage. 163–177.

Kiss, Simon J. 2008. "Selling Government: The Evolution of Government Public Relations in Alberta from 1971–2006." PHD diss., Department of Political Studies, Queen's University. Web.

Klein, Naomi. 2014. *This Changes Everything: Capitalism vs. the Climate*. New York, NY: Simon and Schuster.

Kleiss, Karen. 2013. "Province Ponders Policy for Alternative Energy." *Edmonton Journal*. May 6. A5.

Kolbert, Elizabeth. 2013. "Lines in the Sand." *The New Yorker*. May 27. 23–24.

König, Thomas. 2005. "Useful Concepts for Frame Analysis." Web. No longer online.

Koring, Paul. "Ottawa Pitches the Oil Sands as 'Green.'" *The Globe and Mail*. March 5. Web.

Kress, Gunther, and Theo van Leeuwen. 2006. *Reading Images: The Grammar of Visual Design*. 2nd ed. London, UK: Routledge.

Krugel, Lauren. 2014. "Neil Young Concludes Anti-Oilsands Concert Series." CTV News. January 19. Web.

Krylová, Petra, and Owen Barder. 2014. *Commitment to Development Index 2014*. Web.

Kunzig, Robert. 2009. "The Canadian Oil Boom: Scraping Bottom." *National Geographic* 215, no. 3: 34–59.

Kuypers, Jim A. 2010. "Framing Analysis from a Rhetorical Perspective." In *Doing News Framing Analysis: Empirical and Theoretical Perspectives*. Edited by Paul D'Angelo and Jim A. Kuypers. New York, NY: Routledge. 286–311.

Kyi, Tanya Lloyd. 2005. *Alberta*. 2nd ed. Vancouver, BC: Whitecap Books.

Laghi, Brian. 1989. "Credibility Fades on Environment, Gov't Memo Says; *Star Wars*-Style PR Campaign Urged to Win Back Support." *Edmonton Journal*. December 7. B4.

Lakoff, George. 2014. *The All-New Don't Think of an Elephant! Know Your Values and Frame the Debate*. 2nd ed. White River Junction, VT: Chelsea Green.

Lamb, W. Kaye, ed. 1970. *The Journals and Letters of Sir Alexander Mackenzie*. Toronto, ON: Macmillan.

Lamphier, Gary. 2008. "Another Hatchet Job on Oilsands." *Edmonton Journal*. March 15. E1.

Landon, Stuart, and Constance Smith. 2010. "Energy Prices and Alberta Government Revenue Volatility." Web.

LaPointe, Kirk. 2011. "Review: *The Tipping Point: The Age of the Oil Sands*." Web.

Lavallee, David [dir.]. 2011. *White Water, Black Gold: A Nation's Water in Peril* [DVD]. San Francisco, CA: Video Project.

Laville, Sandra. 2012. "Police Arrested Actors for Spilling Custard, Say Olympic Protesters." *The Guardian*. July 20. Web.

Leach, Andrew. 2011. "Prof Says Slow Oil Sands Development, Ease Rent Dissipation." *Alberta Oil*. October 17. Web.

Leahy, Stephen. 2006. "Oil Sands: Burning Energy to Produce It." *Resilience* [formerly *Energy Bulletin*]. July 27. Web.

Leavy, Patricia, ed. 2015. *Method Meets Art: Arts-Based Research Practice*. 2nd ed. New York, NY: Guildford Press.

Lefébvre, Henri. [1974] 1991. *The Production of Space*. Translated by Donald Nicholson-Smith. Oxford, UK: Blackwell.

Leslie, Jacques. 2014. "Is Canada Tarring Itself?" *The New York Times*. March 30. A21. Web.

Leslie Iwerks Productions. 2013. "About Us." Web.

Lester, Libby. 2010. *Media and Environment: Conflict, Politics and the News*. Cambridge, UK: Polity.

Levant, Ezra. 2010. *Ethical Oil: The Case for Canada's Oil Sands*. Toronto, ON: McClelland and Stewart.

Lewis, Avi [dir.]. 2015. *This Changes Everything* [film]. Toronto, ON: Klein Lewis Productions.

Lewis, Barbara, and Jeffrey Jones. 2013. "EU Executive Thwarts Canada Lobby on Oil Sands." *Financial Post*. January 30. Web.

Lewis, Barbara, David Ljunggren, and Jeffrey Jones. 2012. "Canada's Oil Sand Battle with Europe." Reuters. May 10. Web.

Library and Archives Canada. 2010. "Census of the Prairie Provinces, 1916." Web.

Lieber, Don. 2014. "European Activists Protest First Major Tar Sands Shipment from Canada, Threaten Escalating Actions." DeSmogBlog. June 4. Web.

Lilley, Brian. 2011. "Left Wing Bias Common for State Broadcasters." *High River Times*. March 30. Web.

Limerick, Patricia Nelson, Clyde A. Milner II and Charles E. Rankin. 1991. *Trails: Toward a New Western History*. Lawrence, KS: University Press of Kansas.

Lu, Chaohui, Grant Schellenberg, Feng Hou and John F. Helliwell. 2015. "How's Life in the City? Life Satisfaction Across Census Metropolitan Areas and Economic Regions in Canada." Statistics Canada. Web.

Lukacs, Martin. 2011. "Canada on Secret Oil Offensive: Documents." *The Dominion*. May 25. Web.

MacDonald, Chris. 2011. "The Ethics of 'Ethical Oil.'" *Canadian Business* 84, no. 17: 13.

Macnaghten, Phil, and John Urry. 1998. *Contested Natures*. London, UK: Sage.

Markusoff, Jason. 2008. "Alberta's Image Getting Makeover to Battle Its Environmental Rep." *Edmonton Journal*. April 24. B8.

Marsden, William. 2007. *Stupid to the Last Drop: How Alberta is Bringing Environmental Armageddon to Canada (And Doesn't Seem to Care)*. Toronto, ON: Knopf.

Marx, Michael. n.d. "Some Thoughts on Tourism Boycotts." Web. No longer online.

Mason, Gary. 2013. "Hollywood vs. Oil Sands? Not a Fair Fight." *The Globe and Mail*. September 20. Web.

Mayes, Robyn. 2008. "A Place in the Sun: The Politics of Place, Identity and Branding." *Place Branding and Public Diplomacy* 4, no. 2: 124–135.

McArthur, Neil, and Warren Cariou [dirs.]. 2009a. *Land of Oil and Water* [DVD]. Winnipeg, MB: Warren Cariou and Neil McArthur.

———. 2009b. *Overburden* [DVD]. Winnipeg, MB: Warren Cariou and Neil McArthur.

McDermott, Vincent. 2014. "Local Filmmaker Begins Fundraising Project for Film Targeting Anti-Oil Celebs." *Fort McMurray Today*. September 22. Web.

McFarlane, Andy. 2009. "Camp Targets BP Oil Plan." BBC *News*. September 1. Web.

McGlade, Christophe, and Paul Ekins. 2015. "The Geographical Distribution of Fossil Fuels Unused When Limiting Global Warming to 2°C." *Nature* 517, no. 7533 (January 8): 187–190.

McKibben, Bill. 2005. "Imagine That: What the Warming World Needs Now is Art Sweet Art." Grist.org. April 22. Web.

————. 2012a. "Global Warming's Terrible New Math." *Rolling Stone*. August 2. Web.

————. 2012b. Conversation with the author. Edmonton, AB. October 24.

————. 2012c. "Why I'm Worried about My Trip to Canada." Web.

McLuhan, Marshall. 1964. *Understanding Media: The Extensions of Man*. Toronto, ON: McGraw-Hill.

McMillan, Barbara. 2012. "*Tipping Point: The Age of the Oil Sands (The Nature of Things)*." *CM Magazine*. 18:33.

Mech, Michelle. 2012. *A Comprehensive Guide to the Alberta Oil Sands: Understanding the Environmental and Human Impacts, Export Implications, and Political, Economic, and Industry Influences*. Web.

Meister, Mark, and Phyllis M. Japp. 2002. "Introduction: A Rationale for Studying Environmental Rhetoric and Popular Culture." In *Enviropop: Studies in Environmental Rhetoric and Popular Culture*. Edited by Mark Meister and Phyllis M. Japp. Westport, CT: Praeger. 1–12.

Melnyk, George, ed. 1992. *Riel to Reform: A History of Protest in Western Canada*. Saskatoon, SK: Fifth House Publishers.

————. 1993. *Beyond Alienation: Political Essays on the West*. Calgary, AB: Detselig.

————. 1999. *New Moon at Batoche: Reflections on the Urban Prairie*. Banff, AB: Banff Centre Press.

————. 2007. "The Imagined City: Toward a Theory of Urbanity in Canadian Cinema." *CineAction* 73–74: 20–27.

Mep, Yannick Jadot. 2015. "CETA: Canadian Deal Weakened Key EU Regulation." The Greens / European Free Alliance in the European Parliament. Web.

Mercredi, Mike. 2009. "Life and Death over a Barrel of Oil." *Canadian Perspectives*. Spring. 22–23. Web.

Methot, Suzanne. 2010. "Docs for Schools: *Land of Oil and Water*: Educational Resource." Hot Docs / Dragonfly Canada. Web.

Mettler, Peter [dir.]. 2009. *Petropolis: Aerial Perspectives on the Alberta Tar Sands* [DVD]. Toronto, ON: Mongrel Media.

————. 2012b. *The End of Time* [DVD]. Montréal, QC / Toronto, ON: National Film Board of Canada / Mongrel Media.

Miles, Malcolm. 2010. "Art Goes AWOL." In *Spaces of Vernacular Creativity: Rethinking the Cultural Economy*. Edited by Timothy J. Edensor, Deborah Leslie, Steve Millington and Norma Rantisi. New York, NY: Routledge. 46–60.

Milne, Courtney. 1989. *Prairie Dreams*. Grandora, SK: Earth Vision.

Mirzoeff, Nicholas. 1998. *An Introduction to Visual Culture*. 1st ed. London, UK: Routledge.

————. 2009. *An Introduction to Visual Culture*. 2nd ed. London, UK: Routledge.

———. 2013. "Introduction: For Critical Visual Studies." In *The Visual Culture Reader*. 3rd ed. Edited by Nicholas Mirzoeff. London: Routledge. xxix–xxxviii.

Morris, Peter. n.d. *Canadian Film Encyclopedia* s.v. "The Tar Sands." Web.

Moser, Susanne C., and Lisa Dilling, eds. 2007. *Creating a Climate for Change: Communicating Climate Change and Facilitating Social Change*. Cambridge, UK: Cambridge University Press.

Mouffe, Chantal. 2000. "Deliberative Democracy or Agonistic Pluralism." Institute for Advanced Studies, Vienna. Web.

Muir, John. 1911. *My First Summer in the Sierra*. Boston, MA: Houghton Mifflin. Web.

Murray, Tom. 2013. "Radford, Tom." *The Canadian Encyclopedia*. Web.

Nader, Laura. 1974. "Up the Anthropologist – Perspectives Gained from Studying Up." In *Reinventing Anthropology*. Edited by Dell Hymes. New York, NY: Vintage Books. 284–311.

National Energy Board. 2011. "Canada's Energy Future: Energy Supply and Demand Projections to 2035 – Crude Oil and Bitumen Highlights." Web.

———. 2013. "Canada's Oil Sands: Opportunities and Challenges to 2015." Web.

Natural Resources Defense Council. 2013a. "The Keystone XL Pipeline Puts Millions at Risk—Demand Clean Power" [video]. Web.

———. 2013b. "Tar Sands Oil is Killing Our Planet" [video]. Web.

———. 2015. "About Us." Web.

Nelson, Joyce. 1989. *Sultans of Sleaze: Public Relations and the Media*. Toronto, ON: Between the Lines.

New Brunswick (Government). 2010. *Now Is the Time to Be in New Brunswick* [video]. Web.

The New York Times. 2011. "No to a New Tar Sands Pipeline" [Editorial]. April 2. Web.

———. 2013. "When to Say No" [Editorial]. March 10. Web.

Nikiforuk, Andrew. 2010. *Tar Sands: Dirty Oil and the Future of a Continent*. Rev. ed. Vancouver, BC: Greystone Books.

———. 2012. "Petro State per Usual: Reading Alberta's Election." Web.

Nobel Prize. 2007. "The Nobel Peace Prize 2007." Web.

Obama, Barack. 2015. "Statement by the President on the Keystone XL Pipeline." US Government. November 6. Web.

O'Donnell, Sarah. 2010. "Alberta Pays to Deliver Oilsands Message." *Edmonton Journal*. July 3. A1.

Opel, Andy. 2002. "Monopoly™ the National Parks Edition: Reading Neo-Liberal Simulacra." In *Enviropop: Studies in Environmental Rhetoric and Popular Culture*. Edited by Mark Meister and Phyllis M. Japp. Westport, CT: Praeger. 31–44.

Oreskes, Naomi, and Erik Conway. 2010. *Merchants of Doubt*. New York, NY: Bloomsbury Press.

Ott, Cindy. 2011. "A Visual Critique of Ken Burns's *The National Parks: America's Best Idea.*" *The Public Historian* 33, no. 2: 30–36.

Palmer, Howard, and Tamara Palmer. 1990. *Alberta: A New History*. Edmonton, AB: Hurtig.

Palmer, Matt [dir.]. 2005a. *Pay Dirt: Making the Unconventional Conventional* [DVD]. Kelowna, BC / Carson City, NV: Filmwest Associates.

———. 2005b. *Pay Dirt: Alberta's Oil Sands: Centuries in the Making* [DVD]. Kelowna, BC/ Carson City, NV: Filmwest Associates.

Parkland Institute. 2013. "Alberta is Canada's Most Unequal Province and Calgary the Most Unequal City." Web.

Parliament of Canada. 2015. "Electoral Results by Party." Web.

Paulette et al. v. The Queen. [1977] 2 Supreme Court Reports 628. Web.

Payton, Laura, and Susana Mas. 2014. "Northern Gateway Pipeline Approved with 209 Conditions." CBC News. June 17. Web.

Pearson, Peter [dir.]. 1977. *The Tar Sands* [film]. Toronto, ON: Canadian Broadcasting Corporation. Broadcast on CBC Television, September 12.

Peeples, Jennifer. 2011. "Toxic Sublime: Imaging Contaminated Landscapes." *Environmental Communication* 5, no. 4: 373–392.

Pembina Institute. 2005. "Income Distribution in Alberta." Pembina Institute. Web.

———. 2013. "Losing Ground: Why the Problem of Oilsands Tailings Waste Keeps Growing." Web.

———. 2015. "Alberta Climate Panel Submission." Web.

Peters, John Durham. 2015. *The Marvelous Clouds: Toward a Philosophy of Elemental Media*. Chicago, IL: University of Chicago Press.

Pezzullo, Phaedra C. 2007. *Toxic Tourism: Rhetorics of Pollution, Travel, and Environmental Justice*. Tuscaloosa, AL: University of Alabama Press.

Pink, Sarah. 2003. "Interdisciplinary Agendas in Visual Research: Re-Situating Visual Anthropology." *Visual Studies* 18, no. 2: 179–193.

Pitschen, Salome, and Annette Schönholzer, eds. 1995. *Peter Mettler: Making the Invisible Visible*. Zurich, CH: R. Bilger.

Plec, Emily, and Mary Pettenger. 2012. "Greenwashing Consumption: The Didactic Framing of ExxonMobil's Energy Solutions." *Environmental Communication* 6, no. 4: 469–476.

Potter, Will. 2011. *Green Is the New Red*. San Francisco, CA: City Lights Books.

Pratley, Gerard. 2003. *A Century of Canadian Cinema: Gerard Pratley's Feature Film Guide, 1900 to the Present*. Toronto, ON: Lynx Images.

Pratt, Sheila. 2010. "Eyes of the World Are Watching Alberta." *Edmonton Journal*.
 October 3. A1.

Price, Monroe E. 1995. *Television, The Public Sphere and National Identity*. Oxford, UK:
 Oxford University Press.

———. 2002. *Media and Sovereignty: The Global Information Revolution and its Challenge
 to State Power*. Cambridge, MA: The MIT Press.

R. v. Syncrude Canada Ltd. 2010. Unreported judicial order. Provincial Court of
 Alberta, Criminal Division. Action No. 090157926P1. October 22.

Rabiger, Michael. 2015. *Directing the Documentary*. 6th ed. Burlington, MA: Focal Press.

Radford, Tom. 1971. *Death of a Delta* [film]. Edmonton, AB: Filmwest Associates.

———[dir.]. 1975. *The Man Who Chooses the Bush* [film]. Montréal, QC: National Film
 Board of Canada.

———[dir.]. 1991. *Mother Tongue* [film]. Kelowna, BC / Carson City, NV: Filmwest
 Associates.

———[dir.]. 2008. *Tar Sands: The Selling of Alberta* [video]. Toronto: Canadian
 Broadcasting Corporation. Broadcast on CBC Television, March 13.

Radford, Tom, and Harry Savage, eds. 1987. *The Best of Alberta*. Edmonton, AB: Hurtig.

Radford, Tom, and Niobe Thompson [dirs.]. 2011. *Tipping Point: The Age of the Oil Sands*
 [video]. Broadcast on CBC Television, January 27. Web.

———. 2012. *Tipping Point: The End of Oil* [DVD]. Edmonton, AB: Clearwater
 Documentary.

Raj, Althia. 2010. "CBC to Study Whether Its News is Biased." May 13. Web.

Rancière, Jacques. 2001. "Ten Thesis on Politics." *Theory and Event* 5, no. 3. Web.

———. 2007. *The Future of the Image*. Translated by Gregory Elliott. London, UK:
 Verso.

Raval, Anjli. 2015. "Brent Oil Falls Below $54 for First Time in Five Years." *Financial
 Times*, January 5. Web.

Redford, Alison. 2013. "US–Alberta Energy Relations: A Conversation with Premier
 Alison Redford." Brookings Institution. April 9. Web.

Rehling, Diana L. "When Hallmark Calls Upon Nature: Images of Nature in Greeting
 Cards." In *Enviropop: Studies in Environmental Rhetoric and Popular Culture*.
 Edited by Mark Meister and Phyllis M. Japp. Westport, CT: Praeger. 13–30.

Relph, Edward. 1976. *Place and Placelessness*. London, UK: Pion.

Remillard, Chaseten. 2011. "Picturing Environmental Risk: The Canadian Oil Sands
 and the *National Geographic*." *International Communication Gazette* 73, no. 1–2:
 127–143.

Richards, John, and Larry Pratt. 1992. "Oil and Social Class: The Making of the New West." In *Riel to Reform: A History of Protest in Western Canada*. Edited by George Melnyk. Saskatoon, SK: Fifth House Publishers. 224–244.

Roach, Robert. 2014. "Western Provinces Achieving Good Things Together." Canada West Foundation. March 19. Web.

Roberts, Paul. 2004. *The End of Oil: On the Edge of a Perilous New World*. Boston, MA: Houghton Mifflin.

Rose, Gillian. 1994. "The Cultural Politics of Place: Local Representation and Oppositional Discourse in Two Films." *Transactions of the Institute of British Geographers, New Series* 19, no. 1: 46–60.

Rose, Gillian. 2012. *Visual Methodologies: An Introduction to the Interpretation of Visual Materials*. 3rd ed. London, UK: Sage.

Rosenberg, Sharon, Amber Dean and Kara Granzow. 2010. "Centennial Hauntings: Reckoning with the 2005 Celebration of Alberta's History." *Memory Studies* 3, no. 4: 395–412.

Rosteck, Thomas, and Thomas S. Frentz. 2009. "Myth and Multiple Readings in Environmental Rhetoric: The Case of *An Inconvenient Truth*." *Quarterly Journal of Speech* 95, no. 1: 1–19.

Rust, Stephen, Salma Monani and Sean Cubitt, eds. 2013. *Ecocinema Theory and Practice*. New York, NY: Routledge.

Rusted, Brian. 2010. "The Art of the Calgary Stampede." In *The Art of the Calgary Stampede*. Curated by Brain Rusted. Calgary, AB: The Nickle Arts Museum.

Rutherford, A.C. 1910. "Address to the Canadian Club of Ottawa, October 9, 1906." In *Addresses Delivered before the Canadian Club of Ottawa 1903–1909*. Edited by George H. Brown. Toronto, ON: Mortimer. 56–57.

Saher, Merwan N. 2014. *Report of the Auditor General of Alberta, July 2014*. Web.

Sands, Andrea, and Hanneke Brooymans. 2010. "Rough Welcome for Alberta Minister at Mexico Climate Talks." *Postmedia News*. December 6. Web.

Schneider, Richard, and Simon Dyer. 2006. *Death by a Thousand Cuts: Impacts of In Situ Oil Sands Development on Alberta's Boreal Forest*. Web.

Schorn, Daniel. 2006. "The Oil Sands of Alberta." *60 Minutes* [TV program segment]. Broadcast on CBS on January 22. Web.

Schwalbe, Carol B. 2006. "Remembering Our Shared Past: Visually Framing the Iraq War on US News Websites." *Journal of Computer-Mediated Communication* 12, no. 1: 264–289.

Sharpe, Sydney, ed. 2005. *Alberta: A State of Mind*. Toronto, ON: Key Porter Books.

Sharpley, Richard, and Philip R. Stone, eds. 2009. *The Darker Side of Travel: The Theory and Practice of Dark Tourism*. Bristol, UK: Channel View.

Shepherd, Gregory J. and Eric W. Rothenbuhler. 2001. Preface to *Communication and Community*. Edited by Gregory J. Shepherd and Eric W. Rothenbuhler. Mahwah, NJ: Lawrence Erlbaum Associates.

Shrivastava, Meenal, and Lorna Stefanick, eds. 2015. *Alberta Oil and the Decline of Democracy in Canada*. Edmonton, AB: Athabasca University Press.

Simpson, Jeffrey. 2013. "Bitumen Needed Statesmen, Not Salesmen." *The Globe and Mail*. May 10. A15.

Singer, Ross. 2010. "Neoliberal Style, the American Re-generation, and Ecological Jeremiad in Thomas Friedman's *Code Green*." *Environmental Communication* 4, no. 2: 135–151.

Sinnema, Jodie. 2010. "Bird Deaths from Oilsands Far Greater than Estimated." *Calgary Herald*. September 8. A8.

———. 2015. "Premier Stands by Comments Criticizing Alberta's Past Response to Environmental Protection." *Edmonton Journal*. September 16. Web.

Skuce, Nikki. 2012. "Who Benefits? An Investigation of Foreign Investment in the Tar Sands." Forest Ethics. Web.

Smith, Charlie. 2012. "Richard Stursberg Reveals a CBC Study Indicated Conservatives Were Treated Best by *The National*." Web.

Smith, Marquard. 2008. *Visual Culture Studies: Interviews with Key Thinkers*. London, UK: Sage.

Smith, Mick. 2001. *An Ethics of Place: Radical Ecology, Postmodernity, and Social Theory*. Albany, NY: State University of New York Press.

Smithsonian Folklife Festival. n.d. "Smithsonian Folklife Festival: Mission and History." Web.

Sontag, Susan. 1977. *On Photography*. Harmondsworth, UK: Penguin.

Soron, Dennis. 2005. "The Politics of De-Politicization: Neo-Liberalism and Popular Consent in Alberta." In *The Return of the Trojan Horse: Alberta and the New World (Dis)order*. Edited by Trevor W. Harrison. Montréal, QC: Black Rose. 65–81.

SourceWatch. 2010. "COP15." Web.

Spears, George, Kasia Seydegart and Pat Zulinov. 2010. "The News Balance Report." ERIN Research Inc. Web.

Spears, Tom. "Believing in Clean Oilsands Like Believing in 'Magic Fairies,' Top Scientist Says." *Ottawa Citizen*. April 12. Web.

Statistics Canada. 2005. "Population by Religion, by Province and Territory (2001 Census)." Web.

———. 2008. "Aboriginal Peoples in Canada in 2006: Inuit, Métis and First Nations, 2006 Census." *The Daily*. January 15. Web.

———. 2009a. "Canada's Population by Age and Sex." *The Daily*. January 15. Web.

————. 2009b. "Population by Immigrant Status and Period of Immigration, 2006 Counts, for Canada, Provinces and Territories – 20% Sample Data." Web.

————. 2009c. "Visible Minority Population, by Province and Territory (2006 Census)." Web.

————. 2009d. "Population, Urban and Rural, by Province and Territory." Web.

————. 2014a. "Retail Trade, by Province and Territory." Web.

————. 2014b. "Population by Year, by Province and Territory (Number)." Web.

————. 2014c. "Population Projections: Canada, the Provinces and Territories, 2013 to 2063." *The Daily*. September 17. Web.

————. 2015. "Employment by Major Industry Group, Seasonally Adjusted, by Province (Monthly) (Alberta)." Web.

Stewart, David K., and R. Kenneth Carty. 2006. "Many Political Worlds? Provincial Parties and Party Systems." In *Provinces: Canadian Provincial Politics*. 2nd ed. Edited by Christopher J. Dunn. Peterborough, ON: Broadview Press.

Sturken, Marita, and Lisa Cartwright. 2009. *Practices of Looking: An Introduction to Visual Culture*. 2nd ed. Oxford, UK: Oxford University Press.

Suzuki, David T. 2010. *The Legacy: An Elder's Vision for Our Sustainable Future*. Vancouver, BC: David Suzuki Foundation / Greystone Books.

————. 2012. "A Biocentric Viewpoint is Needed Now!" EcoWatch. May 1. Web.

Svidal, Shelley. 1999. "Government Endorses UN Convention on Human Rights—Sort of." *ATA News* 33, no. 16. Web.

Szeman, Imre. 2012. "Crude Aesthetics: The Politics of Oil Documentaries." *Journal of American Studies* 46, no. 2: 423–439.

Taft, Kevin. 1997. *Shredding the Public Interest: Ralph Klein and 25 Years of One-Party Government*. Edmonton, AB: University of Alberta Press.

Tagg, John. 1993. *The Burden of Representation: Essays on Photographies and Histories*. Minneapolis, MN: University of Minnesota Press.

————. 2009. *The Disciplinary Frame: Photographic Truths and the Capture of Meaning*. Minneapolis, MN: University of Minnesota Press.

Tann, Ken. 2010. "Imagining Communities: A Multifunctional Approach to Identity Management in Texts." In *New Discourse on Language: Functional Perspectives on Multimodality, Identity, and Affiliation*. Edited by Monika Martin and J.R. Bednarek. London, UK: Continuum. 163–194.

Takach, Geo. 1992. "What Makes Us Albertans." *Prairie Journal of Canadian Literature* 19: 45–49.

————. 2006. "Rattus Non Gratus." *Alberta Views* 9, no. 6 (July–August): 40–43.

———— [dir.]. 2008a. *Dual Alberta* [DVD]. Edmonton, AB: Geo con Brio Productions. Premiered at Open Doors Edmonton Festival, Edmonton, AB, May 23–24, 2009.

———[dir.]. 2008b. *Alberta in One Word* [DVD]. Edmonton, AB: Geo con Brio
Productions. Premiered at Open Doors Edmonton Festival, Edmonton, AB, May
23–24, 2009.

———. 2009a. "Mythologized and Misunderstood." *Alberta Views* 12, no. 4: 38–42.

———[dir.]. 2009b. *Will the Real Alberta Please Stand Up?* [video]. Edmonton, AB:
Stand Up Productions Inc. Broadcast on City TV, June 6.

———. 2009c. "Will the Real Alberta Please Stand Up?" *Calgary Herald*. September 22.
A15.

———. 2010. *Will the Real Alberta Please Stand Up?* Edmonton, AB: University of Alberta
Press.

———. 2011. "Talking with the Legends." Public performance featuring Michele
Brown, Provincial Archives of Alberta, Edmonton, AB, January 11.

———. 2012a. "Is Alberta a Branch Plant for American Exceptionalism? Why It
Matters." *Alberta Views* 15, no. 3: 42–46.

———. 2012b. "War of the Wild Roses." Unpublished stage play in progress, work-
shopped at a public reading, MacEwan University, Edmonton, AB, September 20.

———. 2013a. "Selling Nature in a Resource-Based Economy: Romantic/Extractive
Gazes and Alberta's Bituminous Sands." *Environmental Communication* 7, no. 2:
211–230. Reprinted 2015. *Visual Environmental Communication*. Edited by Anders
Hansen and David Machin. London, UK: Routledge. 61–78.

———[dir.]. 2013b. *Voices from the Visual Volley: Filmmakers, the Tar Sands and Public
Health* [video]. Edmonton, AB: Geo con Brio Productions. Premiered at *InSight 2:
Engaging the Health Humanities*, University of Alberta Fine Arts Building Gallery,
May 14–June 8.

———. 2013c. "Environment, Communication and Democracy: Framing Alberta's
Bituminous Sands Onscreen." PHD diss., University of Calgary, Calgary, AB.
Web.

———. 2014. "Visualizing Alberta: A Battle of Branding, Nature and Bituminous
Sands." In *Found in Alberta: Environmental Themes for the Anthropocene*. Edited by
Robert Boschman and Mario Trono. Waterloo, ON: Wilfrid Laurier University
Press, 2014. 85–103.

———. 2016. *Scripting the Environment: Oil, Democracy and the Sands of Time and Space*.
London, UK: Palgrave Macmillan.

Tann, Ken. 2010. "Imagining Communities: A Multifunctional Approach to Identity
Management in Texts." In *New Discourse on Language: Functional Perspectives
on Multimodality, Identity, and Affiliation*. Edited by Monika Bednarek and J.R.
Martin. London, UK: Continuum. 163–194.

Taras, David. 2006. "Alberta in 2004." In *Alberta Formed—Alberta Transformed,
Volume 2*. Edited by Donald G. Wetherell, Michael Payne and Catherine Anne
Cavanaugh. Edmonton, AB / Calgary, AB: University of Alberta Press / University
of Calgary Press. 748–765.

Tar Sands Blockade. 2012. "Who We Are." Web.

Thompson, Elizabeth. 2010. "Family Trumps Country: Poll." *Belleville Intelligencer*.
June 12. Web.

Thompson, Niobe. 2008. "Producer Defends CBC Documentary" [letter to the editor].
Edmonton Journal. March 18. A17.

Thomson, Graham. 2010a. "Dead Ducks Haunt Oilsands' Reputation." *Edmonton
Journal*. July 20. A12.

———. 2010b. "Dump Spotty Water-Monitoring Regime." *Edmonton Journal*. August
31. A12.

———. 2013a. "Pitching Our Brand to World." *Edmonton Journal*. May 18. A19.

———. 2013b. "Raising a Sticky Issue." *Edmonton Journal*. August 14. A21.

Timilsina, Govinda R., Nicole LeBlanc and Thorn Walden. 2005. *Economic Impacts of
Alberta's Oil Sands*. Calgary, AB: Canadian Energy Research Institute. Web.

Timoney, Kevin. 2013. *The Peace-Athabasca Delta: Portrait of a Dynamic Ecosystem*.
Edmonton, AB: University of Alberta Press.

Tingley, Ken, and R.F.M. McInnis. 2005. *A is Alberta: A Centennial Alphabet*. Regina, SK:
Simple Truth Publications Inc.

Todd, Anne Marie. 2010. "Anthropocentric Distance in *National Geographic*'s
Environmental Aesthetic." *Environmental Communication* 4, no. 2: 206–224.

Trachtenberg, Alan. 1989. *Reading American Photographs: Images as History, Mathew
Brady to Walker Evan*. New York, NY: Hill and Wang.

Tuan, Yi-Fu. 1977. *Space and Place: The Perspective of Experience*. Minneapolis, MN:
University of Minnesota Press.

The Tyee. 2015. "New Oilsands Documentary Due Out This Fall." June 18. Web.

UK Tar Sands Network. 2011a. "'Oil Orgy' Invades Energy Summit." Web.

———. 2011b. "'Guerilla Ballet' Disrupts BP-sponsored Opera Event in Trafalgar
Square." Web.

———. 2013. "The 'Felt Impacts of the Tar Sands' Artwork Unveiled at the Canada
Europe Energy Summit." Web.

———. 2015. "Stopping the World's Most Destructive Project." Web.

United Nations. 2013. "Permanent Forum on Indigenous Issues." Web.

United Nations Framework Convention on Climate Change. 2013. "Copenhagen
Climate Change Conference – December 2009." Web.

United States Department of State. 2014. "Executive Summary." In *Final Supplemental Environmental Impact Statement for the Keystone XL Project*. Web.

United States Energy Information Administration. 2015. "Canada: International Energy Data and Analysis." Web.

van Dam, K.I.M. 2005. "A Place Called Nunavut: Building on Inuit Past." In *Senses of Place: Senses of Time*. Edited by G.J. Ashworth and Brian Graham. Farnham, UK / Burlington, VT: Ashgate. 105–117.

van Ham, Peter. 2002. "Theory Branding Territory: Inside the Wonderful Worlds of PR and IR." *Millennium: Journal of International Studies* 31: 249–269.

———. 2010a. "Place Branding and Globalisation. The Media is the Message?" In *Media, Organizations and Identity*. Edited by Lilie Chouliaraki and Mette Morsing. Houndmills, UK: Palgrave Macmillan. 149–167.

———. 2010b. *Social Power in International Politics*. Oxon, UK: Routledge.

van Herk, Aritha. 2001. *Mavericks: An Incorrigible History of Alberta*. Toronto, ON: Penguin.

———. 2005a. "Who You Callin' Cultured?" *Alberta Views* 8, no. 8 (December–January): 28–32.

———. 2005b. "Alberta Unbound." *The Globe and Mail*. October 1. D6.

———. 2007. "Atelier Alberta: Future Home to Art and Artists." In *Alberta's Energy Legacy: Ideas for the Future*. Edited by Robert Roach. Calgary, AB: Canada West Foundation. 121–132.

Van Horn, Tim, and Kristen Wagner. 2005. *I Am Albertan: A Modern-day Photographic Essay on the Albertan People*. Red Deer, AB: This Country Canada.

Van Praet, Nicolas. 2012. "Quebec Minister Lashes Out against Plans to Bring Alberta Oil to Province." *Financial Post*. November 14. Web.

Vanderly, Bob. 2008 (March 14, 11:06 a.m.). Comment on "Tar Sands: The Selling of Alberta." CBC Documentaries Blog. March 11, 2008.

Volmers, Eric. 2009. "Down Stream of Oscar." *Calgary Herald*. January 21. C1.

Vorkinn, Marit, and Hanne Riese. 2001. "Environmental Concern in a Local Context: The Significance of Place Attachment." *Environment and Behavior* 33: 249–263.

Wainwright, M. 2009. "Canada Tourist Video Shot in Northumbria." *The Guardian*. May 1. Web.

Waldie, Paul. 2013. "Canada Dead Last in Ranking for Environmental Protection." *The Globe and Mail*. November 18. Web.

Walsh, Brian. 2011. "Bienvenue au Canada: Welcome to Your Friendly Neighborhood Petro-State." *Time*. December 14. Web.

Walsh, Shannon [dir.]. 2009a. *H₂Oil* [DVD]. Montréal, QC: Loaded Pictures.

———. 2009b. "A Word from the Director – Shannon Walsh." Web.

Walters, Marylu. 2006. *Alberta's Centennial—A Celebration!* Edmonton, AB: Alberta Community Development.

Warren, John T. 1999. "Living within Whiteness: A Project Aimed at Understanding Racism." In *Intercultural Communication: A Reader.* Edited by Larry A. Samovar, Richard E. Porter and Edwin R. McDaniel. Lanham, MD: Rowland and Littlefield. 79–92.

Wayne, Mike. 2002. *The Politics of Contemporary European Cinema: Histories, Borders, Diasporas.* Bristol, UK: Intellect Books.

Webb, Jen. 2009. *Understanding Representation.* Thousand Oaks, CA: Sage.

Weber, Bob. 2011. "Nobel Laureates Press Harper to Oppose Alberta Oil-Sands Expansion." *The Globe and Mail.* September 28. Web.

———. 2014. "Federal Study Says Oil Sands Toxins Are Leaching into Groundwater, Athabasca River." *The Globe and Mail.* February 21. A5.

———. 2015. "Alberta's Climate Plan was Rooted in Talks between Environmentalists, Oilsands Execs." *Huffington Post Alberta*, November 25. Web.

Weir, Erin. 2010. "Alberta Royalty Rate Cuts Set a Dangerous Precedent." *The Globe and Mail.* April 7. Web.

Weismiller, Bryan. 2013. "Province Pushes Keystone XL Pipeline with Another Round of US Ads." *Calgary Herald.* April 7. Web.

Wells, Paul. 2012. "Crude Awakening." *Maclean's* 125, no. 3 (January 30): 17.

White, Jerry, ed. 2006. *Of This Place and Elsewhere: The Films and Photography of Peter Mettler.* Toronto, ON: Toronto International Film Festival.

———. n.d. *Spotlight.* CS41. "*Petropolis: Aerial Perspectives on the Alberta Tar Sands* (Peter Mettler, Canada)." Web.

Whitelaw, William George. 2007. "The Ascendancy of Albertanness: Neoliberalism, Political Identity and the Cowboy Citizen." MA thesis, Faculty of Communication and Culture, University of Calgary. Calgary, AB.

Wiebe, Rudy, Harry Savage and Tom Radford, eds. 1979. *Alberta, A Celebration.* Edmonton, AB: Hurtig.

Wilkinson, Charles [dir.]. 2011. *Peace Out* [video]. Vancouver, BC: Shore Films.

———. 2013a. *The Working Film Director: How to Arrive, Survive and Thrive in the Director's Chair.* 2nd ed. Studio City, CA: Michael Wiese Productions.

——— [dir.]. 2013b. *Oil Sands Karaoke* [video]. Vancouver, BC: Shore Films. Web.

———. 2013c. "Oil Sands Karaoke." charleswilkinson.com. Web.

———. 2015a. *Peace Out.* Markham, ON: Red Deer Press.

———. 2015b. "Currently." charleswilkinson.com. Web.

Williams, Raymond. 1973. *The Country and the City.* Oxford, UK: Oxford University Press.

Wolf, Frank [dir.]. 2011. *On the Line* [DVD]. Vancouver, BC: Gravywolf Films.

Wood, James. 2013. "Robert Redford Launches Attack on Alberta's Oilsands." *Calgary Herald.* September 17. Web.

Worster, Donald. 1991. "Beyond the Agrarian Myth." In *Trails: Toward a New Western History.* Edited by Patricia Nelson Limerick, Clyde A. Milner II and Charles E. Rankin. Lawrence, KS: University Press of Kansas. 3–25.

Zubjek, Alexandra, and Trish Audette. 2007. "Tradition in Transition." *Edmonton Journal.* September 13. A1.

Interviews Conducted by the Author

Quotations included in this book that are taken from the following interviews are identified as such but do not have accompanying endnotes.

Anonymous. Edmonton, AB, September 7, 2012.

Benoit, Roxanna. Edmonton, AB, July 18, 2012.

Calder, Frank. Edmonton, AB. July 3, 2012.

Cariou, Warren. Calgary, AB, June 22, 2012.

Coats, Emily. London, UK, September 11, 2012.

Davies, Travis. Calgary, AB, August 3, 2012.

Fiege, John. Video call from Austin, TX, May 16, 2014.

Gallant, George. Video call from Lethbridge, AB, August 28, 2012.

Iwerks, Leslie. Telephone from New York, NY, November 29, 2012.

Lavallee, David. Video call from Vancouver, BC, June 4, 2012.

Mettler, Peter. Telephone from Zurich, CH, October 27, 2012.

Palmer, Matt. Calgary, AB, June 25, 2012.

Potter, Gerry. Edmonton, AB, November 2, 2012.

Radford, Tom. Edmonton, AB, March 30 and April 4, 2012.

Sereda, Mark. Edmonton, AB, October 2, 2012.

Thompson, Niobe. Edmonton, AB, August 15, 2012, and e-mail, August 28 and 29, 2012.

Walsh, Shannon. Video call from Montréal, September 28, 2012.

Wilkinson, Charles. Telephone from Vancouver, BC, June 15, 2012, and March 27, 2014.

Wolf, Frank. Telephone from Vancouver, BC, June 26, 2012.

Index

Gismondi, Mike, 31

glaciers, 90–91

globalist bully frame, 99, 102, 115, 117f

globalization
environmental communications, 21,
158–59
place branding as response to, 27–28
See also neoliberalism

global warming. *See* climate change

Goffman, Erving, 33

Gore, Al, 18, 132–33

Gould, Stephen Jay, 158, 166

governments. *See* Alberta, government
and politics; Canada,
government and politics

greed frame, 38, 41f, 116, 117f

green art, 166

green (or denial) frame, 34–35, 36, 40,
41f, 116, 117, 117f, 118, 154, 156

Green Party, 2, 47, 140

Greenpeace
activism in Europe, 76, 100
ecocide, 40
producer of *Petropolis*, 62–66, 151
tailings ponds, 52–54

*Greenwash Gold. See Vote BP for
Greenwash Gold* (video)

Grierson, John, 89, 158, 164, 181n195

Gross National Happiness index, 2

H_2Oil (Walsh, film), 66–69, 73, 85, 100,
109, 110, 116, 179n129

Hansen, Anders, 22, 24, 158

Harper, Stephen, government, 51, 54, 67,
76, 123, 125

health effects of bit-sands mines
Athabasca River delta communities,
54–55, 66–67
cancers, 49, 54–55, 65, 85–86, 155
health frame, 39, 41f, 117f
O'Connor as whistleblower, 54–55,
72, 73, 109, 113, 155, 176n57
water pollution, 67, 87, 91

health frame, 39, 41f, 117f

Henderson, Henry, 73–74

history and forward-looking imagery,
145–48

Honour the Treaties tour (music), 8,
121

human geography, 133

Identica, 58

identity, place. *See* place-identity

images
apocalyptic imagery, 66, 144, 148
in books on Alberta, 146
critical approach, 24–25, 133–34
history of western Canada, 29–31,
127, 133
inaccurate and irrelevant images,
154
manipulation of, 23
power of, 23–24, 28
in society, 10, 157
wilderness and visual arts, 22–23
See also frames; nature; visual media

An Inconvenient Truth (Gore, film), 18,
115, 132–33

independent films. *See* films and videos,
documentary

Indigenous Environmental Network,
76, 100

241

Index

Other Titles from The University of Alberta Press

Unsustainable Oil

Facts, Counterfacts anad Fictions

JON GORDON

Groundbreaking study of theoretical, political, and environmental issues around the culture and ethics of petroculture.

The Algal Bowl

Overfertilization of the World's Freshwaters and Estuaries

DAVID W. SCHINDLER & JOHN R. VALLENTYNE

Eminent water experts examine the global threat of cultural eutrophication (nutrient pollution) and potential solutions.

The Peace-Athabasca Delta

Portrait of a Dynamic Ecosystem

KEVIN P. TIMONEY

Timely ecology of the Peace-Athabasca Delta— home of wildlife, indigenous cultures, and Alberta's oil sands.

More information at www.uap.ualberta.ca